Motor Blues

Impressum / *Imprint*

Motor Blues.
Die Schenkung AutoWerke von BMW Financial Services
an das Museum der bildenden Künste Leipzig

Motor Blues.
The Donation AutoWerke given by BMW Financial Services
to the Museum der bildenden Künste Leipzig

Die Schenkung umfasst 75 Fotografien und Videoarbeiten von
28 Künstlerinnen und Künstlern. / *The donation consists of 75 photographs*
and video works by 28 artists.

Museum der bildenden Künste Leipzig
Katharinenstr. 10
04109 Leipzig
Tel. 0341 / 216 999 12
Fax 0341 / 216 999 99
E-Mail mdbk@leipzig.de
www.mdbk.de

Herausgeber / *Publisher*
Hans-Werner Schmidt

Redaktion / *Editor*
Barbara Hentschel

Lektor / *Copy-editing*
B. Thomas Huber

Englische Übersetzung / *English translation*
Michael Eldred

Deutsche Übersetzung / *German translation*
Hans-Dieter Jünger

Gestaltung und Satz / *Graphic design and typesetting*
Severin Wucher, Leipzig / Berlin

Künstlerische Beratung / *Artistic advice*
Prof. Rayan Abdullah
Hochschule für Grafik und Buchkunst Leipzig
Wächterstr. 11
04107 Leipzig

Druck / *Printer*
Kerber Verlag, Bielefeld

Bindung / *Binding*
Buchbinderei S. R. Büge GmbH, Celle

Printed in Germany

Kerber Verlag
Windelsbleicher Str. 166
33659 Bielefeld
Tel. 0521 / 950 08 10
Fax 0521 / 950 08 88
E-Mail info@kerber-verlag.de
www.kerber-verlag.de

ISBN 3-938025-41-7

In freundlicher Zusammenarbeit mit der / *In friendly collaboration with the*

BMW Group

MOTOR BLUES

Die Schenkung AutoWerke von BMW Financial Services an das
Museum der bildenden Künste Leipzig

KERBER VERLAG

Inhalt / *Content* 5

Grußwort

Auftragskunst ist keine Gefälligkeitskunst. Immer dann, wenn die BMW Group sich kulturell engagiert, setzt sie voll auf die absolute Freiheit des kreativen Potenzials – die in der Kunst genauso Garant für bahnbrechende Werke ist wie sie für die wichtigsten Innovationen in einem erfolgreichen Wirtschaftsunternehmen steht.

Als die BMW Group Ende der 1990er-Jahre zumeist junge internationale Fotografen beauftragte, Arbeiten zum Thema Mobilität zu schaffen, da konnte noch niemand wirklich ahnen, wie kometenhaft die Karriere zahlreicher beteiligter Künstler verlaufen würde. Viele von ihnen sind inzwischen weltweit mit wichtigen Ausstellungen bedacht worden. Die BMW Group freut sich außerordentlich darüber, am neuen Werksstandort Leipzig im April 2005 die Sammlung »AutoWerke« in ihrer Gesamtheit als Schenkung dem Museum der bildenden Künste Leipzig übergeben zu haben. Diese bedeutende Institution ist genau das richtige Haus, um die Ausstellung, die zukünftige Leihgabe, an weitere Kultureinrichtungen und die Pflege dieser einzigartigen Exponate auf Dauer zu gewährleisten.

In den USA hat Kunstförderung durch Unternehmen eine lange Tradition. Gerade junge Künstler brauchen eine faire Chance und den nötigen finanziellen Spielraum, um sich frei entfalten zu können. Aus diesem Ansatz heraus hat die Sparte Finanzdienstleistungen der BMW Group im Jahr 1997 ein Projekt für zeitgenössische Fotografie in Auftrag gegeben. Maßgeblich beteiligt an der Entstehung der Sammlung »AutoWerke« war der damalige Leiter von Financial Services North America und das spätere Vorstandsmitglied unseres Unternehmens, Günter Lorenz.

In dem anlässlich der Ausstellung von »AutoWerke« im Jahr 2000/2001 in den Hamburger Deichtorhallen erschienenen Katalog geht er in seinem Grußwort auf die Genese der Sammlung ein: »Wir baten ein Kuratorenteam, zehn Künstler auszuwählen, die für ihren innovativen Umgang mit dem Medium Fotografie bekannt sind, damit sie sich fotografisch mit dem Geist von BMW auseinander setzen. Diese Künstler sind Heike Baranowsky, Thomas Demand, Rineke Dijkstra, Nina Fischer & Maroan el Sani, Candida Höfer, Boris Michailov, Johannes Muggenthaler, Ursula Rogg, Thomas Struth und Alexander Timtschenko. Von ihren Reisen brachten sie eindrucksvolle Bilder mit, die ihre unabhängige künstlerische Leistung überzeugend zum Ausdruck bringen. Wir glauben, dass dieses Projekt neue Maßstäbe setzt und neue Möglichkeiten für die Auftragskunst und die Kunstsammlungen von Unternehmen eröffnet.«

Gemäß der ursprünglichen Idee wuchs die Sammlung schließlich auf 75 Arbeiten von insgesamt 28 Künstlern heran. Hierzu zählen auch die Arbeiten sechs britischer Künstler, darunter Hannah Starkey und Sarah Jones, die 1999 im Rahmen des Projekts »Making Your Dreams Come True« realisiert wurden, das BMW Financial Services UK initiiert hatte. In ihrer Gesamtheit wird die Sammlung vom Museum der bildenden Künste Leipzig nun treffend, und vor allem von Beat Streulis Arbeiten inspiriert, unter »Motor Blues« geführt.

Wir haben allen Künstlern zwei Jahre lang alle Türen unseres Unternehmens geöffnet, selbst die Wohnungen unserer Mitarbeiter. Wir wollten durch die Sprache der Kunst erfahren, was die Faszination der Marke BMW ausmacht, was die Künstler an einem Automobilhersteller wie der BMW Group fasziniert, was sie umtreibt, auch was sie als problematisch erachten mögen. Nicht nur Marktanalysen und Kundenbefragungen sind für uns von Bedeutung. Es ist ebenso spannend zu wissen, wie durch das Medium Kunst unsere Automobile und die Marke wahrgenommen werden.

Foreword

Commissioned art does not have to please. Whenever the BMW Group becomes culturally involved, it fully commits itself to the absolute freedom of the creative mind, something equally as crucial to ground-breaking art as it is synonymous with the most important innovations within a successful business undertaking.

When, at the end of the nineties, a number of predominantly young international photographers were commissioned by the BMW Group to perform artistic work focusing on the subject of mobility, no one could really know just how rapidly the careers of a large number of the participating artists would progress. Many of them have since had their works exhibited at important venues all over the world. The BMW Group is exceptionally pleased to have handed over in April 2005, at the site of the new BMW Leipzig plant, the entire collection bearing the title "AutoWerke" as a donation to the Museum der bildenden Künste Leipzig. This renowned institution is undoubtedly the most suitable place to ensure that the exhibition, the future loaning of exhibits to other cultural organizations, and the consistent care of these unique works of art is adequately conducted.

In the USA the corporate promotion of art has a long-standing tradition. Young artists in particular need fair opportunities and the necessary financial leeway to develop their capabilities to the full. With this in mind, BMW Group Financial Services commissioned a project encompassing contemporary photography in 1997, the then manager of Financial Services North America and later a board member of our company, Günter Lorenz, being decisively involved in the creation of the art collection "AutoWerke". In the catalogue published on the occasion of the exhibition "AutoWerke" held in 2000/2001 at the Hamburg Deichtorhallen, his welcoming speech included the following words dealing with the genesis of the collection: "We commissioned a team of curators to select ten artists known for their innovative approach to photography in order that they may reflect the spirit of BMW utilizing photography as a medium. The artists chosen were Heike Baranowsky, Thomas Demand, Rineke Dijkstra, Nina Fischer & Maroan el Sani, Candida Höfer, Boris Michailov, Johannes Muggenthaler, Ursula Rogg, Thomas Struth and Alexander Timtschenko. They returned from their travels with a number of impressive photographs that expressed each of their own particular artistic abilities in a most convincing manner. We believe that this project sets new benchmarks and opens new possibilities for commissioned art and corporate art collections."

In keeping with the original idea, the collection eventually grew to comprise 75 works by a total of 28 artists. These also include the works of six British artists—two of them by Hannah Starkey and Sarah Jones—which were realized in 1999 within the framework of the project "Making Your Dreams Come True" initialized by BMW Financial Services UK. As the collection is now being exhibited at the Museum der bildenden Künste Leipzig in its entirety it is aptly titled "Motor Blues", predominantly derived from and inspired by the work of Beat Streuli.

For a period of two years, all of the artists were granted access to every area of the company, this including even our employees' homes. Through the language of art it was essential for us to learn from ongoing discussions just what each artist found fascinating about BMW, about a car manufacturer such as the BMW Group—what they were preoccupied with, even what they might deem problematic. After all, we are not interested in market analyses and customer surveys alone. It is equally as crucial to sense the recognition of our cars and brand via the medium of art.

Wir wollten nicht das tun, was viele Unternehmen tun, nämlich einfach bereits angesehene und teure Kunstwerke kaufen, um damit die Konzernzentrale zu schmücken. Wir wollten mit dieser Fotosammlung die Schaffung neuer Werke ermöglichen. Und dies ist wahrlich gelungen: Die 75 Arbeiten der Sammlung »AutoWerke« geben einen umfassenden Überblick über Positionen zeitgenössischer Foto- und Videokunst. Dabei waren weder Motivwahl noch Medium der Umsetzung vorgegeben, jeder Künstler sollte eigene ästhetische wie inhaltliche Ansätze frei verfolgen können. Die »AutoWerke« präsentieren daher stark differenzierte künstlerische Sicht- und Produktionsweisen. Die Sammlung verdankt ihre Einzigartigkeit aber nicht nur der unterschiedlichen Motivwahl der Arbeiten, sondern auch den verschiedenen technischen Umsetzungen, die von Schwarzweiß- oder Farb-Fotografie bis hin zur Videotechnik reichen.

Genau deshalb sollte diese wertvolle Sammlung nicht nur intern unsere Mitarbeiter und Gäste erfreuen. Wir haben entschieden, sie einer breiten interessierten Öffentlichkeit dauerhaft zugänglich zu machen. Wir sind sicher, die Sammlung ist in Leipzig in den besten Händen. Und wir freuen uns, wenn die Kunstwerke auch an andere Museen verliehen werden und sie so um die ganze Welt gehen.

»In Leipzig haben sich schon immer Unternehmer für die Kultur engagiert. Ich bin sehr glücklich, dass sich auch die BMW Group nicht nur für den Wirtschaftsstandort Leipzig engagiert, sondern ebenso den Kunststandort Leipzig fördert.« Das Zitat von Leipzigs Oberbürgermeister Wolfgang Tiefensee anlässlich der Schenkungsübergabe ist weltweit für alle Standorte unsere Devise. Unser Dank gilt an dieser Stelle vor allem den Künstlern und denjenigen, die an unserem Projekt mitgearbeitet und zum Erfolg beigetragen haben. Als Direktor des Museums der bildenden Künste Leipzig wünschen wir Herrn Dr. Schmidt und seinem Kuratorenteam mit der Sammlung viel Freude.

Stefan Krause
Mitglied des Vorstands der BMW AG

We did not wish to do what many companies do, and that is to simply purchase already highly respected and expensive works of art which merely adorn a room at group headquarters. With this photographic collection it was our intention to render possible the creation of new works, a task we have truly succeeded in doing. The 75 works included in the collection "AutoWerke" provide an extensive overview of contemporary photographic and video art. No preconditions were made with regard to motif and medium used in the realization of the works, so that each artist was able to freely utilize his or her own approach in terms of aesthetics and content. Therefore, the "AutoWerke" exhibits represent strongly differentiating artistic styles. However, the uniqueness of the collection can be put down not only to the different choice of motifs used in creating the works, but also to the diverse techniques involved in their realization, these ranging from black and white and colour photography to video film technology.

It was precisely for this reason that access to this valuable art collection was to be granted not only to company employees and guests. We decided to make it permanently available to a broad and interested public. We are sure that the collection is in good hands in Leipzig. And we will be most pleased if these works are put on loan to other museums so that they can be seen by people all over the world.

"Entrepreneurs in Leipzig have always been committed to cultural involvement. I am most happy that the BMW Group is not only supporting Leipzig as an industrial location, but also as a city of art." This statement by Wolfgang Tiefensee, Lord Mayor of Leipzig, on the occasion of the handing over of the donation reflects our maxim in the case of all company locations worldwide. May we take this opportunity to express our gratitude in particular to the artists and all those who collaborated in this project, thereby contributing to its success. We hope that Dr. Schmidt, as director of the Museum der bildenden Künste Leipzig, and his team of curators will derive great pleasure from this collection.

Stefan Krause
Member of the Board of Management, BMW AG

Hans-Werner Schmidt

Rede

anlässlich der Schenkungs-Übergabe der
BMW-Sammlung »AutoWerke« am 28. April 2005
im Museum der bildenden Künste Leipzig

Als im Vorfeld dieses heutigen Schenkungsaktes die entsprechende Kunde die Runde machte, beförderte dies eine ganze Reihe von Fragen. Bekannt war schon, dass BMW nicht wie der Mitanbieter Daimler-Chrysler eine hauseigene Kunstsammlung besitzt. Oder hatte man die Sammlungsaktivität bisher einfach nicht in der entsprechenden Dimension wahrgenommen, weil man sich im Hause BMW auf das Segment der zeitgenössischen Fotografie festgelegt hatte und Insider dies noch nicht breit kommuniziert hatten? War man dabei, die Fragen zu beantworten, provozierte man ein Mehr an Fragen, ja Skepsis. Die Entstehungsgeschichte der fotografischen Sammlung ist deshalb im Nachvollzug nicht einfach, weil sie gängige Denkschablonen konterkariert.

BMW ging als Auftraggeber auf Fotografinnen und Fotografen zu und bat sie, ein ästhetisch anspruchsvolles und prestigehaftes Produkt – nämlich BMW – in einen ungewöhnlichen Kontext zu stellen. So heißt es im Vorwort des Kataloges der Deichtorhallen in Hamburg, wo die Sammlung unter dem Titel »AutoWerke« im Jahr 2000 ausgestellt wurde: »Die Auswahl der eingeladenen und beauftragten Künstler ist mehreren unabhängigen Juroren übertragen worden, deren Augenmerk jenen Positionen galt, die konzeptuelle und kontextkritische Arbeiten geliefert haben. In dieser Hinsicht ist auch hervorzuheben, dass der Auftraggeber durchaus bereit war, zum Thema ›AutoWerke‹ Beiträge zu akzeptieren, die von vornherein keineswegs nur glanzvolle Illustrationen zur Werbung für die eigenen Produkte bieten.« Eine neue Sicht neben der eingeübten visuellen PR-Strategie wurde also gesucht – denn: Jede Form des mit gedanklicher Trägheit einhergehenden Pragmatismus geht mit einem Perspektivenschwund einher.

Und – je ausgefeilter, dezidierter Methoden in der Analyse eingesetzt werden, umso vorbestimmter, ja schmaler ist das Ergebnisspektrum. Und – jeder Produktentwickler muss die Deckungsgleiche zwischen Bedürfnis und Angebot fürchten, steuert man doch so einen Kreisverkehr an, der keine Ausfahrt in eine andere Richtung kennt. Letztlich ist der Volksmund angesichts dieses hier skizzierten Szenariums wieder einmal am treffsichersten. Er kombiniert Blindheit mit Betrieb und liefert damit ein anschauliches Bild.

Also vertraute man sich dem offenen System Kunst an, hier nun der Fotografie, um fixierte Vorstellungen und Hypothesen zu überprüfen, die Pfeiler und Perspektiven einer globalen BMW-Kultur sind. Angesichts dieser fundamentalen Fragestellung konnte man die historisch vorformulierten Sparten wie »Werksfotografie«, »Arbeiterporträt« oder auch »Produktfotografie« ad acta legen. Es ging um Aura und Mythos und dies nicht konzentriert auf ein blauweißes Rautenmuster. Es ging um Automobilität, die heute als Grundzug unserer Lebensorganisation eingeschrieben ist.

An drei darauf bezogenen künstlerischen Analysen sind beteiligt gewesen: Heike Baranowsky, Thomas Demand, Rineke Dijkstra, Todd Eberle, Nina Fischer und Maroan el Sani, Noritoshi Hirakawa, Candida Höfer, Tom Hunter, Sarah Jones, Inez van Lamsweerde und Vinoodh Matadin, Glenn Ligon, Sharon Lockhart, Boris Michailov, Johannes Muggenthaler, Catherine Opie, Sophy Rickett, Ursula Rogg, Paul Seawright sowie David Shrigley, Bridget Smith, Hannah Starkey, Beat Streuli, Thomas Struth, Wolfgang Tillmans, Alexander Timtschenko und Gillian Wearing.

Speech

*on the occasion of the presentation of the donation
of the BMW collection »AutoWerke« on 28 April 2005
at the Museum der bildenden Künste Leipzig*

When in the run-up to today's ceremonial donation, the donor was shown around the house, this gave rise to a whole series of questions. It was already known that BMW, unlike its competitor, DaimlerChrysler, did not possess its own art collection. Or had the collecting activities in the appropriate dimensions to date simply not been noticed because BMW had committed itself to the segment, contemporary photography, and insiders had not yet communicated this broadly? Whilst trying to answer the questions, even more questions were provoked, indeed scepticism. The history of how the photographic collection came about is therefore not easy to follow, because it does not fit into the usual clichés of thinking.

BMW approached photographers and asked them to place an aesthetically sophisticated and prestigious product—namely BMW—in an unusual context. This is what we read in the preface to the catalogue of the Deichtorhallen in Hamburg, where the collection was exhibited in 2000 under the title "AutoWerke": "The selection of the artists to be invited and commissioned was placed in the hands of several independent jurors whose focus was on those positions which have provided conceptual works that are critical of context. It must also be emphasized that the client was prepared to accept contributions on the theme "AutoWerke" which from the outset in no way provided only glamorous illustrations for advertising the client's own products". Thus, a new view was sought apart from the routine visual PR strategy since every form of pragmatism inherent in conceptual lethargy goes hand in hand with a loss of perspective.

And, the more elaborately and decisively methods are employed in the analysis, the more predetermined and narrow is the spectrum of results. And every product developer must fear the equalization of demand and supply, for then one is aiming at a circulation of traffic that does not know any exit in another direction. Ultimately, in view of the scenario sketched here, the vernacular is once again closest to the mark. It combines profession with blindness and thus provides a vivid image.

So one puts one's faith in the open system called art, here photography, to examine fixed ideas and hypotheses that are the supports and perspectives of a global BMW culture. In view of this fundamental problematic, it was possible to put aside the historically preformulated branches such as works photography, worker's portraits and product photography. It was a matter of aura and myth, and this not with a concentration on the blue-and-white quadrant symbol. It was a matter of automobility which today is inscribed as a basic trait into the organization of our lives.

The following persons were involved in three artistic analyses relating to this problematic:
Heike Baranowsky, Thomas Demand, Rineke Dijkstra, Todd Eberle, Nina Fischer and Maroan el Sani, Noritoshi Hirakawa, Candida Höfer, Tom Hunter, Sarah Jones, Inez van Lamsweerde and Vinoodh Matadin, Glenn Ligon, Sharon Lockhart, Boris Michailov, Johannes Muggenthaler, Catherine Opie, Sophy Rickett, Ursula Rogg, Paul Seawright, David Shrigley, Bridget Smith, Hannah Starkey, Beat Streuli, Thomas Struth, Wolfgang Tillmans, Alexander Timtschenko, Gillian Wearing.

Ihre Werke gehen heute aus dem Besitz von BMW Financial Services in die Sammlung des Museums der bildenden Künste ein. Dafür möchte ich an dieser Stelle allen beteiligten Aktivposten bei BMW danken – das sind: Stefan Krause, Vorstandsmitglied der BMW AG, Dr. Thomas Brakensiek, BMW Financial Services, Peter Claussen, Leiter BMW Werk Leipzig, Thomas Girst, Leiter Referat KulturKommunikation.

Am 4. Dezember 2004 wurde das neue Museum der bildenden Künste Leipzig eröffnet, am 13. Mai 2005 wird das neue BMW-Werk in Leipzig eröffnet. Der Schenkungsakt befindet sich also in einer zeitlichen Sandwichposition. Sicherlich hat das Wachsen dieser beiden signalhaften Bauten in Leipzig dazu beigetragen, dass Schenkgeber und Schenknehmer bei gegenseitigen Baustellenbesuchen sich euphorisiert haben.

Bevor ich eine kurze Charakterisierung der fotografischen Werke gebe, möchte ich eine Rückblende unternehmen, mit der ich auch ganz deutlich machen kann, dass die Schenkung an ihrem richtigen Ort angekommen ist.

Bereits 1893 richtete die »Sächsische Königliche Kunstakademie und Kunstgewerbeschule Leipzig« ein »Photomechanisches Institut« ein. Die »Abteilung für photographische Vervielfältigungstechnik« erhielt 1901 Hochschulstatus. Die Aufgabenstellungen bezogen sich auf die Bereiche Buchschmuck, Illustration und Werbung. 1913 wurde dieser Bereich in einen der künstlerischen Fotografie umgewandelt. Die erste deutsche Professur für Fotografie erhielt 1914 der Amerikaner Frank Eugène Smith. Der Erste Weltkrieg verhinderte ein künstlerisches Durchstarten auf diesem neuen Terrain. Aber man muss es sich auf der Zunge zergehen lassen: 1928 unterrichteten hier László Moholy-Nagy und 1929 Hugo Erfurth.

In den dreißiger Jahren vertrat man allerdings ausschließlich die Losung, dass Handwerk allein goldenen Boden habe, wobei der Blick hinsichtlich der künstlerischen Wertigkeit auf eine Schmalspurbahn gelenkt wurde, und 1946 wurde das Rad im Zustand des Zurückfahrens fixiert. Unter der Oberzeile »Graphisches Gewerbe« galt das Augenmerk in der fotografischen Ausbildung von nun an der Reportagefotografie, der wissenschaftlichen visuellen Dokumentation und der Werbefotografie. Der individuelle Fokus, das fotografische Experiment bleibt von da an studentischen Aktivitäten überlassen, die sich stets in einer Zone zwischen Bevormundung und Duldung bewegt. Erst 1967 gelingt Joachim Jansong die Weichenstellung in Richtung experimentelle Fotografie, doch der Studienabschluss sieht weiterhin eine Konzentration auf den Bildjournalismus vor. Aufträge von Großbetrieben sollten Milieuschilderungen liefern.

Der Versuch einer grundsätzlichen Verortung der Leipziger Fotografie könnte heißen: Der Weg des fotografischen Selbstverständnisses und die daraus abgeleitete Ausbildung oszillierte im letzten Jahrhundert in der hiesigen Kunsthochschule immer zwischen dem Angewandten, dem Journalistisch-Dokumentierenden und dem Freien, dem elaborierten subjektiven Code Zugewandten. Dafür wird 1992 nach Konsolidierung und Verjüngung des Fachbereichs in einem Positionspapier ein Selbstverständnis formuliert, das »Fotografie im Eigenauftrag als bedingungslose Art zu leben« begründet. Die Fotografie an der Hochschule für Grafik und Buchkunst (HGB) wird heute vertreten durch Tina Bara, Joachim Brohm, Timm Rautert und Helfried Strauß.

Their works are today being handed over by BMW Financial Services to the collection of the Museum der bildenden Künste. For this donation I would like to thank all the persons involved at BMW. These are Stefan Krause, member of the board at BMW AG, Dr. Thomas Brakensiek, BMW Financial Services, Peter Claussen, head of the BMW works in Leipzig, Thomas Girst, head of the cultural communication department.

The new Museum der bildenden Künste Leipzig was opened on 4 December 2004, and on 13 May 2005, the new BMW works in Leipzig will be opened. The donation ceremony is thus situated in a temporal sandwich position. To be sure, the growth of these two exemplary buildings in Leipzig has contributed to donors and recipients becoming euphoric when visiting each other's construction sites.

Before giving you a brief characterization of the photographic works, I would like to provide a flashback with which I can make it quite clear that the donation has arrived at its proper place.

Already in 1893, the »Sächsische Königliche Kunstakademie und Kunstgewerbeschule Leipzig« (Saxon Royal Art Academy and Applied Arts School) set up a Photo-Mechanical Institute. The Department for Photographic Reproduction Technology was given status as an institution of higher learning in 1901. The areas of work were book decoration, illustration and advertising. In 1913, this department was transformed into a Department of Artistic Photography. The first German professorship for photography was awarded to the American Frank Eugène Smith. The First World War prevented the initiation of artistic work on this new terrain. But one must duly appreciate the following fact: In 1928, László Moholy-Nagy taught here and, in 1929, Hugo Erfurth.

In the 1930s, however, the slogan was exclusively propagated that only craft was golden, so that the perspective on artistic value was restricted to a narrow strip, and in 1946 the wheel was locked in a state of regression. Under the heading, Commercial Graphics, the focus was now on photographic training for journalistic photography, scientific visual documentation and advertising photography. By this time, the individual focus, the photographic experiment was left to student activities which moved within a zone situated between paternalism and toleration. Only in 1967 did Joachim Jansong succeed in shifting the direction towards experimental photography, but the final qualification continued to concentrate on photographic journalism. Commissions given by large organizations were supposed to deliver illustrations of a milieu.

An attempt at situating Leipzig photography in a fundamental way could run: the path of how photography was understood, and the training derived from this in the last century oscillated at the Leipzig art school between the applied, the journalistic-documentary, and free photography devoted to an elaborate subjective code. In 1992, however, after consolidation and rejuvenation of the faculty, a conception of the faculty's task was formulated in a position paper that established "photography undertaken individually and independently, without any strings attached, as a way of living". Photography at the Academy of Visual Arts is today taught by Tina Bara, Joachim Brohm, Timm Rautert and Helfried Strauß.

Gleich, welchen Stellenwert die Fotografie seit mehr als 100 Jahren an der hiesigen Kunstakademie hatte, hinweg durch fünf politische Systeme zeigte sich das Museum der bildenden Künste merkwürdig imprägniert gegen alle fotografischen Leistungen, die an dieser Schule hervorgebracht wurden. Die Fotografie, der Graphischen Sammlung im Hause zugeordnet, führt eher ein zufälliges Dasein und ist in der Dimension sehr überschaubar. Ich habe versucht, den Ball, den eine solche Ausbildungsstätte am Ort dem Museum als Partner zuspielt, aufzugreifen, bin allerdings an der Begrenztheit der Mittel gescheitert. Auch die Idee, eine mit dem Medium verwandte Industrie am Ort als Partner für den Aufbau einer fotografischen Sammlung zu finden, fand kein Echo. Doch nun wird mit der Schenkung der fotografischen Sammlung von BMW ein Fundament gelegt und ein Terrain abgesteckt, für das andere Kunstinstitute oft Jahre brauchen bei kontinuierlichem Mittelfluss. Und, was es immer wieder gilt zu unterstreichen, die Spezifik dieser Sammlung, die in der Form der eingangs geschilderten Auftragsvergabe begründet ist, korrespondiert mit der Geschichte der Fotografie am Kunstort Leipzig.

Es würde Sie und auch mich hier überfordern, alle 28 künstlerischen Beiträge in lexikalischer Kürze und Präzision vorzustellen. Wir zeigen die gesamte Schenkung im Rahmen einer Ausstellung vom 19. Juni bis zum 21. August hier im Haus. Nur soweit: Thomas Demand zeigt in der ihm eigenen Weise Architektur und Ambiente als Kulisse, als Surrogat und Vorspiegelung falscher Tatsachen. Hierzu könnte ich gleich mehrere fotografische Positionen vor Ort benennen, die vornehmlich in einer solchen Sicht die nach Losungen gestaltete Wirklichkeit als die Realität der Kulissen wahrgenommen haben – formal anders, aber im Kern vergleichbar.

Rineke Dijkstra fotografiert Jugendliche, die am BMW-Ausbildungsprogramm »Euro-Azubi« teilgenommen haben. Ihr geht es dabei darum, Individualität in der Gruppe aufzuspüren. Sie fokussiert Abweichungen im Muster. Ein soziologischer Fokus und eine psychologische Tiefenschärfe charakterisieren ihre Bilder. Hier muss man natürlich auf Evelyn Richter verweisen, die Arbeiterinnen und Lehrlinge an ihren Arbeitsplätzen beobachtet hat und dabei vor allem, wie sich pubertärer Eigensinn in der Schablone Arbeitsablauf in sympathischer Weise verkantet.

Candida Höfer widmet sich der Produktionsstätte am Münchner Standort des Unternehmens. Auch wenn keine Menschen am Ort des Geschehens präsent sind, so treten in ihren Aufnahmen die Organisationsstrukturen und die Arbeitsabläufe deutlich vor Augen. Die Addition des Maschinenparks als funktionierendes Räderwerk stellt sie als Umsetzung menschlichen Konzeptvermögens und Gestaltungswillens heraus. Den Ort fokussiert sie als einen für Menschen gestalteten. Bei ihr wird wiederum deutlich, dass hinter der Folie des Dokumentarischen eine Handschrift steckt. Dies war über Jahrzehnte an der hiesigen Ausbildungsstätte ein schwieriges Feld, inwieweit der subjektive Faktor das Feld des Objektiven infiltrieren kann, in ihm – im subjektiven Faktor – ein Spürsinn arbeiten kann, der Tiefenschärfe nicht nur als formales Kriterium begreift.

Independently of the position that photography had for more than one hundred years at the Art Academy in Leipzig, through five different political systems, the Museum der bildenden Künste showed itself to be remarkably immune to all the photographic achievements made in this school. The photography, allocated to the Graphics Collection in the museum, has had a rather meagre existence and in its dimensions is quite small. I have tried to pick-up the ball which such a training institution in the city can pass on to the museum as a partner, but have come up against the barrier of limited resources. Even the idea of finding locally an industry related with the medium as a partner for building up a photographic collection did not find any echo. But now with the donation of the photographic collection by BMW, a foundation is laid and terrain is staked out for which other art institutions often require many years with a continuous stream of financial resources. And, it should be underscored once more, the specificity of this collection, which is grounded in the form of the commission given as I have already outlined, matches well the history of photography in Leipzig as a place of art.

It would overtax me and also you to present all 28 artistic works with the brevity and precision of an encyclopaedia. We are showing the entire donated collection here at the museum in an exhibition from 19 June to 21 August. But briefly: Thomas Demand is showing in his own inimitable way architecture and ambient as a backdrop, as a surrogate and presentation of falsehoods. Here I could easily mention several local photographic positions which, mainly from such a viewpoint, have perceived reality shaped according to slogans as the reality of backdrops—formally different, but basically comparable.

Rineke Dijkstra has photographed youths who have taken part in the BMW training program, Euro Trainee. For her it is a matter of detecting individuality in the group. She focuses on deviations within the pattern. The photographs are characterized by a sociological angle and a psychological depth of focus. Here, of course, I must refer to Evelyn Richter who has observed female workers and apprentices at work and above all, how teenage obstinacy jams in a likeable way in the work routines.

Candida Höfer devoted herself to the company's Munich production plant. Even when there are no people present at the site of the happening, the organizational structures and the work procedures are still clearly visible in her photographs. She draws out the addition of the functioning clockwork of a plant as the deployment of human conceptual capacity and the will to shape and form. She focuses on the location as one that has been shaped for people. In her work it becomes apparent that, behind the foil of documentary, there is a personal handwriting. For several decades this was a difficult topic at this training institution—the question of to what extent the subjective factor can infiltrate the field of what is objective, to what extent a sensitivity can be at work in the subjective factor which does not conceive of depth of focus only as a formal criterion.

Musste unter den Bedingungen des real existierenden Sozialismus sich der objektive Faktor Subjektivität im Rahmen des gesellschaftlichen Auftrages behaupten, so war seitens BMW der Auftrag formuliert, eben mit dieser Subjektivität Vorstellungen von Objektivität zu befragen und letztlich diese mit subjektiven Bildern zu perforieren. War es im Lehrplan des Sozialismus nicht opportun, diesen als Mythos zu durchleuchten, so war gerade dies bei BMW der Auftrag, einen die Marke umgebenden Mythos zu befragen, damit eben dieser nicht die Bodenhaftung zur Realität verliert. So kommen hier am Ort nun zwei Fotowelten zusammen, HGB-Tradition und BMW-Kultur, die jeweils Bilder hervorgebracht haben, bei denen Dokumentationen subjektive Handschriften besitzen und das Inszenatorische im Zugriff auf die Motive das scheinbar Vertraute in unvertrauten Bildern aufmischt. Das ist die große Qualität der Kunst, dass sie in der Befragung der Realität in ihrer Freestyle-Manier im Gegensatz zu methodisch kanalisierten Verfahren die Mobilität des Denkens viel mehr befördert.

Ich danke noch einmal allen, dass dieses visuelle Gedankenpotenzial in das Museum der bildenden Künste eingeht und ich sage Dank für die Kommunikationskultur, die man gemeinsam, BMW und Museum der bildenden Künste, hier in den letzten zwei Jahren entwickeln konnte.

If under the conditions of real existing socialism, the objective factor, subjectivity, had to assert itself within the framework of a social mission, the task presented by BMW was precisely to question ideas of objectivity with this subjectivity and ultimately to perforate this objectivity with subjective images. If in the curriculum of socialism it was not advantageous to illuminate it as a myth, for BMW this was precisely the mission, to question the myth surrounding the brand so that the myth did not lose contact with the ground of reality. Thus, here at this location, two photographic worlds have come together—the tradition of the Academy of Visual Arts and BMW culture— each of which has brought forth images in which documentation has a subjective handwriting and the staging, in accessing the motifs, mixes the apparently familiar with unfamiliar images. This is the great quality of art, that in questioning reality in a freestyle manner, it promotes the mobility of thinking much more than methodologically channelled procedures.

I would like to thank everybody once again that this visual potential for thinking is now entering the Museum der bildenden Künste, and I express my thanks for the culture of communication that has developed here over the past two years in cooperation between BMW and the Museum der bildenden Künste.

Barbara Hentschel

Motor Blues

Fotografische Sichten auf das Automobil

Die Faszination für das Automobil als mythisch besetztes, von Fantasien und kollektiven Gefühlen begleitetes Objekt der Begierde geht über seine rein technische Funktion und Nützlichkeit hinaus und hat viele Künstler seit Beginn des 20. Jahrhunderts dazu beflügelt, sich mit ihm zu beschäftigen. So feierten die italienischen Futuristen das aufheulende Rennauto und hielten es für schöner als die antike Skulptur der Nike von Samothrake. Pop-Art-Künstler wie Tom Wesselmann und James Rosenquist integrierten das Auto in die bunte Werbeästhetik ihrer Bilder. Gerhard Richter malte nach fotografischen Vorlagen zwei sich auf einer Straße begegnende Fiats und empfand den Bewegungsmoment der fahrenden Wagen mit seiner verwischenden, verunklärenden Malerei nach. Martin Kippenberger verneinte die Markenidentität des von ihm gemalten mit Schnee bedeckten Fahrzeugs: »Kein Capri«. In jüngerer Zeit verunsicherte Maurizio Cattelan mit einer Installation, in der mitten durch einen Wagen ein Baum wuchs und die das Thema Autocrash damit auf eine sinnliche Weise neu entdeckte.

In den Jahren 1998 bis 2000 beauftragte BMW 28 internationale Fotografen, sich mit den Themen Auto und Mobilität auseinander zu setzen. Es entstanden 75 Arbeiten, die ganz unterschiedliche Sichten auf die (auto)mobilisierte Gesellschaft darbieten. Dass der Auftrag an Foto-Künstler ging und nicht an Maler, hatte sicherlich auch damit zu tun, dass es gerade das Medium Fotografie ermöglicht, »die Wirklichkeit in ihrer Komplexität, Zeitlichkeit und all ihren Facetten zu erfassen und so Veränderung und Transformation zu veranschaulichen« (Dirk Snauwaert). Über die bloße Abbildung hinausgehend, machen die unterschiedlichen Bildsprachen der Künstler – ob Dokumentation oder fiktionaler Fotoroman – die zwischen Mythos und Technik liegende Faszination für das Auto fassbar.

Einige Künstler sind direkt in die Fabriken gegangen und haben die Architektur der Produktionshallen und -anlagen fotografiert. Andere haben sich mit dem Arbeiterporträt beschäftigt oder als Fotoreportage die Arbeitsprozesse der Belegschaft am Fließband beobachtet. Zugleich wurde die Straße von den Künstlern als Bewegungsfeld des modernen Menschen und als prägende Struktur des Städtebildes, ja sogar als Ort des Verbrechens, thematisiert. Narrative Aspekte kommen in Fotoserien zum Ausdruck, in denen das Auto zum Requisit bzw. Aufhänger für eine Geschichte wird. Geschwindigkeit als fiktive Verfolgungsjagd oder psychologisch schwierig zu meisternde Situation ist eine andere Facette von Automobilität. Im Spiel mit der Werbeästhetik BMWs und seinem Design wurde zudem der Mythos der Marke BMW beleuchtet.

Zur Sammlung gehört auch ein Sonderprojekt, das BMW sechs britischen Künstlern mit den Worten »Making Your Dreams Come True« (»Macht eure Träume wahr«) als freie Auftragsarbeit übertrug. Es entstanden Fotos mit spezifisch britischen Themen: die Reihenhausgärten der englischen Mittelklasse als Orte des Heranwachsens oder die Fotokulissen – »Glamour-Studios« – in den Provinzstädten. Einige dieser Arbeiten verweisen aber auch auf das Thema Mobilität, wie ein Pferderennen oder die Porträts von jugendlichen, um die Welt reisenden Ravern als moderne Globetrotter.

Barbara Hentschel

Motor Blues

Photographic Views of the Automobile

The fascination for the automobile mythically charged object of desire accompanied by fantasies, and collective feelings goes beyond its purely technical function and usefulness, and has inspired many artists since the beginning of the twentieth century to occupy themselves with it. Thus, the Italian futurists celebrated the howling racing car, and held it to be more beautiful than the ancient sculpture of Nike of Samothrace. Pop art artists such as Tom Wesselmann and James Rosenquist integrated the car into the colourful advertising aesthetics of their paintings. Gerhard Richter used photographs as models to paint two Fiats encountering each other on a road and empathetically captured the moment of movement of the travelling cars with his blurred painting technique that makes things unclear. Martin Kippenberger negated the brand identity of the vehicle he painted covered with snow: "Not a Capri". In recent times, Maurizio Cattelan caused consternation with an installation in which a tree was allowed to grow through the middle of a car, thus rediscovering the subject of the car crash in a sensuous way.

In the period from 1998 to 2000, BMW commissioned 28 international photo artists to engage with the subjects of car and mobility. A total of 75 works came about which offer very different views of automobilized society. That the commission was given to photo artists and not painters certainly also has to do with the fact that precisely the medium of photography is able "to grasp reality in its complexity, temporality and all its facets and thus to graphically portray change and transformation" (Dirk Snauwaert). In going beyond mere depiction, the differing visual languages of the artists, whether documentation or fictitious photo novel, make the fascination for the car, which is situated somewhere between technology and myth, comprehensible.

Some artists went straight to the factories and photographed the architecture of the production workshops and facilities. Others concerned themselves with the portraits of workers or observed, as photo reporters, the work processes of the workforce on the conveyor belt. At the same time, the street as the field of movement of modern-day people and as the characteristic structure of the urban scene, even as the scene of the crime was thematized. Narrative aspects are expressed in photo series in which the car becomes a prop or the instigator for a fictitious story. Speed as an unreal chase or as a situation that is hard to master psychologically, is another facet of automobility. Furthermore, in interplay with the BMW's advertising aesthetics and design, the myth of the BMW brand is illuminated.

The collection includes also a special project that BMW assigned to six British artists as an open commissioned work with the words, "Making Your Dreams Come True". Photos came about with specifically British subjects such as terrace-house gardens as places where the English middle class grows up, and the photo backdrops, or glamour studios, in provincial towns. Some works, however, also refer to the subject of mobility, such as the course of a horse race or the portraits of youthful ravers travelling around the world as modern globetrotters.

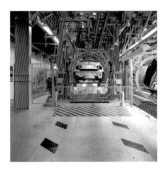
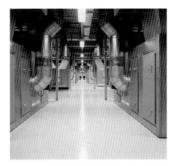

Candida Höfer
BMW München 2000

Candida Höfer
BMW München 2000

Im Inneren von BMW

Ein Blick ist auf die Arbeitsprozesse und -bedingungen in
einer modernen Produktionswelt wie den BMW-Werken
in Europa und Amerika gerichtet. So zeigen die Foto-
grafien von **CANDIDA HÖFER** technisierte, nahezu menschen-
leere Werkhallen (»BMW München«). Höfer besuchte die
Werkbereiche Rohbau, Karosserie, Lackiererei und
Montage des Münchner BMW-Werkes und fotografierte
sie bei den Lichtbedingungen, die in den Hallen herrschen.
Seit Ende der 1960er-Jahre untersucht Höfer in Serien
und Motivgruppen die konstruktive, geometrische Struktur
von Räumen wie Bibliotheken, Verwaltungen und anderen
öffentlichen Gebäuden.

Ihre Fotografien zeigen die hoch technisierte Industrie-
welt im Inneren des BMW-Werkes als funktional angelegte
Ordnungen. Die Funktionalität der Werkbereiche spiegelt
sich auch in den glänzenden, sauberen Oberflächen der
technischen Anlagen. Eine nahezu klinische Atmosphäre
vermitteln selbst die Lichtreflexe der Neonbeleuchtung
auf den mit Metall verkleideten Anlagen und den hell-
grauen Fußböden. Die Architektur der Laufbänder und
technischen Anlagen wird in Höfers Fotografien zur abs-
trakten, klar gegliederten Struktur. »Ich suche in Räu-
men Ähnliches, wobei mich anzieht, wie verschieden das
Ähnliche ist«, formuliert die Künstlerin ihr Anliegen.

Abstrakte Ordnungen und Strukturen entdeckte auch
THOMAS DEMAND im Münchner BMW-Werk. Ein Akustik-
labor mit der Raumbezeichnung »77 – E – 217« wurde
zum Vorwurf für seine künstlerische Arbeit. In dem
abgedämmten, mit Mikrofonen versehenen Raum werden
die Innengeräusche eines fahrenden BMW-Fahrzeugs
simuliert. Der Bildhauer und Fotograf Thomas Demand
baute die schallgedämmten Wände des Labors als
Papiermodell im Masstab 1:1 in seinem Atelier nach und
fotografierte es dann mit einer Großbildkamera. Dies
entspricht der Arbeitsweise des Künstlers, der mit seinen
Fotografien das Verhältnis von Realität bzw. Bild und
Abbild in Frage stellt und damit das klassische foto-
grafische Prinzip umkehrt. Die Fotografien der perfekt
imitierten, lebensgroßen und menschenleeren Papier-
attrappen erschaffen eine zweite Wirklichkeit, die vom
Betrachter erst nach einer Weile bemerkt wird. Häufig
sind Demands Fotografien unterschwellig konnotiert und
verweisen auf Orte von Katastrophen und Verbrechen
wie der Flugschalter, an dem die Attentäter des 11. Septem-
ber eincheckten oder die private Küche Saddam Husseins,
Fotos, deren Vorlagen Demand im Fernsehen oder
im Netz fand.

Am Akustiklabor hat Demand wohl vor allem die Stille
interessiert, die auch viele der von ihm fotografierten
papierenen Modelle vermitteln: »Neben der grund-
sätzlichen Unmöglichkeit, Geräusche fotografisch wieder-
zugeben, gilt hier die Aufmerksamkeit der Künstlichkeit
des Vorhabens, ein im Innenraum stillstehendes Fahrzeug
als ein in einer Landschaft rasendes zu untersuchen; hier
tritt ein Denken in Modellen zutage, bei dem sich vielfache
Bezüge zu meinem Fotografieverständnis ergeben.«

Thomas Demand
77 – E – 217 2000

On the Inside of BMW

A gaze is directed at the working processes and working conditions in the modern production world of the BMW plants in Europe and America. The photographs of CANDIDA HÖFER *show technicized factory buildings, almost without any people ("BMW Munich", 2000). Höfer visited the plant areas chassis, body, paint shop and assembly at the Munich BMW plant and photographed it with the neon light that is used in the buildings as light source. Since the end of the 1960s Höfer has been investigating in series and groups of motifs the constructive, geometrical structure of spaces like libraries, administrative and other public buildings.*

Her photographs show the highly technicized industrial world on the inside of a BMW plant as functionally arranged orders. The functionality of the plant areas is mirrored also in the shiny, clean surfaces of the technical installations. Even the reflections of light from the neon lighting on the metal-clad installations and the light-grey floors suggest an almost clinical atmosphere. The architecture of the conveyor belts and the technical installations becomes in Höfer's photographs an abstract, clearly articulated structure. "I look for what is similar in spaces and am attracted by how different similar things are," is how the artist formulates her project.

THOMAS DEMAND *also discovered abstract orders and structures at the Munich BMW plant. An acoustic laboratory with the designation "77 – E – 217" became the model for his artistic work. In the acoustically insulated room fitted with microphones, the vehicle noises of a driving car are simulated. The sculptor and photographer, Thomas Demand, made a full-scale mock-up of the insulated laboratory's walls as a paper model and then photographed it with a large-format camera. This corresponds with the artist's working attitude, who, with his photographs, puts the relation between reality and image or portrayal into question and, thus, inverts the classical photographic principle. The perfectly imitated, life-size paper mock-ups create a second reality that the viewer only notices after a while. His photographs are frequently pervaded by subliminal connotations and often bear witness to places of disasters and crimes, such as the check-in counter at which the assassins of 11 September checked in or Saddam Hussein's private kitchen, photographs, of which Demand finds his models in published images from magazines or on the internet.*

The stillness, communicated by many of his photographed paper backdrops, probably interested Demand most of all in the acoustic laboratory: "Apart from the basic impossibility of photographically reproducing noises, the attention is here focused on the artificiality of the project of investigating a vehicle standing still in an interior room as a car racing through the countryside. Here a thinking in terms of models becomes apparent which results in many points of reference to my understanding of photography."

Glenn Ligon
South Carolina's Own 1 1998

Der arbeitende Mensch

Der amerikanische Künstler **GLENN LIGON** beobachtete die Arbeitsabläufe der farbigen Belegschaft im BMW-Werk Spartanburg, USA (»South Carolina's Own 1–3«). Seine Fotografien verknüpfte er mit Interviews, die Auskunft über das Selbstverständnis der Arbeiter geben. Ligons künstlerische Arbeiten fragen häufig nach der Identität der schwarzen amerikanischen Bevölkerung – historisches Material wie amerikanische Sklavenerzählungen aus dem 19. Jahrhundert, der Million Man March oder die Aktfotografien aus dem »Black Album« des Fotografen Robert Mapplethorpe dienen dem Künstler als Grundlage. Als Ligon den Auftrag von BMW erhielt, fühlte er sich an seinen Vater erinnert, der 30 Jahre im Autokonzern General Motors tätig war und sich dort vom Kantinenkoch bis zum Vorarbeiter hochgearbeitet hatte, ohne je einen Tag zu fehlen: »Durch die Dokumentation der schwarzen Arbeiter im Werk in Spartanburg, durch die Interviews, Fotos von ihnen und dem Werk und die Zeit, die ich mit ihnen verbrachte, begann ich langsam zu verstehen, warum mein Vater so in seiner Arbeit aufgegangen war und auch was es für ihn bedeutete, etwas die Straße entlangfahren zu sehen, an dem man selbst mitgebaut hatte.«

Ligon beobachtete die Belegschaft beim Herstellungsprozess des *Z3*-Roadsters. Seine Fotoreportage zeigt die Arbeiter bei der Montage oder in Gespräche mit Kollegen vertieft. Manche lächeln während des Arbeitsprozesses stolz in die Kamera, zum größten Teil jedoch scheinen die Menschen die anwesende Kamera nicht wahrzunehmen und sind ganz auf ihre Aufgaben konzentriert. In den Interviews, die Ligon mit ihnen führte, kommen das Verantwortungsbewusstsein der Arbeiter, ihr Stolz für eine Marke wie BMW zu arbeiten, aber auch kritische Einsichten über die Arbeit im Werk und die Kooperation mit anderen Partnern zu Wort.

Mit vergleichbar sachlichem Blick porträtierte die niederländische Künstlerin **RINEKE DIJKSTRA** Auszubildende der gewerblich-technischen Berufsausbildung und des Euro-Azubi-Programms im Münchner BMW-Werk. Porträts von Heranwachsenden und jungen Erwachsenen sind bevorzugtes Thema Dijkstras: Für ihre Strandporträts (1992–1996) fotografierte sie beispielsweise Jugendliche an europäischen und amerikanischen Stränden. Dijkstras sensiblem Blick gelingt es, ohne die Würde der Porträtierten zu verletzen, das Schwanken zwischen Unsicherheit und gespieltem erwachsenen Selbstbewusstsein der amerikanischen Badeschönheit ebenso einzufangen wie die Unbekümmertheit und Natürlichkeit der unbewusst als Botticellis schaumgeborene Venus posierenden polnischen Jugendlichen. In ihren Fotografien treten Bezüge zur Malerei, und insbesondere zur Porträtmalerei zu Tage, die von Dijkstra bewusst intendiert werden.

Vor einer grauen Wand posieren die Auszubildenden, alles ist ganz auf ihre Gesichter und Oberkörper konzentriert. Dijkstra zeigt anhand der Körpersprache die unterschiedliche Selbstdarstellung der nahezu einheitlich in Werkskluft gekleideten Jugendlichen auf: »Mein Interesse gilt der Fotografie von Personen, die Teil einer Gruppe sind, um zu sehen, wodurch sie sich voneinander unterscheiden. Ich mag es, wenn das an kleinen Details erkennbar wird, z.B. daran, wie sie ihre Arbeitskleidung tragen oder wie sich ihre Persönlichkeit in ihrer Erscheinung spiegelt.« So steht nicht unmittelbar die Zugehörigkeit der jungen Männer zu einer Berufsgruppe im Vordergrund, sondern das wache, tatenlustige Auftreten des einen, der gelassene, selbstsichere Blick des anderen, die unsichere, verschlafene Haltung des dritten und der – angesichts der fotografischen Situation – offensichtlich skeptische Blick des vierten Porträtierten.

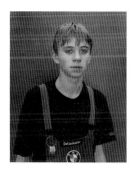

Rineke Dijkstra
**Martin Dettenhofer,
Auszubildender
Werkzeugmacher**
25. April 2000

Rineke Dijkstra
**Tom Coates,
Technischer
Auszubildender**
26. April 2000

Working People

The American artist GLENN LIGON observed the work routines of the workforce at the BMW plant in Spartanburg, USA ("South Carolina's Own 1–3"). His photographs are linked with interviews which provide information about how the workers understand themselves. Ligon's artistic works frequently ask about the identity of the black American population—historical material such as American slave stories from the nineteenth century, the Million Man March or the nude photos from the "Black Album" of the photographer Robert Mapplethorpe serve the artist as a basis. When Ligon received the commission from BMW, he was reminded of his father who worked for the car group General Motors for thirty years and had worked his way up the hierarchy from canteen cook to foreman, never missing a day of work: "Through the documentation of the black workers at the plant in Spartanburg, through the interviews, photos of them and the plant, and the time I spent with them, I slowly began to understand why my father had been so absorbed by his work and also what it meant for him to see something driving along the road which he himself had helped to build."

Ligon observed the workforce during the production process of the Z3 roadster. His photographic report shows the workers assembling or discussing earnestly with colleagues. Some of them smile proudly into the camera during the work process; for the most part, however, they do not take any notice of the camera and are completely concentrated on their tasks. In the interviews which Ligon had with the workers, their responsible attitude, the pride in working for a brand like BMW, but also critical insights into the work at the plant and the cooperation with other partners are expressed.

With a comparably objective view, the Dutch artist RINEKE DIJKSTRA made portraits of the trainees in commercial-technical vocational training and the program, Euro Trainee at the Munich BMW plant. Portraits of adolescents and young adults are a preferred subject for Dijkstra: in her beach portraits (1992 to 1996), for instance, she photographed youths on European and American beaches. Dijkstra's sensitive way of seeing succeeds without harming the dignity of her subjects, in capturing the vacillation between nervousness and pretended adult self-confidence of the American bathing beauty as well as the carefreeness and naturalness of Polish youths posing unconsciously as Botticelli's foam born Venus. In her photography references to painting and in particular to portrait art are intended by Dijkstra.

The trainees pose in front of a grey wall; everything is concentrated entirely on their face and torso. On the basis of body language, Dijkstra succeeds in showing the differing self-presentations of them who are clothed almost identically in the plant uniform. "My interest is in the photography of persons who are part of a group to see how they differ from each other. I like it when this becomes visible in small details, e.g. how they wear their working clothes or how their personality is reflected in their appearance." Thus, the fact that the young men belong to a vocational group does not stand in the foreground, but the aware, active manner of one trainee, the relaxed, self-confident look of another, the unsure, sleepy stance of a third, and the obviously sceptical gaze of a fourth in view of the photo-session situation.

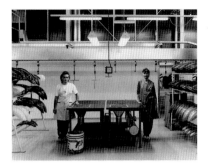

Sharon Lockhart
**Halime Gueler and Elke Gnewkow /
BMW AG / Werk Berlin** 1998

Wie Rineke Dijkstra ist die amerikanische Künstlerin
SHARON LOCKHART für ihre Fotografien in die BMW-Werks-
hallen gegangen. Anders als Dijkstra richtete Lockhart
ihre Kamera jedoch auf den Arbeitsort, an dem sie die
Arbeiter porträtiert. Die Architektur des Ortes gab dabei
den Ausschnitt vor, den Lockhart für ihre Aufnahmen
wählte: Die Ständer mit den lackierten Blechen im Berliner
Motorradwerk, die seitlich und an der Decke befindlichen
technischen Anlagen der Lackiererei im amerikanischen
Spartanburg oder die Halle im mexikanischen BMW-Werk,
in der die Autos abschließend inspiziert werden, bevor
sie das Werksgelände verlassen.

Wie auf einer Bühne präsentieren sich die Arbeiter
frontal in Werkskleidung, zwischen ihnen die Laufbänder
oder Werkstische, an denen sie ihre Arbeit verrichten.
Die stilisierte Anordnung ist bewusst inszeniert und
ordnet sich in ein strenges fotografisches System ein.
In der Reduktion auf die paarweise Anordnung der
Arbeiter in einem von den bestehenden architektonischen
Gegebenheiten definierten Raum erweisen sich Lockharts
Arbeiten als konzeptuell. Die strenge Choreografie
der stehenden, den Betrachter anblickenden und für die
Fotografin posierenden Arbeiter lässt dabei durchaus
Raum für reale Befindlichkeiten. So präsentieren sich die
Berlinerinnen Halime Gueler und Elke Gnewkow lächelnd,
ein von Hand bemalter Abfalleimer im Vordergrund
lockert den ansonsten streng gegliederten Arbeitsort
auf und vermittelt den Eindruck von Individualität.

Über einen Zeitraum von einer Woche beobachtete
TODD EBERLE die Arbeitsabläufe von vier Autodesignern
im BMW-»Designworks USA«. Die »pathologische Auto-
obsession«, die er hoffte bei den dänischen, deutschen
und kroatischen Designern anzutreffen, fand der Künstler
tatsächlich bestätigt. Als Architekturfotograf, der
u. a. für Zeitschriften wie »Vanity Fair« und »New Yorker«
Inneneinrichtungen fotografiert, interessierte sich
Eberle vor allem für die privaten Lebensräume der vier
»Car Designer«. In den sparsam möblierten und ohne
Schnörkel eingerichteten Wohnräumen traf Eberle
auf viele Hinweise, die von der Autoobsession der Männer
zeugen: ein Autositz als Sessel im Wohnraum, Auto-
magazine auf dem Fußboden, das BMW-Logo am Küchen-
schrank oder ein Sportfahrzeug als Spielmodell auf der
Fensterbank.

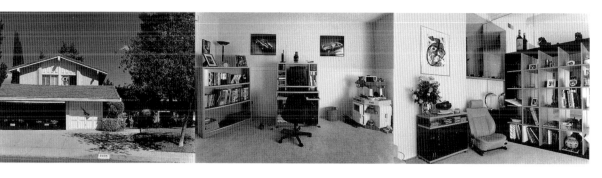

Todd Eberle
Henrik Fisher, Car Designer 1998

Like Rineke Dijkstra, the American artist SHARON LOCKHART *went into the BMW factory buildings to make her photographs. In contrast to Dijkstra, however, Lockhart directed her camera toward the workplace where she makes portraits of the workers. The architecture of the place determined the detail which Lockhart chose for her shots: the stands with the painted bodies in the Berlin motorbike plant, the installations for painting the vehicles situated to the side and on the ceiling in Spartanburg, USA, or the building in which the cars are given their final inspection before leaving the plant at Toluca in Mexico.*

As if on a stage, the workers present themselves frontally in working clothes, between them the conveyor belts or work benches where they do their work. The stylized arrangement was intentionally staged and is part of a strict photographic system. In the reduction to the pairwise arrangement of the workers in a given working space defined by the existing architectural features, Lockhart's works show themselves to be conceptual. The strict choreography of the standing workers posing for the photographer and looking at the viewer leaves room for real moods. Thus, the Berlin women Halime Gueler and Elke Gnewkow present themselves smiling; a hand-painted waste basket in the foreground loosens up the otherwise strictly structured workplace, and conveys an impression of individuality.

Over a period of a week, TODD EBERLE *observed the work routines of four car designers at BMW-"DesignWorks USA". The "pathological automobile obsession" which he hoped to find in the Danish, German and Croatian designers was actually confirmed. As a photographer of architecture who photographs interiors for magazines such as "Vanity Fair" and "New Yorker", Eberle was mainly interested in the private living spaces of the four car designers. In the sparsely furnished living spaces without any superfluous decoration, Eberle came across many hints providing evidence of the men's obsession with cars: a car seat as an armchair in the living room, car magazines on the floor, the BMW logo on a kitchen cupboard, or a sports car as toy model on the window ledge.*

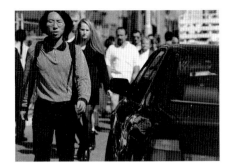

Beat Streuli
Sydney / BMW 1998

On the Road – Die Straße als Bewegungsfeld
des modernen Menschen

Die Straße als Bewegungsfeld der jungen Gesellschaft
ist das Thema von **BEAT STREULI**. In den Fußgängerzonen
und belebten Einkaufsstraßen der großen Metropolen
der Welt entstehen seine Foto- und Videoarbeiten. Mit
voyeuristischem Blick nimmt Streuli sich unbeobachtet
wähnende, vorwiegend junge Passanten in den Fokus
seiner Kamera. Der Bildausschnitt ist eng gewählt und
friert die Bewegung und Hektik der Straße ein, alles ist auf
eine einzelne Person oder wenige Menschen konzentriert.
Sein Teleobjektiv richtet der Künstler dabei bevorzugt
auf Passanten, die wie er selbst sagt, ihr »öffentliches
Gesicht« vergessen und »einen etwas abwesenden Aus-
druck« haben.

Für den Auftrag von BMW änderte Streuli seine künstleri-
sche Strategie und benutzte einen BMW als feststehendes
Requisit. Das Fahrzeug parkte er an Straßenecken in
Sydney und in Tokio, um es zusammen mit an ihm vorbei-
gehenden Passanten abzulichten. Nicht immer gelang es
dem Künstler sofort, Menschen in der Nähe des BMW zu
fotografieren – deshalb bat Streuli auch Bekannte, sich
neben das Auto zu setzen. Das Spiel mit den unterschied-
lichen Texturen von sonnenbeschienener lackierter Auto-
oberfläche und der Kleidung der Menschen – in »Sydney /
BMW« spiegelt die glänzende Oberfläche des Fahrzeugs
sogar den seitlich vorbeigehenden Mann – mag nur ein
Reiz für den Künstler gewesen sein. Für Streuli bedeutete
der Auftrag von BMW vor allem ein »Meta-Product-Place-
ment«: »Die Mischung aus gestellten Fotos, ›Product
Placement‹ und natürlichen ›Schnappschüssen‹ ist auch
für mich interessant: ›Cinema vérité‹, einerseits doku-
mentarisch; andererseits gestellt, manipuliert, ›gefälscht‹,
fast wie Werbung, ›Fiktion‹. Eine Mischung, die nicht mehr
leicht zu trennen ist.«

Neben Porträts sind die vom Menschen gestalteten
architektonischen Lebensräume das Hauptthema von
THOMAS STRUTH. Seit mehr als 25 Jahren bereist Struth
die Metropolen der Welt und fotografiert die urbanen
Alltagsräume. Seine »Veduten des Alltags« (Christoph
Schreier) stehen in der Tradition des Architekturbildes,
das in der Malerei u. a. von Künstlern der Frührenaissance
und des 18. Jahrhunderts wie Canaletto und Piranesi
geprägt wurde und mit den um 1900 entstandenen Paris-
Fotografien von Eugène Atget auch in der Fotografie
einen künstlerischen Höhepunkt erreichte.

Struths Fotografien sind von kompositionellen Gesetzen
bestimmt und erlangen durch einen kalkulierten Bildaus-
schnitt Strenge und Festigkeit. Die große Tiefenschärfe
misst jedem Detail die gleiche Bedeutung bei. Was
dem flüchtigen Blick entgeht, wird von der Kamera
aufmerksam wahrgenommen. Seine Fotografien sind eine
Aufforderung an den Betrachter, genau hinzusehen und
verweisen auf Edward Westons Forderung, Fotografie
solle den Menschen »zeigen, was ihren eigenen, mit
Blindheit geschlagenen Augen bis dahin verborgen ge-
blieben ist«. Der nur flüchtig hinsehende Betrachter
der »Straße in San Francisco« wähnt sich aufgrund der
das Straßenbild dominierenden chinesischen Schrift-
zeichen zunächst in Asien. Die erst auf den zweiten Blick
erkennbare Zweisprachigkeit dieses Städtebildes
macht deutlich, dass die Aufnahme in einer westlichen
Metropole entstanden sein muss, in die chinesische
Einwanderer ihre Kultur und ihre Zeichen mitgebracht
haben. Struths Fotografien verweisen so auch auf soziale
Gegebenheiten und die Identität von Heimat.

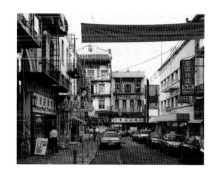

Thomas Struth
Straße in San Francisco, San Francisco 1999

*On the Road—The Street as Field of Movement
for Modern-Day People*

*The street as field of movement for a young society is
BEAT STREULI'S subject. His photographic and video
works are made in the pedestrian zones and lively shop-
ping streets of the world's great metropolises. With a
voyeuristic gaze, Streuli takes mainly young passers-by
who think they are not being observed into the focus
of his camera. The frame of the photograph is chosen to
be very narrow, and freezes the movement and hectic
pace of the street; everything is concentrated on a single
person or just a few people. The artist trains his
telephoto lens preferably on passers-by who, as he says
himself, have forgotten their "public face" and have
"a somewhat absent expression".*

*For his commission from BMW, Streuli changed his
artistic strategy and used a BMW as a stationary prop.
He parked the car on corners in Sydney and Tokyo
to photograph it together with the people passing it by.
The artist did not always immediately succeed in pho-
tographing people near the BMW, so that he also asked
acquaintances to position themselves next to the car.
The game with the differing textures of the painted
surface of the car shining in the sun and the clothing of
the people—in "BMW / Sydney" the shiny surface of the
vehicle even reflects an Asian man passing by along
the side—may have been merely a stimulus for the artist.
For Streuli, the commission from BMW meant above
all a "meta-product placement": "The mixture of posed
photos, 'product placement' and natural 'snapshots'
is interesting also for me: 'cinema vérité'—on the one
hand, documentary; on the other, posed, manipu-
lated, 'falsified', almost like advertising, 'fiction'.
A mixture which is not always easy to separate."*

*Apart from portraits, the main subject for **THOMAS STRUTH**
are the architectural living spaces shaped by people.
For more than twenty-five years, Struth has been
travelling to the world's metropolises and photographing
the urban spaces of everyday life. His "vedutes of
everyday life" (Christoph Schreier) are situated within the
tradition of architectural scenes that was developed
in painting by artists of the early Renaissance and the
eighteenth century such as Canaletto and Piranesi, and
which reached an artistic apogee also in photography
around 1900 with the Paris photographs by Eugène Atget.*

*Struth's photographs are determined by compositional
laws and attain rigour and firmness through a
calculated framing of the image. The great depth of focus
gives every detail an equal significance. What escapes
the fleeting gaze is attentively perceived by the camera.
His photographs are a challenge to the viewer to
look carefully and refer to Edward Weston's demand that
photography should show people "what has remained
up until then hidden to their own eyes that have
been struck by blindness". At a fleeting glance, viewers
of "Straße in San Francisco" first think that they are
in Asia. Only the English translations of the Chinese
characters that dominate the street scene make it clear
that the shot must have been made in a metropolis like
San Francisco, to where Chinese immigrants have
brought their culture and their characters. Struth's photo-
graphs thus refer to social situations and the identity
of home.*

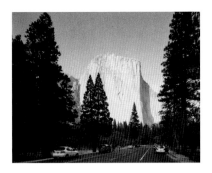

Thomas Struth
**El Capitan, Yosemite National Park /
California** 1999

Mit dem im amerikanischen Yosemite National Park aufgenommenen Steinmassiv »El Capitan« verweist Struth dagegen auf die Fotografie- und Kunstgeschichte: Die steile Wand des Bergmassivs wurde bereits von Fotografen wie Edward Muybridge als Motiv entdeckt. Seine erhabene Wirkung, in dessen Vergleich die sich auf der Straße bewegenden Menschen verschwindend klein erscheinen, erinnert an die Malerei der Romantik. Hell-Dunkel-Kontraste unterstreichen die suggestive Kraft des Bergmassivs: Dunkle Tannen rahmen ihn, während im hellen Sonnenlicht verheißungsvoll der weiße Stein des »El Capitan« leuchtet.

Mit ihrer Videoarbeit »Alle Wege führen nach Rom / All Roads Lead to Rome – A Line Made by Driving Video« haben sich die Künstler **NINA FISCHER** und **MAROAN EL SANI** dem Thema Bewegung auf der Straße auf eine Weise genähert, die an die Situationisten erinnert. Im Sinne einer Umgestaltung urbaner Strukturen hatten diese sich in den 1950er/60er-Jahren gegen den weiteren Bau von Autostraßen gewandt und in einer spielerischen Aktion beispielsweise den Harz mit dem Stadtplan von London in der Hand durchquert.

Für ihre Arbeit »Alle Wege führen nach Rom« nahmen sich Fischer/el Sani vor, mit einem BMW-Fahrzeug das BMW-Logo in das Stadtbild Roms einzufahren. Mittels GPS (Global Positioning System) wurden die Künstler am 11. Dezember 1999 durch die Stadt navigiert – beginnend an der Ausfahrt der Villa Massimo über den äußeren Stadtring Roms bis hin zur Via Aurelia Antica.

Eine im Cockpit des Fahrzeugs installierte Kamera filmte die insgesamt acht Stunden dauernde Fahrt. »Unsere Absicht war es, dem Navigationssystem eine ungewöhnliche Aufgabe zu stellen. Statt der klassischen, funktionalen Wegführung von A nach B, kam es uns darauf an, eine grafische Form zu fahren, die der Windrose eines Kompasses oder auch der Form des BMW-Logos mit den vier Flügeln möglichst nahe kommt. ... Auf dem Navigationskontrollschirm ließ sich die gefahrene Strecke verfolgen, sodass die Entstehung einer – möglichst – symmetrischen Form sichtbar wurde, eine Art Navigationslogo, von uns in das Stadtbild von Rom eingeschrieben.«

Das im Splitscreen-Verfahren montierte Video zeigt die auf eine Stunde verkürzte Fahrt durch Rom und das in die digitale Stadtkarte Roms als animierte Linie eingefahrene BMW-Logo; ein weiterer Monitor verkürzt die Fahrt auf eine Minute. Eine Tonspur gibt die künstliche Stimme des Navigationssystems und die Originalaufzeichnungen aus dem Innenraum des Autos während der Fahrt wieder – »Gedanken, Anmerkungen zu besonderen Straßen, Orten, die wir passieren«. So wird die Fahrt durch Rom zu einer Stadtrundfahrt, in der subjektive Ansichten ein technisches Vorhaben begleiten.

Mit der Straße als Ort des Verbrechens beschäftigt sich der in Belfast geborene Fotograf **PAUL SEAWRIGHT**. Als »generic malevolent landscape«, als an sich böswillige Landschaften, bezeichnet er Orte, die zuvor Schauplatz von Katastrophen waren. Nicht die direkte Gewaltauseinandersetzung – wie den nordirischen Kampf um Konfession und Staatszugehörigkeit – fotografiert Seawright, sondern die Plätze, an denen diese stattfanden. »Ich bin immer fasziniert gewesen vom Unsichtbaren, vom Ungesehenen, von einem Thema, das sich nicht direkt der Kamera präsentiert«, sagt der Künstler. Mit seinen auf wenige Details reduzierten Fotografien bezieht Seawright keine Stellung. Von seinen Arbeiten geht eher eine beklemmende poetische Stille aus.

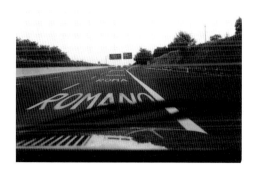
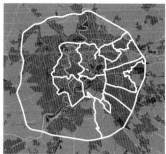

Nina Fischer & Maroan El Sani
**Alle Wege führen nach Rom / All Roads Lead to Rome –
A Line Made by Driving Video** 1999

With the rock massif, "El Capitan", photographed in Yosemite National Park in America, by contrast, Struth refers to the history of photography and art: photographers such as Edward Muybridge have discovered and taken photographs of the steep wall of the massif as a motif. The sublimeness of the steeply rising rock that is like a monument, in comparison to which the people moving on the road below seem very tiny, recalls romantic painting. The contrasts between light and dark are made intentionally and radiate the suggestive power of the massif. Dark fir trees frame the mountain, whereas in the bright sunlight, the white stone of "El Capitan" shines, full of promise.

With their video work, "All Roads Lead to Rome—A Line Made by Driving Video", the artists **NINA FISCHER** *and* **MAROAN EL SANI** *have approached the subject of movement on the street in a way which recalls the situationists. They turned against the construction of roads in the sense of reshaping urban structures and, in a playful action, for instance, crossed the Harz Mountains with a street map of London in their hands.*

For their work, "All Roads Lead to Rome", Fischer/el Sani undertook to 'drive' the BMW logo into the urban space of Rome with a BMW car. By means of GPS (Global Positioning System), the artists were navigated through the city on 11 December 1999, starting at the exit of the Villa Massimo via the outer arterial ring of Rome to Via Aurelia Antica. A camera installed in the cockpit of the vehicle filmed the journey that lasted a total of eight hours. "Our intention was to present the navigation system with an unusual task. Instead of the classic, functional guidance from point A to point B, we were concerned with driving along a graphic form which came as close as possible to the quadrants of a compass or the form of the BMW logo with its four quadrants. What was interesting was whether the route indicated could also be driven, i.e. whether the pre-given form

would finally come about. ... On the navigation control screen, the route travelled could be followed so that the emergence of a symmetrical form—as far as possible—became visible, a kind of navigation logo inscribed by us into the urban space of Rome."

The video assembled in splitscreen procedure shows the journey through Rome compressed into one hour, and the BMW logo that was driven as an animated line on the digital maps of Rome; a further monitor shortens the journey to one minute. A soundtrack plays back the artificial voice of the navigation system and the original recordings from inside the car during the journey— "thoughts, notes on particular streets, places we pass through". In this way, the journey through Rome becomes a tour of the city in which subjective views accompany a technical, scientific project.

The photographer **PAUL SEAWRIGHT** *who was born in Belfast, occupies himself mainly with the scenes of crimes. He calls places which have been marked by conflicts before as "generic malevolent landscape". The artist did not photograph directly the violent struggle—like the Northern Ireland struggle over confession and nationality—, but the scenes where these struggles took place. "I have always been fascinated by the invisible, by the unseen, by a subject that does not present itself directly to the camera," explains the artist. With his photographs that have been reduced to a few details, Seawright does not adopt a specific position. His works emanate rather an oppressive poetic stillness.*

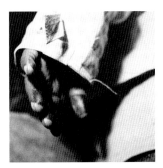

Paul Seawright
Ohne Titel 1 1998

Paul Seawright
Ohne Titel 3 1998

Für den Auftrag von BMW begleitete Seawright über einen Zeitraum von fast zwei Wochen in Johannesburg ein Team von Polizisten in einem Sondereinsatzfahrzeug. Das Auto gehörte zu einer Fahrzeugflotte, die BMW der südafrikanischen Polizei zur Verfügung gestellt hatte. Seine Erlebnisse notierte Seawright schriftlich: »Die Routine nimmt dir die Emotionen. Das Prozedere des Polizeialltags, Fingerabdrücke nehmen, Notizen machen, Formulare ausfüllen, Verhöre ... all das schafft eine Kälte, die ich darstellen muss.« So zeigt eine Fotografie die schwarze Tinte an der Hand eines Mannes, von der offensichtlich kurz zuvor Fingerabdrücke gemacht worden sind. In der Nahaufnahme stechen die schwarzgefärbten Rillen seiner Fingerkuppen als grafisches Detail hervor, während der Jackenärmel des Mannes als große weiße Fläche im Hintergrund verschwimmt.

Extrem reduziert ist auch der Bildausschnitt des dritten Fotos: Die blutbefleckte Hand eines Farbigen sowie verstreut umherliegende Geldstücke künden von dem Verbrechen, das soeben auf der Straße stattgefunden hat: »... Ein bewaffneter Räuber wird von jemandem erschossen, der versucht hat, seine Beute zu stehlen, dieser wird wiederum von einem Polizisten erschossen, dessen Kugel auch einen Straßenverkäufer tötet. Ihre Körper und die gesamte Szene ergeben ein chaotisches Bild ... Das Geld liegt mit Blut vermischt auf der Straße und der Besitzer des Geschäftes sammelt es mit einem Plastiksack ein ...« Die großformatige Detailaufnahme rückt die grausige Tat aus dem Blickfeld des Betrachters und lässt die körnige Struktur des Asphalts zur abstrakten Fläche werden, auf der die Indizien eines nicht nachvollziehbaren Tathergangs nur am Rande fokussiert werden.

Geschichten rund ums Auto

Mit seiner Arbeit »The Blues on the Bimmer« schuf **NORITOSHI HIRAKAWA**, wie er selbst sagt, die »Allegorie einer verbotenen Liebesaffäre«: »Ich hatte gehofft, mit ›The Blues on the Bimmer‹ eine neue mythologisch-narrative Ästhetik zu schaffen. Ich habe daher drei verschiedene Dramen in drei verschiedenen Ländern mit drei verschiedenen Protagonisten inszeniert. In jeder dieser poetischen, sensiblen Geschichten gibt es eine Frau, zwei Männer und einen BMW.«

Hirakawa beschäftigt sich in seinen Arbeiten häufig mit Themen der öffentlichen Moral, vor allem der in Japan tabuisierten Sexualität, und dem Verhältnis von Privatheit und Öffentlichkeit. Auf seinen Reisen um die Welt fordert er Zufallsbekanntschaften oder Menschen auf der Straße – getreu seinem Motto »Kunst muss direkt auf der Straße beginnen« – auf, in seinen als Erzählfragmente angelegten Fotoserien mitzuwirken.

Im Zentrum der Schwarzweiß-Fotos steht der »Bimmer« – so wird im Amerikanischen umgangssprachlich ein BMW genannt –, der zum Requisit einiger Liebesszenen wird, die von je einem zufällig hinzukommenden Mann beobachtet werden. Ihre überraschten, eifersüchtig oder neidisch blickenden Gesichter flankieren zusammen mit den von ihnen wahrgenommen Szenen – die sich in eindeutiger Pose ineinander verkeilten Beine eines Paares oder der an die Schulter seiner Motorrad fahrenden Freundin gelehnte Kopf eines langhaarigen Mannes – in farblicher Vergrößerung das zentrale Bildmotiv. Die Wiederholung und Vergrößerung dieser Szenen verleiht den Triptychen voyeurhaften und erzählerischen Charakter: Der Betrachter wird aufgefordert, die zwischen Alltag und Fantasie angesiedelten Erzählfragmente der Geschichte weiterzuspinnen.

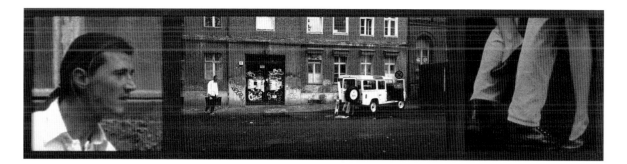

Noritoshi Hirakawa
The Blues on the Bimmer, Berlin-Mitte 1998

For the commission from BMW, Seawright accompanied a team of policemen for almost a fortnight in Johannesburg in a police car for special deployment which BMW had made available to the South African Police along with other vehicles. Sewright jotted down his experiences in writing: "The routine takes away your emotions. The procedure of daily police life, taking fingerprints, making notes, filling out forms, interrogations ... all that creates a coldness which I have to present." Thus, one photograph shows the black ink on the hand of a man from which obviously fingerprints have just been taken. In the close up, the grooves of his fingertips protrude as a graphic detail, whereas the man's jacket remains blurred in the background.

The detail of the third photo is also extremely reduced: the bloodstained hand of a coloured man as well as coins scattered about tell of the crime that has just been perpetrated on the street: "An armed robber is shot dead by somebody who tried to steal his loot who in turn is shot dead by a policeman whose bullet also kills a street vendor. Their bodies and the entire scene result in a chaotic picture ... The money is lying on the street mixed with blood, and the shop owner is gathering it into a plastic bag ..." The large detailed close up removes the grisly deed from the viewer's field of vision and makes the asphalt's grainy structure to an abstract surface, on which the clues of a not yet comprehensible action are focussed on only marginally.

Stories around the Car

With his work "The Blues on the Bimmer" NORITOSHI HIRAKAWA *created, as he says himself, "an allegory for a forbidden love affair": "I had hoped, with 'The Blues on the Bimmer', to create a new mythological, narrative aesthetics. I have therefore staged three different dramas in three different countries with three different protagonists. In each of these sensitive, poetic stories there is a woman, two men and a BMW."*

Hirakawa frequently devotes himself in his works to the subjects of public morality, especially to sexuality, which is taboo in Japan, and the relationship between the private and the public spheres. On his journeys around the world, he calls on accidental acquaintances or people on the street—true to his motto, "art must start directly on the street"—to take part in his photo series designed as narrative fragments.

At the centre of his black-and-white photos stands the Bimmer—this is what a BMW is called in the American vernacular—which becomes a prop in love scenes that are observed by men who coincidentally pass by. Their surprised, jealous or envious faces, together with the scenes they are watching—the wedged legs of a couple in an unambiguous pose, or the head of a longhaired man leaning on the shoulder of his girlfriend driving a motorbike—, flank the central image motif as a colour enlargement. The repetition and enlargement of these scenes lend the triptychs voyeuristic and narrative character. The viewer is called upon to continue to unfold the narrative fragments of the story situated between everyday life and fantasy.

Boris Michailov
BMW (My Old Story) – The Line In My Brand 2000

Auch der ukrainische Fotograf **BORIS MICHAILOV** ersann eine Geschichte rund um ein BMW-Fahrzeug. In einer Art Fotoroman als Abfolge von 22 Aufnahmen erzählt Michailov die Geschichte von »BMW (My Old Story)« als »The Line in my Brand«, als Linie in meiner Marke, die ihn und seine Frau Wita, »B(oris) M(ichailov) W(ita)«, schon aufgrund der Initialien mit BMW verbindet. Szenen von spielenden und herumstreunenden Kindern stehen neben der Geschichte eines Autounfalls und einem plötzlich auftauchenden BMW. Aus der Verbindung von biografischen Elementen mit Bildern des Alltags in seiner Heimatstadt Charkow entsteht eine heiter-ironische Fotosequenz, die aus einem scheinbar dokumentarischen Blickwinkel erzählt wird.

Viele der Fotografien verweisen auf frühere Arbeiten Michailovs, wie die Aufnahme der Frau, die mit militärischem Stechschritt über ein grabähnliches Kellerloch schreitet – als ironische Anspielung auf die sowjetische Kriegspropaganda –, eine Szene, die Michailov schon in der Serie »Am Boden« (1991) verwirklicht hatte. Auch der seinen nackten, muskelbepackten Oberkörper präsentierende Mann spielt auf den sowjetischen Heldentypus an. Die Szenen, in denen eine Frau auf dem von allen bewunderten BMW-Motorrad laszive Posen einnimmt, kann in Beziehung gesehen werden zu den Aktaufnahmen, die der Künstler in den 1970er-Jahren von seiner Frau anfertigte, was dazu führte, dass er seinen Job als Ingenieur in einer Fabrik verlor. Auf einem der letzten Fotos stemmt der Künstler selbst eine Kugelhantel stolz in die Luft: »Ich spürte zum ersten Mal, dass diese Muskeln für etwas Wichtigeres als für eine imaginäre Vorstellung da waren. Und dieser Kontakt mit dem schmutzigen Metall der alten BMW Maschine weckte in mir ein Verlangen, das ich bisher nicht gekannt hatte.«

Einen eher melancholischen Blick auf eine inzwischen legendäre Route wirft **JOHANNES MUGGENTHALER**: Sein »Road Movie in Standbildern« bewegt sich auf der Mille Miglia, einer von Brescia nach Rom und wieder zurück führenden Rennstrecke. Muggenthaler fuhr die Strecke, auf der BMW in den 1930er-Jahren erfolgreich war, nach. Nicht das Fahrzeug des Fahrers oder der Fahrer selbst stehen im Mittelpunkt seiner Arbeit, sondern die Rennstrecke, die auf öffentlichen Straßen entlangführt. Die Fotoserie bewegt sich zwischen Fiktion und Realität und ist geprägt von einer vom Künstler beabsichtigten »filmischen Atmosphäre«: »Filme von Antonioni oder Godard, in denen der Raum, die Weite, die Straße das Thema ist.«

Zwei Schilder in einer winterlichen Landschaft markieren als fiktive Richtungen Ausgangspunkt und Ziel der Route: »Heimweh« und »Fernweh«. Muggenthalers Arbeiten gehen häufig spielerisch-ironisch mit einem Thema um. So zielen seine Objekte und Fotografien auf Zweideutigkeiten des Sehens und Probleme der bildlichen Sprache. »Heimweh« und »Fernweh« führen in diesem Sinne an denselben Ort zurück. Die Fotoserie hat Muggenthaler, der auch Schriftsteller ist, erzählerisch eingebettet: »Ein Autofahrer wird vorgestellt. Kraftzeugmechaniker, einer aus den hinteren Reihen des Motorsports. Ein Enthusiast, der die Mille Miglia mit seinem Sportwagen nachfährt, sich als Rennfahrer träumt. Ziel meiner Arbeit war es, ein Road Movie in Standbildern zu schaffen ... Ein Paradox gewiss, aber durchaus angemessen für einen Rundkurs, wo bekanntlich sogar Start und Ziel dassselbe sein können. Die Fotoreihe sagt etwas über das Autofahren selbst: Fernweh und Heimweh sind ein ewiger Kreislauf. Mille Miglia ist eine Metapher.«

Johannes Muggenthaler
Mille Miglia 2000

The Ukrainian photographer **BORIS MICHAILOV** *too, thought-up a story around a BMW. In a kind of photo novel as a sequence of 22 shots, Michailov tells the story of "BMW (My Old Story)" as "The Line in My Brand" which connects him and his wife, Wita—"B(oris) M(ichailov) W(ita)"—with BMW already on the basis of initials. Scenes of children playing and wandering around stand next to the story of a car accident and a BMW suddenly turning up. In the combination of biographical elements with images from everyday life in his home town Charkow, a funny-ironic photo sequences arises, told from an apparently documentary point of view.*

Many of the photographs refer to earlier works by Michailov, such as the shot of a woman who is marching in military goosestep over a basement hole resembling a grave—an ironic allusion to the Soviet war propaganda, which Michailov had realized already in the series, "By the Ground" (1991). Also, a man presenting his naked, muscular torso alludes to the Soviet type hero. The scenes in which a woman poses lasciviously on the universally admired BMW motorbike can be seen in relation to the nude shots which the artist made of his wife in the 1970s and which led to him losing his job as an engineer in a factory. In one of the last photos, the artist himself lifts a dumb bell proudly into the air: "I felt for the first time that these muscles were there for something more important than for an imaginary idea. And this contact with the dirty metal of an old BMW machine aroused in me a desire which I had not known up to that time."

JOHANNES MUGGENTHALER *casts a rather melancholy gaze at a route which in the meantime has become legendary. His "road movie in stills" moves along the Mille Miglia, a racing route from Brescia to Rome and back again. Muggenthaler drove along the route on which BMW had been successful in the 1930s. Not the driver's vehicle or the driver himself are at the focus of his work, but the racing route, which passes along public roads. The photo series moves between fiction and reality and is characterized, so intended by the artist, by a "filmic atmosphere", "films by Antonioni or Godard in which the wide open spaces, the road is the subject".*

Two signs in a winter landscape mark as fictitious directions, the starting point and destination of the route: homesickness and the longing for far-off places. Muggenthaler's works frequently treat a subject with playful irony. Thus, his subjects and photographs aim at ambiguities in seeing and problems in visual language. Homesickness and the longing for far-off places, in this sense, lead back to the same place. Muggenthaler, who is also a writer, has embedded the photo series in a narrative: "A car driver is imagined. Car mechanic, one from the back rows of motor sport. An enthusiast who drives the Mille Miglia in his sports car and dreams that he is a racing car driver. The aim of my work was to create a road movie in stills, certainly a paradox, but completely appropriate for a circular route where, as we know, the start and the finish can be the same. The photo series says something about car driving itself. Homesickness and the longing for far-off places are an eternal cycle. Mille Miglia is a metaphor."

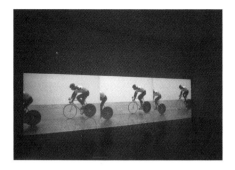

Heike Baranowsky
Radfahrer (Hase und Igel) 2000

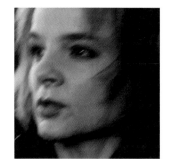

Ursula Rogg
Ladies Training 2000

Bewegung als Motiv

Bewegung ist das Thema der Videokünstlerin
HEIKE BARANOWSKY. Ihr geht es »um die Realität, die 1:1
wiedergegeben wird, aber durch Effekte, wie Loops,
in eine neue Art der Wahrnehmung, auf eine andere
Ebene gebracht wird«. In ihren tonlosen Videoloops
projiziert Baranowsky häufig die gleiche Szene mehrfach
zeitversetzt und in verschiedenen Geschwindigkeiten.
So inszenierte sie in ihrer Videoarbeit »AUTOSCOPE«
(1996/97) eine Autofahrt rund um den Pariser Boulevard
Péripherique als raumgreifenden, Schwindel erregenden
Loop, in dessen gegenseitig gespiegelten 4-Kanal-
Projektionen Anfang und Ende der Fahrt nicht mehr
erkennbar waren. In »Out of the Blue (Test 1)« (2003)
dagegen benutzte Baranowsky ein Zeitungsfoto von über
Afghanistan kreisenden Militärflugzeugen als Vorlage,
um kreisförmige, sich am Himmel abzeichnende
Kondensstreifen zu entwickeln. Diese wurden in das
bewegte Bild einer amerikanischen Wüste montiert.

Für das Video »Radfahrer (Hase und Igel)« nahm die
Künstlerin Radfahrer im Velodrom auf. Eine kurze geloopte
Sequenz ließ sie dreimal – zeitversetzt und in verschiede-
nen Geschwindigkeiten – ablaufen, sodass die parallele,
nebeneinander laufende Projektion der Loops wie eine
fiktive Verfolgungsjagd erscheint: »Dadurch entsteht der
Eindruck, als ob der Fahrer aus dem jeweils rechten Bild
sich selbst im linken verfolgt bzw überholen müsste. ...
Der Loop lässt die Bewegung zu einem beständigen Kreis-
lauf werden, wobei es nicht darauf ankommt, wer vorne
oder hinten ist.«

Das Testen von Geschwindigkeiten auf einer zuvor
präparierten Strecke ist Inhalt der von **URSULA ROGG** rea-
lisierten Fotoserie. Inspiriert wurde die Künstlerin durch
den »verhältnismäßig hohen Anteil« von BMW-Fahrerinnen
in den USA: »Sie entsprachen der Beschreibung des
BMW-Kundenprofils (selbstständig und aktiv, selbst-

bewusst, wettbewerbs- und erfolgsorientiert), telefo-
nierten fast ausnahmslos während des Fahrens (rege
unternehmerische Tätigkeit) und fuhren einen offensiven
Stil. Diese Frauen fahren BMW, weil es ein männliches
Image hat (›Work hard, play hard‹).« Während eines
»Ladies Training«, eines speziellen Fahrzeugtrainings für
Frauen, fotografierte Rogg die von ihr eigens engagierten
Schauspielerinnen, die sie durch den mit Sprühfontänen
und Hindernissen markierten Parcours schickte. Das
Münchner BMW-Trainingsgelände in der Nähe des Flug-
hafens wird auf dem größten Foto der Serie gezeigt.
Die skeptischen Blicke der Teilnehmerinnen, die ihre
Kolleginnen bei den riskanten Autofahrten beobachten,
und die ängstlichen, konzentrierten Gesichter der durch
den Parcours fahrenden Frauen drücken die Gefühls-
momente aus, denen die Frauen ausgeliefert sind.

Menschen, die sich in einer ihnen zugewiesenen Rolle
freiwillig in zum Teil extreme Situationen begeben, inte-
ressieren Ursula Rogg. Vor allem um die möglichst
realistische Simulation von Ereignissen und den Umgang
mit Rollenmodellen geht es der Künstlerin, die ihre
Themen bevorzugt in Trainings- und Ausbildungssituatio-
nen findet. So zeigt die Videoarbeit »Casino« (2000) ein
Schauspieltraining, in dem die gespielten Szenen in
chronologischer Umkehrung in die sachliche Situation
eines Unterrichts münden.

Als aus dem Autofenster vorbeifliegende, verwischte
Landschaftsstrukturen zeigen die Künstler **INEZ VAN
LAMSWEERDE** und **VINOODH MATADIN** die Geschwindigkeit
des Autofahrens (»Speedscape 1–3«). Als »euphorische
Überschneidung von Auto, Straße, Raum und Sicht«
(Joshua Decter) erscheinen die abstrakten, als Triptychen
realisierten Aufnahmen. Mittels digitaler Bildbearbeitung
ließen Lamsweerde und Matadin, die beide vorwiegend
im Bereich der Kunst- und Modefotografie arbeiten, neue
künstliche Landschaften entstehen, die wie Farbräusche
oder das Elektrokardiogramm eines in der Dunkelheit
fahrenden Autos wirken.

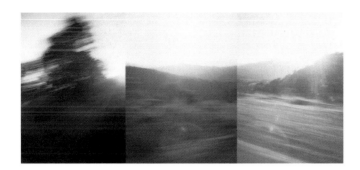

Inez van Lamsweerde & Vinoodh Matadin
Speedscape 1 1998

Movement as a Motif

Movement is the subject of the video artist **HEIKE BARANOWSKY.** *She is concerned with "reality which is reproduced one-to-one, but is transformed by effects such as loops into a new kind of perceiving and brought onto another plane." In her soundless video loops, Baranowsky frequently projects the same scene several times with temporal displacements and at different speeds. Thus, in her video work, "AUTOSCOPE" (1996/97), she staged a journey by car around the Paris Boulevard Péripherique as a space-filling, dizzying loop in whose reciprocal mirrored 4-canal-projections beginning and end of the journey were no longer recognizable. In "Out Of the Blue (Test 1)" (2003), by contrast, Baranowsky used a newspaper photo of military planes circling over Afghanistan as model in order to develop circular vapour trails across the sky. These were created as a montage in the moving image of an American desert.*

For the video, "Cyclists (The Hare and The Tortoise)", the artist filmed cyclists in a velodrome. A short, looped sequence was run three times with temporal displace-ments and at different speeds so that the parallel projection of the loops next to each other seems to be a fictitious chase: "In this way the impression arises that the rider from the right-hand image in each case were chasing himself in the left-hand image and had to over-take himself. ... The loop causes the movement to become a perpetual circuit where it does not matter who is in front and who is behind."

The testing of speeds on a previously prepared route is the subject of the photo series realized by **URSULA ROGG** *for BMW. The artist was inspired by the "relatively high proportion" of female BMW drivers in the United States: "They corresponded to the description of the BMW customer profile (independent and active, self-confident, competitive and ambitious), almost always spoke on the phone while driving (lively entrepreneurial activity), and drove with an assertive style. These women*

drive BMW because it has a masculine image (work hard, play hard)." During a lady's training course, a special driver training course for women, Rogg photographed the female actors she had herself engaged, sending them off along the course dotted with spraying fountains and obstacles. The Munich BMW training grounds near the airport are shown on the largest photo in the series. The sceptical looks of the participants who are observ-ing their female colleagues during their risky driving manoeuvres, and the anxious, concentrated faces of the women driving the course express the emotional moments to which the women are subjected.

Rogg prefers to deal with people who voluntarily put themselves into occasionally extreme situations in a role that has been assigned to them. The artist who finds her subjects in training situations is concerned especially with the simulation of events in the most realistic way possible, and the way role models are dealt with. Thus, the video work, "Casino" (2000), shows scenes from an actors' training course in which the scenes played chronologically in reverse end up in the matter-of-fact situation of a class being taught.

The artists **INEZ VAN LAMSWEERDE** *and* **VINOODH MATADIN** *show the speed of car driving as blurred landscape structures flying past the car window ("Speedscape 1–3"). The abstract shots realized as triptychs appear as a "euphoric overlapping of car, road, space and sight" (Joshua Decter). By means of digital image-processing, Lamsweerde and Matadin, who both work mainly in the areas of art and fashion photography, allowed new, artificial landscapes to emerge that are like the streaks of colour or the electrocardiogram of a car driving in the dark.*

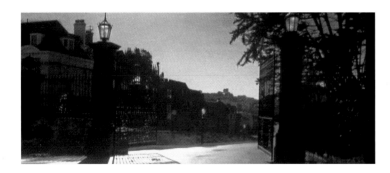

Alexander Timtschenko
Power 2000

Mythos BMW

Ein BMW-Werbespot war Ausgangspunkt für die Foto-
grafien von **ALEXANDER TIMTSCHENKO**, der sich in seinen
künstlerischen Arbeiten oft mit der perfekten Welt der
Illusion beschäftigt – Kunstwelten wie Freizeitparks, den
Architekturkulissen in Las Vegas oder den Märchen-
schlössern von Ludwig II. Timtschenko zerlegte die Film-
sequenzen des BMW-Spots in *film stills,* in Standbilder,
und komponierte sie am Computer neu. In den von ihm
bearbeiteten *film stills* taucht der BMW nicht mehr auf,
stattdessen stehen die vom Auto befahrenen Wege
im Vordergrund: Eine bei Nacht von Straßenlaternen nur
schwach beleuchtete, regennasse Straße, eine in ein
schlossartiges Ambiente führende herrschaftliche Einfahrt
und eine rote Sandpiste im Urwald. Die Fotografien tragen
die Titel »Love«, »Joy«, »Power« und »Force« und ver-
weisen auf Schlagworte aus dem BMW-Spot. Die Werbe-
botschaften zeugen von Optimismus und körperlicher
Überlegenheit. Von Timtschenko zudem als winziger
Schriftzug digital in die Mitte des jeweiligen Fotos gesetzt,
imprägnieren sie als Slogan die jedem *film stills* zugrunde
liegende Stimmung: So wird die nächtliche Straße zum
romantischen Ort (»Love«), das von einem hohen,
verschnörkelten Eisengitter abgeschottete Anwesen
(»Power«) steht für gesellschaftliche Anerkennung und
Macht, und die rote, von wild gewachsenen Pflanzen
gesäumte Sandpiste (»Joy«) vermittelt Lust am Abenteuer.
»Letztendlich erzählen diese Bilder Wahrheiten, die
aus einer anderen, perfekteren Welt stammen müssen«,
findet Alexander Timtschenko.

Die britische Künstlerin **GILLIAN WEARING** näherte sich
dem Mythos der Marke BMW auf eine andere Weise.
In eine große Londoner Tageszeitung setzte sie eine
Anzeige, in der sie BMW-Besitzer dazu aufforderte, ihre
Autoerfahrungen mitzuteilen. Aus der zugesandten Post
wählte Wearing drei Briefe aus und besuchte die BMW-
Fahrer, um sie zusammen mit dem Objekt ihrer Leiden-
schaft zu fotografieren (»Shine«, »Paul«, »Thomas«). Diese
reportagenahe, fast soziologische Vorgehensweise ist
charakteristisch für die Foto- und Videoarbeiten Wearings,
die Menschen per Anzeige um das Statement zu einem
Thema (»Confess all on video, Don't worry, you will be
in disguise, Intrigued? Call Gillian«, 1994) bittet oder sie
auf der Straße anspricht. Die Aufzeichnung und Wieder-
gabe der von der Künstlerin in Erfahrung gebrachten
Seelenzustände oder privaten Geschichten ist formal auf
ein sachliches Maß reduziert – im Falle von »Shine« und
»Paul« eine Schwarzweiß-Aufnahme, die sie in ihrem
BMW zeigt, und die handgeschriebenen Briefe, mit denen
sie auf die Anzeige antworteten.

Die voyeuristische Neugier der Künstlerin überträgt sich
auf den Betrachter, der sich erst beim Lesen der Briefe
ein genaues Bild über die von ihnen gepflegten Besitzer-
rituale und ihre BMW-Obsession macht. So berichtet
die 33-jährige Shine von den Beweggründen, sich einen
BMW zu kaufen und der Angst, das das Fahrzeug, zu dem
sie inzwischen eine Beziehung aufgebaut hat, gestohlen
werden könnte. Der halbwüchsige Thomas wünscht sich,
später selbst einen BMW zu besitzen und hofft, sein Onkel
könne ihm seinen BMW vererben. Und Paul schildert
ausführlich, welche Besonderheiten sein BMW hat, und
gesteht, dass er eine Art Familienersatz für ihn ist.

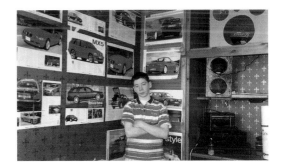

Gillian Wearing
Thomas 1998

The BMW Myth

A BMW advertising spot was the starting-point for the work by Alexander Timtschenko, who in his artistic works concerns himself with the perfect world of illusion— artificial worlds of recreational parks, the architectural backdrops in Las Vegas or the fairy-tale castles of Ludwig II. Timtschenko dissected the film sequences of the BMW spot into film stills and recomposed them on the computer. In the film stills he processed, the BMW no longer appears; instead, the routes travelled by the car are in the foreground: a rain-wet road illuminated only weakly by street lighting at night, a grand drive leading into a mansion-like ambient, and a red sand track in the jungle. The photographs bear the titles, "Love", "Joy", "Power" and "Force", and refer to catchwords from the BMW spot. The advertising messages bear witness to optimism and physical superiority. Placed by Timtschenko in the middle of each photo digitally and in tiny lettering, they impregnate the mood underlying each film still as a slogan. Thus, the night-time street becomes a romantic place ("Love"), the estate protected by a high, fancy wrought-iron gate ("Power") marks the place of social recognition and power, and the red sand track bordered by wild plants ("Joy") communicates the pleasure of adventure. "Ultimately, these images tell truths that have to come from another, more perfect world," finds Alexander Timtschenko.

The British artist GILLIAN WEARING approaches the myth of the BMW brand in another way. She placed an advertisement in a large London daily newspaper in which she called on BMW owners to tell their experiences with the car. From the mail she received, Wearing selected three letters and visited the BMW drivers to photograph them together with the object of their desires ("Shine", "Paul", "Thomas"). This quasi-journalistic, nearly sociological way of proceeding is characteristic for Wearing's photographic and video works. She asks people by advertisement for a statement on a given subject ("Confess all on video, Don't worry, you will be in disguise, Intrigued? Call Gillian", 1994) or accosts them on the street. The recording and playback of the psychic states or private stories brought to light by the artist is formally reduced to a matter-of-fact measure. In the case of "Shine" and "Paul", it is a black-and-white shot which shows them in their BMW's together with the handwritten letters with which they responded to the advertisement.

The voyeuristic curiosity of the artist carries over to the viewer who, only on reading the statements of the people about the owner's rituals they cultivate, forms an impression of their BMW obsession. Thus, the 33-year-old Shine tells of the motives for her to buy a BMW and the fear that the vehicle, with which she has built up a relationship in the meantime, could be stolen. The adolescent Thomas wants to own a BMW himself later on, and hopes that he could inherit one from his uncle. And Paul describes in detail the particular features of his BMW and confesses that it is a kind of surrogate family for him.

Catherine Opie
Ohne Titel 1998

Einen eher ironischen Blick auf die Marke BMW wirft die amerikanische Künstlerin CATHERINE OPIE. Opie, die vorwiegend Menschen aus der amerikanischen Subkultur wie der Lesben-, Sadomaso- oder Lederszene portraitiert und sie u. a. mit ihren sozialen Codes, den tätowierten, verletzten Körpern aufnimmt, empfand ihre mehrteilige Arbeit der Architektur des Gebäudes eines BMW-Verkaufsbüros in Los Angeles nach: »Da ich mir dachte, dass BMW nicht nur ein Auto ist, sondern auch für eine Lebensart steht, habe ich das Thema Auto mit dem Thema Architektur verbunden. ... Ich wollte, dass die Arbeit in ihrer Form einem Gebäude oder, wenn möglich, einer Fabrik ähneln sollte. Oben sollte das BMW-Logo sein (die einzige Aufnahme, die in L. A. gemacht wurde) und dann neun Innenaufnahmen des Münchner BMW-Werkes. Die Flügel meines Gebäudes bestehen aus zwei Panoramaaufnahmen von verschiedenen Abschnitten der Autobahn außerhalb und innerhalb Münchens. ... Es bleibt nur die Architektur, und der Raum kann nur als Beschreibung der Funktion des Autos existieren.«

Die neun Fotografien im Zentrum von Opies Arbeit zeigen vorwiegend Detailaufnahmen des Produktionsprozesses. Die kühle, sachliche Fotografie der Roboter und Maschinen nimmt vor allem die ästhetischen Reize ihrer Oberflächen wahr. Die seitlich flankierenden Ansichten von leeren Autobahnen verweisen auf eine Fotoserie, die Opie Mitte der 1990er-Jahre in Los Angeles realisierte, in der sie die leeren Highways als Relikte einer vernetzten Gesellschaft aufnahm. Als »imperiale Insignie« (Joshua Decter) prangt das BMW-Logo über dem Fotoensemble: Es verweist auf die von der Marke BMW durchdrungene automobile Gesellschaft und Produktionswelt.

Für die designte Oberfläche des Automobils als entscheidenden Markenfaktor interessierte sich WOLFGANG TILLMANS. In begrenztem Bildausschnitt fotografierte er die glänzenden Oberflächen der Fahrzeuge, auf denen Regentropfen schimmern (»BMW Project I (Silver)«, »BMW Project II (Red)«, »BMW Project III (Blue)«). Tillmans fühlte sich zunächst von der »außerirdischen Science-Fiction-Erscheinung« des Münchner BMW-Gebäudes angeregt, an dem er als Kind auf dem Weg zum Urlaubsort mit seinen Eltern oft vorbeigefahren war: »Der Auftrag von BMW hat mich an diese Faszination erinnert und als ich an einem Sonntag letzten Jahres zu dem Hauptgebäude gegangen bin, um es mir näher anzusehen, sah ich eine BMW-Ausstellungsfläche. Ich beschloss, mich in meinen Aufnahmen mit den vergänglichen Auto-Oberflächen auseinander zu setzen.«

Die glatten, intakten Oberflächen der Fahrzeuge wirken wie abstrakte Farbflächen. Die Natur scheint im Zusammenspiel mit dem lackierten Gehäuse filigrane, reliefartige Kunstformen zu produzieren. In der Reduktion auf einen stark begrenzten Bildausschnitt hatte Tillmans zuvor eine Serie verwirklicht, in der er Kleider wie Landschaften drapierte und damit auch die ästhetischen Reize ihrer Stofflichkeit in den Blick rückte.

Wolfgang Tillmans
BMW Project I (Silver) 1998

The American artist CATHERINE OPIE *casts a rather ironic glance at the BMW brand. Opie, who mainly makes portraits of people from the American subculture such as the lesbian, sadomasocism and leather scenes, and photographs them with their social codes, the tattooed, injured bodies, modelled her multipartite work on the architecture of the building of a BMW sales office in Los Angeles. "Since I thought to myself that BMW is not only a car, but also stands for a lifestyle, I combined the subject of car with the subject, architecture. ... I wanted the work to resemble a building or, if possible, a factory in its form. The BMW logo should be at the top (the only shot that was taken in L.A.), and then nine interior shots of the Munich BMW plant. The wings of my building consist of two panorama photographs of various sections of the expressway outside and within Munich. ... Only the architecture remains, and space can only exist as the description of the function of the car."*

The nine photographs at the centre of Opie's work show mainly detailed shots of the production process. The cool, matter-of-fact photography of the robots and machines captures especially the aesthetic attractions of their surfaces. The views of empty expressways flanking on both sides refer to a photo series which Opie realized in the mid-1990s in Los Angeles in which she took shots of empty highways as the relics of a networked society. As an "imperial insigne" (Joshua Decter), the BMW logo is prominently displayed above the ensemble of photos: it refers to the penetration of the automobile society and the world of production by the BMW brand.

The designed surface of the automobile as a factor decisively determining the brand interested WOLFGANG TILLMANS. *Within a restricted image frame he photographed the shiny surfaces of vehicles on which rain drops shimmer ("BMW Project I (Silver)", "BMW Project II (Red)", "BMW Project III (Blue)"). Tillmans first felt himself stimulated by the "extraterrestrial, science fiction appearance" of the Munich BMW building which he often drove past with his parents as a child on the way to their vacation destination. "The commission from BMW reminded me of this fascination and, when I went to the main building last year on a Sunday to look at it more closely, I saw a BMW display area. I decided to engage in my photographic project with the transient surfaces of cars."*

The smooth, intact surfaces of the vehicles have the effect of abstract patches of colour. Nature, in an interplay with the painted body, seems to produce filigrane art forms resembling reliefs. Tillmans had previously realized the reduction to a strictly limited image frame in a series, in which he draped clothes like landscapes, thus bringing also the aesthetic attractiveness of their materiality into view.

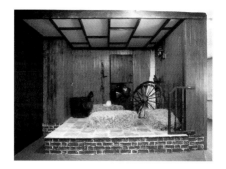

Bridget Smith
Glamour Studio (Stable) 1999

David Shrigley
This H 1999

»Making Your Dreams Come True«

»Making Your Dreams Come True« (»Macht eure Träume wahr«) lautete die Aufforderung von BMW an sechs britische Künstler im Jahr 1999. Ohne jegliche inhaltliche Vorgabe sollten sie künstlerisch das verwirklichen können, was sie sich schon immer erträumt hatten. Auf diese Weise entstanden Arbeiten, die sich sehr spezifisch mit Themen wie Britischsein, Heranwachsen und Jugend oder dem modernen Globetrotter auseinander setzen.

Mit Kulissen und dem »Bedürfnis von Illusion als grundlegender menschlicher Eigenschaft« (Mark Haworth-Booth) beschäftigt sich **BRIDGET SMITH** in ihren Arbeiten. Mitte der 1990er-Jahre fotografierte sie u.a. die geschlossenen Vorhänge in Londoner Kinos und Theatern oder die Architekturkulissen von Las Vegas. Für die Serie »Glamour Studios« besuchte Smith Fotokulissen in britischen Provinzstädten. Smith wirft einen unspektakulären Blick auf die von Scheinwerfern beleuchteten kleinen Kabinen – eine Umkleidekabine, einen Stall, ein Badezimmer –, in denen Menschen sich in der von ihnen gewünschten Rolle fotografieren lassen können.

Der Zeichner, Bildhauer, Schriftsteller und Fotograf **DAVID SHRIGLEY** ist oft mit Papier, Schere und Klebeband unterwegs. Mit diesen Utensilien bewaffnet, greift er in die vorhandene Umgebung ein. Seine humorvollen und hintergründigen Arbeiten begegnen der tristen Realität des Alltags. Ein mitten in einem Park stehendes, H-förmiges Metallgelände wird mit in weißer Farbe aufgemalten Buchstaben von Shrigley zum Eingangsportal erklärt: »This H stands for Hello, welcome to the Park«. Eine weitere Arbeit erklärt der Künstler folgendermaßen: »›Your Name Here‹ zeigt eine andere befremdliche Situation. Eine Schnecke verkauft Werbefläche auf ihrem Häuschen. Aber für was würden Sie dort werben? Gärtnerei-Produkte etwa?«

Junge Menschen bevölkern die Fotografien von **SARAH JONES**. So fotografierte sie über einen längeren Zeitraum heranwachsende Mädchen der britischen Mittelklasse in ihren Elternhäusern. Historische Porträtfotografien aus dem 19. Jahrhundert, aber auch die detailfreudige Malerei der Präraffaeliten inspirierten die Künstlerin für ihre Aufnahmen. Die vier Arbeiten für BMW gehören zur Serie »The Dining Room«, in denen Jones junge Mädchen, teilnahmslos am Tisch des Esszimmers ihres Elternhauses oder auf der Bettkante ihres Zimmers sitzend, fotografierte. Der *back garden,* der hintere Garten eines englischen Reihenhauses, wird zum Ort des Erwachsenwerdens: So steht eines der Mädchen mit einem Frosch in der Hand vor einem Apfelbaum, während ihre Schwester auf einem anderen Foto auf eine Leiter steigt und über die Mauer des *back garden* blickt. »In diesen Bildern geht es darum, was geschieht, wenn wir uns erinnern oder uns bewusst machen, was wir begehren oder einst begehrt haben«, fasst die Künstlerin ihr Anliegen zusammen.

Autobahnen und Verkehrsinseln waren Ende der 1990er Orte, an denen **SOPHY RICKETT** ihre Schwarzweiß-Fotografien realisierte. In der tiefdunklen Nacht waren in der Ferne schlafende oder sitzende Menschen zu erkennen. In der für BMW geschaffenen Arbeit sitzt, mit dem Rücken zum Betrachter, eine Frau in einer saftgrünen Wiese, auf einem zweiten Foto liegt sie im Gras. Irritierend ist der die Hälfte des Bildes bestimmende nachtschwarze Himmel. Die Leere des Ortes und die Einsamkeit des Menschen treffen in Ricketts Fotografien aufeinander, die Dunkelheit der Nacht löst dramatische Verdachtsmomente aus. Wie die Künstlerin fragt sich der Betrachter: »Lähmt sie die Umgebung, die keine Fluchtmöglichkeit bietet, oder betrachten sie die dunkle Weite der Nacht und denken über ihre Geheimnisse nach und die unglaublichen Möglichkeiten, die sie birgt?«

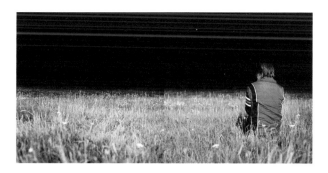

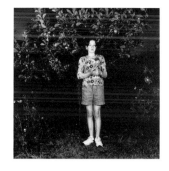

Sophy Rickett
Ohne Titel 1 1999

Sarah Jones
The Apple Tree (Charlton) II 1999

"Making Your Dreams Come True"

"Making Your Dreams Come True" was the challenge presented by BMW to six British artists in 1999. Without any restrictions at all regarding the subject, they were to be able to realize artistically what they had always dreamed of. In this way, works arose which engage very specifically with subjects such as being British, growing up and youth, and the modern globetrotter.

BRIDGET SMITH concerns herself in her works with backdrops and the "need for illusion as a fundamental human trait" (Mark Haworth-Booth). Since the mid-1990s, she has been photographing the closed curtains in London cinemas and theatres, and the architectural backdrops of Las Vegas. For the series "Glamour Studios" Smith visited photo backdrops in provincial British towns. Smith casts an unspectacular glance at the small rooms of the backdrops illuminated by spotlights—a changing cubicle, a stable, a bathroom—in which people can be portraited in their favorite role model.

The graphic artist, sculptor, writer and photographer DAVID SHRIGLEY often travels around with paper, scissors and adhesive tape. Armed with these utensils, he intervenes in the environment at hand. His humorous and enigmatic works thus counter the dreary reality of everyday life. An H-shaped metal railing standing in the middle of a park with a letter painted on it in white paint is declared by Shrigley to be an entrance portal. "This H stands for Hello, welcome to the Park." The artist explained another work in the following way: "'Your Name Here' shows another strange situation. A snail sells advertising space on its shell. But what would you advertise there? Gardening products perhaps?"

Young people populate the photographs of SARAH JONES. Thus, she photographed over a long period adolescent girls from the British middle class in their parental homes. Historical portrait photographs from the nineteenth century, but also the detailed painting of the Pre-Raphaelites, inspired the artist to make her photos. The four works for BMW are part of her series, "The Dining Room", in which Jones photographed young girls, sitting indifferently at the table of the dining room of their parents' home, or sitting on the edge of the bed in her bedroom. The "Back Garden" of an English terrace house becomes a place for growing up. Thus, one of the girls stands in front of an apple tree with a frog in her hand, while her sister, in another photo, climbs up a ladder and looks over the wall of the back garden. "In these pictures it is a matter of what happens when we recollect or become aware of what we desire or once desired," is how the artist summarizes her project.

Expressways and traffic islands were the places where SOPHY RICKETT realized her black-and-white photographs at the end of the 1990s. In the deep dark night, people sleeping or sitting far off could be made out. In the work created for BMW, a woman with her back to the viewer sits on a lush green meadow and in a second photo, she is lying on the grass. What causes confusion is the black night sky that takes up half the photograph. The emptiness of the place and the loneliness of the person encounter each other in Rickett's photographs. The darkness of the night stimulates dramatic suspicions. Like the artist, viewers ask themselves, "Are they paralyzed by the environment which does not offer any escape route, or are they viewing the dark expanse of the night and thinking about their secrets and the incredible possibilities which they hold?"

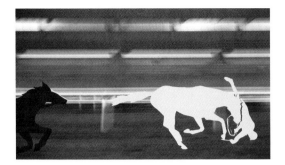

Hannah Starkey
Horsepower 3 1999

Geschwindigkeit und Bewegung bzw. die mobile Gesellschaft wurden von zwei Künstlern thematisiert. Ein Pferderennen inspirierte **HANNAH STARKEY** zu ihrer Fotoserie. Starkey entdeckte im Fenster eines Wettbüros Werbematerial und fand so die Vorlage für »Horsepower 1–4«. Während die Zuschauertribünen im Hintergrund verschwimmen, erscheinen die Silhouetten der Pferde und ihrer Jockeys als digital bearbeiteter, farbiger Scherenschnitt. Das Rennen wird von dem gelben Pferd bestimmt, das, zunächst zurückliegend, bald in führende Position gelangt. In einem unglücklichen Bewegungsmoment stürzt der Jockey vom Pferd. Sein Pferd geht zwar als erstes durchs Ziel, aber wie Starkey das von ihr erfundene Rennen interpretiert: »Wir haben auf das gelbe Pferd gesetzt, das deshalb unseren Ehrgeiz verkörpert. Schließlich geht es als erstes durchs Ziel – aber ohne Jockey. Die Wette ist ungültig.«

Den modernen Globetrotter fotografierte **TOM HUNTER**. Er begleitete jugendliche Raver auf ihren globalen Trips. In geradezu klassisch anmutender Pose zeigt Hunter das junge Paar vor dem Hintergrund einer staubigen indischen Landschaft (»Rose Water, Goa«). Seine Fotos tragen häufig malerischen Charakter und sind von irisierendem Licht durchflutet. In einem Interview gestand Hunter, dass seine Themen (Reisende in ihren Wohnwagen, die alternative Szene, Hausbesetzer) sich eher für die Schwarzweiß-Dokumentarfotografie eignen würden. Ihm gehe es jedoch nicht darum, die Menschen als Opfer, denen die gesellschaftliche Anerkennung verweigert wird, zu zeigen. »Obwohl diese Menschen nicht aus reichen Familien stammen und über keine großen Besitztümer verfügen, sind sie trotzdem stolz auf die Landschaft, in der sie leben und der sie angehören. Meine Bilder zeigen, dass sie die Träume der alten gesellschaftlichen Elite leben.« Statt dessen verweisen Hunters Kompositionen auf die Malerei der englischen Präraffaeliten, Vermeers oder, im Falle der jungen Raver, auf Rollenporträts des 18. Jahrhunderts.

Tom Hunter
Rose Water, Goa 1999

Speed and movement, or the mobile society were taken-up as subjects by two artists. A horse race inspired HANNAH STARKEY *to make her series. Starkey discovered advertising material in the window of a betting shop and thus found the model for her series, "Horsepower 1–4". Whereas the spectators' stands remain blurred in the background, the outlines of four horses and their jockeys appear as a digitally processed, colour silhouette. The race is dominated by the yellow horse which, at first set back, soon attains the leading position. In an unlucky moment, the jockey falls from the horse. The horse is the first to cross the finishing line but, as Starkey interprets the race she has invented: "We put our money on the yellow horse which therefore embodies our ambition. At the finish, it is the first to cross the line, but without a jockey, so the bet is invalid."*

TOM HUNTER *photographed the modern globetrotter. He accompanied young ravers on their global trips. In decidedly classic poses, Hunter takes shots of a young couple against the background of a dusty Indian landscape in "Rose Water, Goa". His photos of them have a painterly character and are flooded by iridescent light. In an interview Hunter confessed, that his subjects (travellers in their mobile homes, the alternative cultural scene, house squatters) would normally be appropriate for black-and-white documentary photography. He is concerned, however, not with showing people as victims who are refused social recognition. "Although these people do not come from rich families and do not have extensive possessions, they are nevertheless proud of the landscape in which they live and to which they belong. My pictures show that they live the dreams of the old social elite." Instead, in the composition of his photographs, Hunter refers to the painting of the English Pre-Raphaelites or Vermeer or, in the case of the young ravers, to role portraits from the eighteenth century.*

HEIKE BARANOWSKY

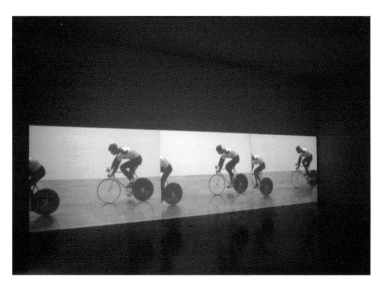
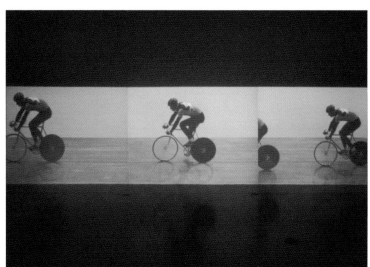

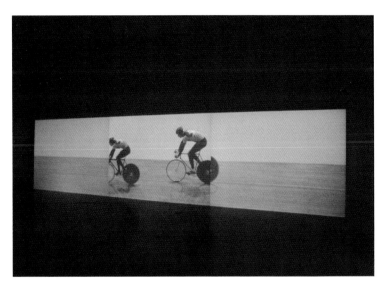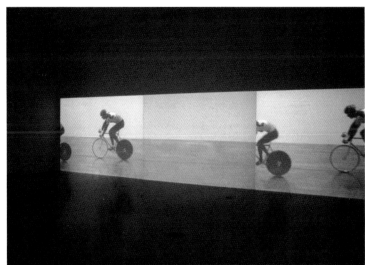

THOMAS DEMAND

Thomas Demand
77 – E – 217 2000
203,2 × 310,3 cm
C-Print, Diasec
Inv.-Nr. F 2005-1

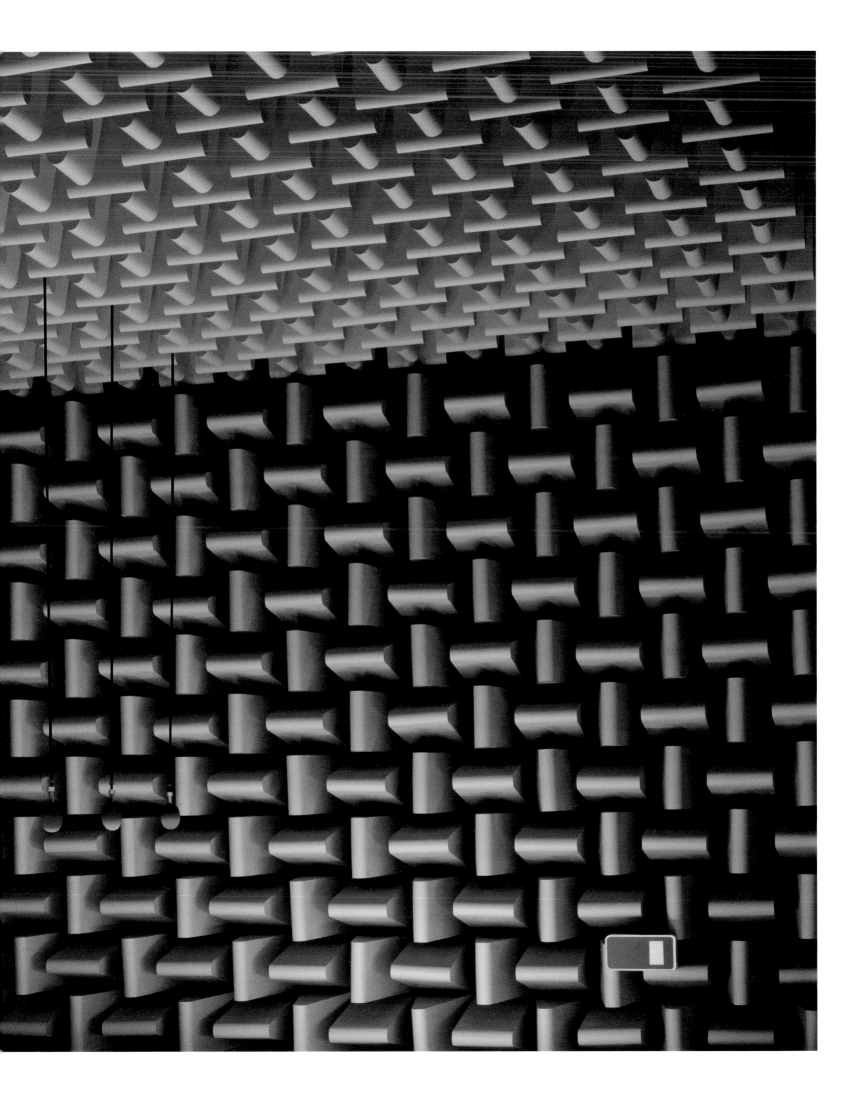

RINEKE DIJKSTRA

Rineke Dijkstra
Martin Scherz, Auszubildender Industriemechaniker 25. April 2000
120 × 100 cm
C-Print
Inv.-Nr. F 2005-2

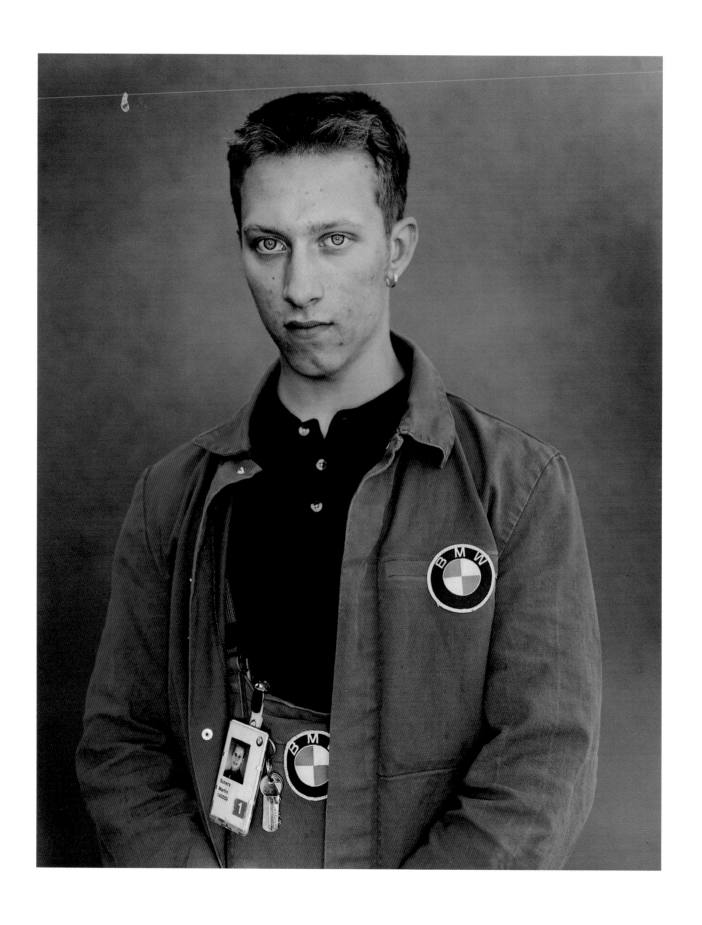

Rineke Dijkstra
Tom Coates, Technischer Auszubildender 26. April 2000
120 × 100 cm
C-Print
Inv.-Nr. F 2005-3

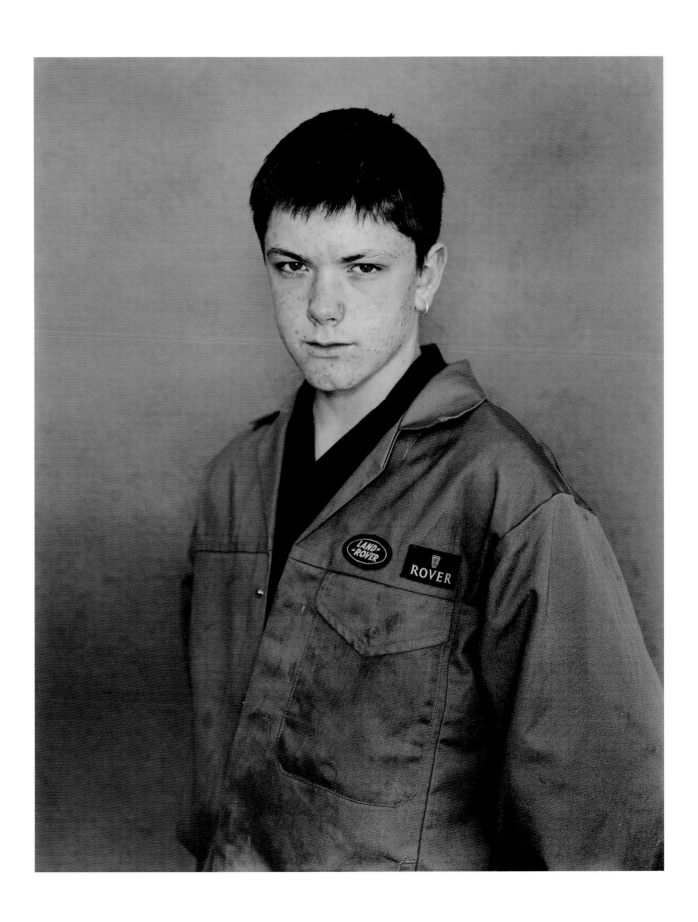

Rineke Dijkstra
Martin Dettenhofer, Auszubildender Werkzeugmacher 25. April 2000
120 × 100 cm
C-Print
Inv.-Nr. F 2005-4

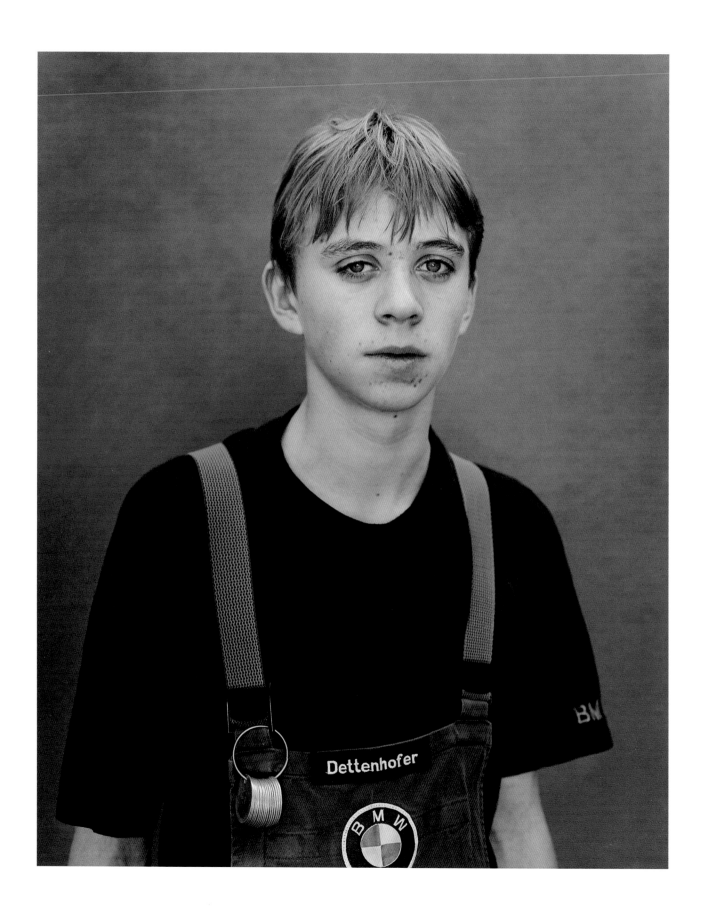

Rineke Dijkstra
Senol Dogruel, Auszubildender Industriemechaniker 25. April 2000
120 × 100 cm
C-Print
Inv.-Nr. F 2005-5

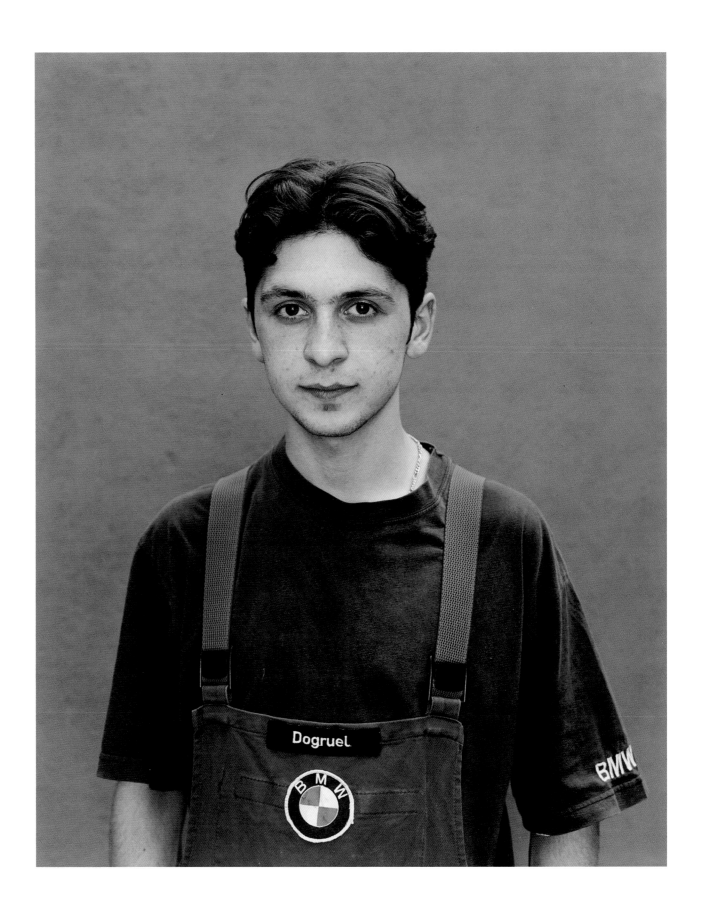

TODD EBERLE

Todd Eberle
Ohne Titel 1998
75,4 × 101 cm
Digitaler C-Print
Inv.-Nr. F 2005-73

Todd Eberle
Henrik Fisher, Car Designer 1998
3-teilig, je 75,4 × 101 cm
Digitaler C-Print
Inv.-Nr. F 2005-6

Todd Eberle
Marek Reichman, Car Designer 1998
3-teilig, je 75,4 × 101 cm
Digitaler C-Print
Inv.-Nr. F 2005-7

Todd Eberle
Anders Warming, Car Designer 1998
3-teilig, je 75,4 × 101 cm
Digitaler C-Print
Inv.-Nr. F 2005-8

NINA FISCHER &
MAROAN EL SANI

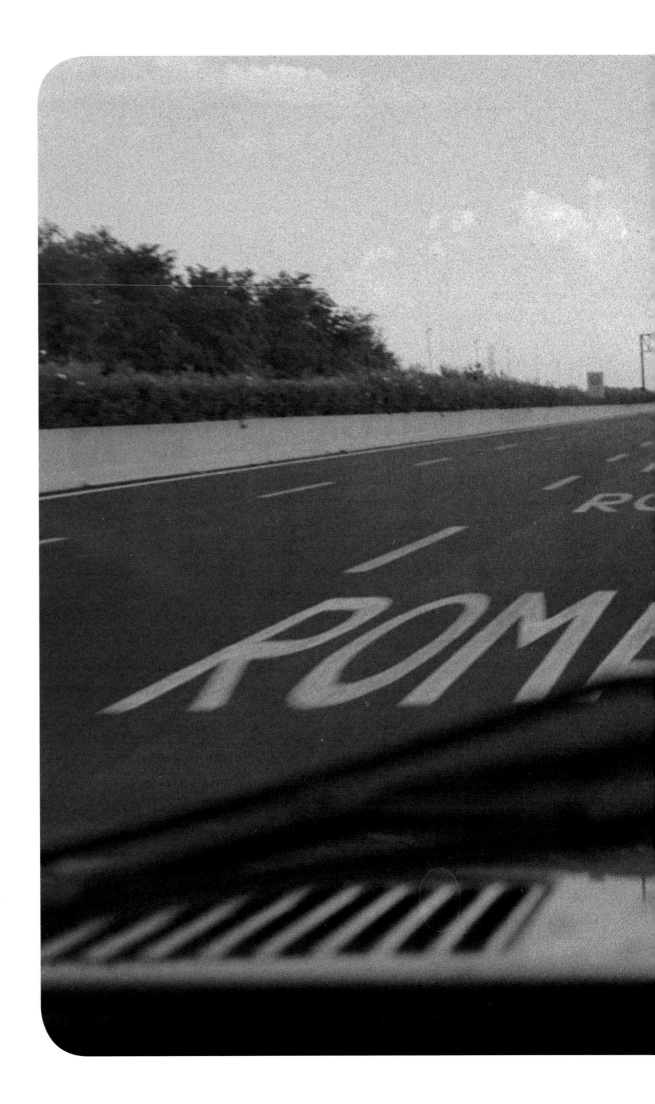

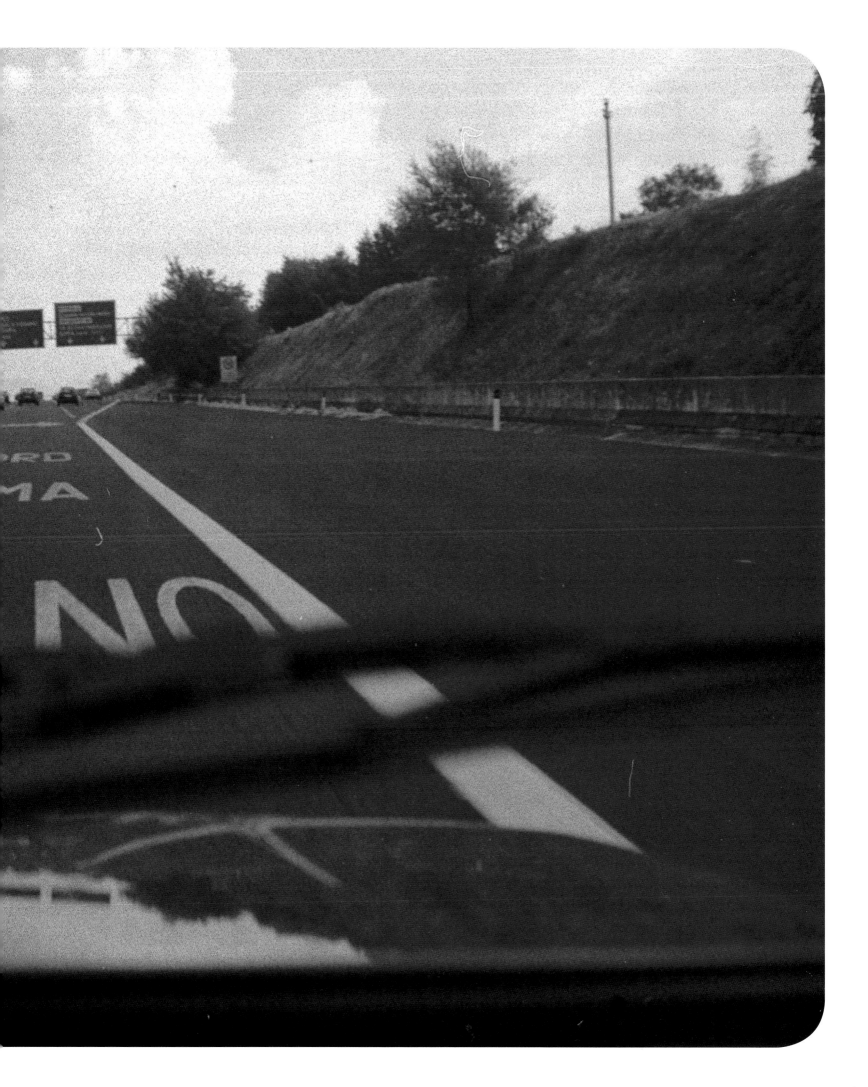

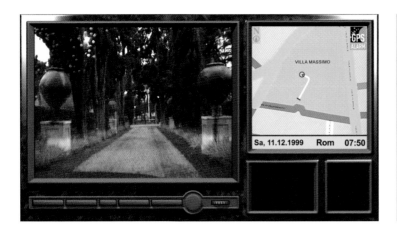

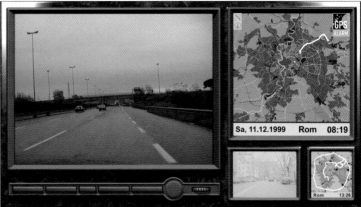

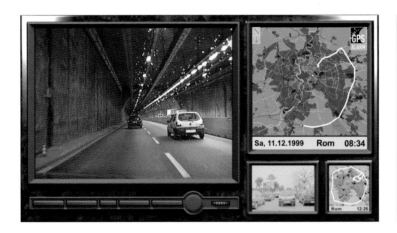

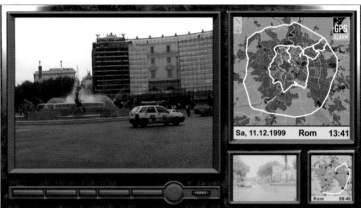

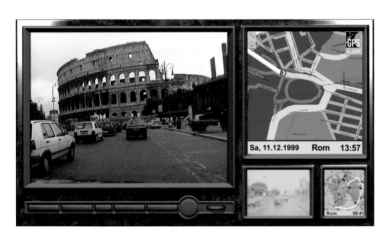

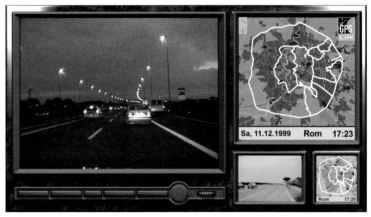

1 Videoaufzeichnung der Fahrt, 8-fach beschleunigt
 auf 1 Stunde / *Video recording of the journey at 8-fold*
 speed, shortening it to one hour
2 GPS-Aufzeichnung der Fahrt, 8-fach beschleunigt
 auf 1 Stunde / *GPS record of the journey at 8-fold speed,*
 shortening it to one hour
3 Videoaufzeichnung der Fahrt, 480-fach beschleunigt
 auf 1 Minute / *Video recording of the journey at 480-fold*
 speed, shortening it to one minute
4 GPS-Aufzeichnung der Fahrt, 480-fach beschleunigt
 auf 1 Minute / *GPS record of the journey at 480-fold speed,*
 shortening it to one minute

Ort: Rom, Italien, Datum: 11. 12. 1999
Handlung: Fahrt einer Figur in den Stadtraum Roms
mit GPS-Navigationssystem (Global Positioning System)
Start: 7:45, Villa Massimo, Rom,
Ziel: 18:48, Via Aurelia Antica/Via Leone XIII

Location: Rome, Italy, Date: 11-Dec-1999
Action: Journey of a figure in the urban space of Rome
using a GPS navigation system (Global Positioning System)
Start: 7:45, Villa Massimo, Rome,
Destination: 6:48, Via Aurelia Antica/Via Leone XIII

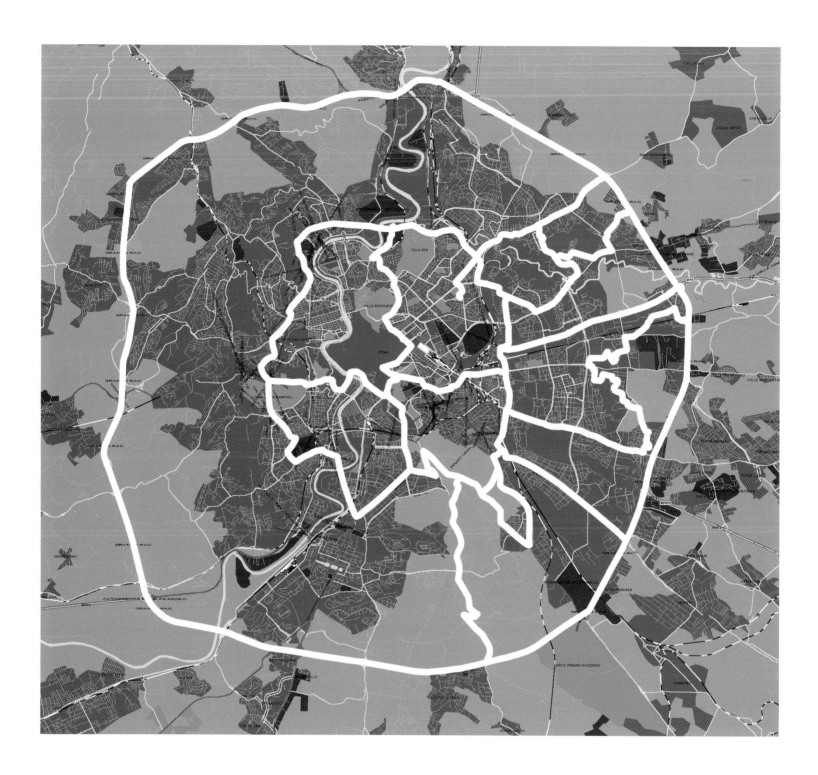

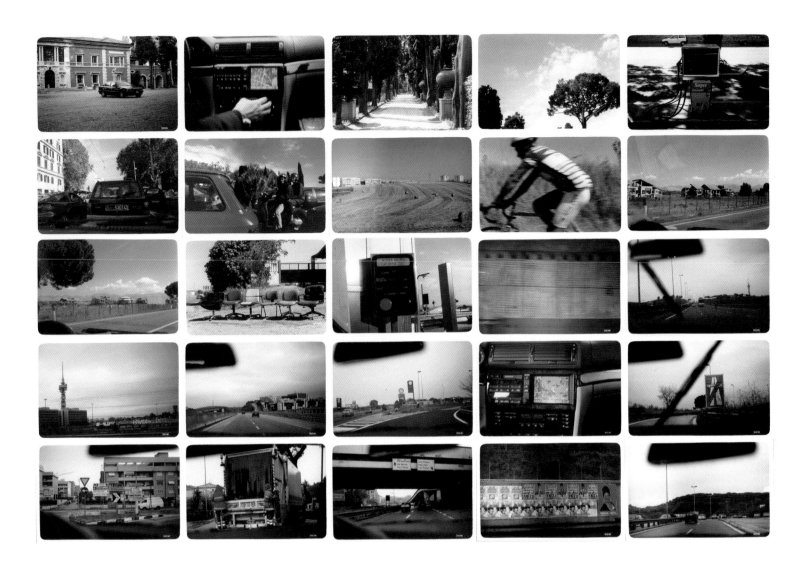

7:45 Villa Massimo, Via Nomentana — 8:13 **Uscita 11**, Grande Raccordo Anulare (GRA), **Uscita 12**, Via Fabriano, Via del Casale di S.Basilio, Via Tiburtina, Via R. Majetti, Viale Kant/Nomentana, Viale Kant, Via F.Cigogna, Ponte Mammolo, Via Tiburtina — 9:50 **Via dei Monti Tiburtini**, Circonvallazione Nomentana

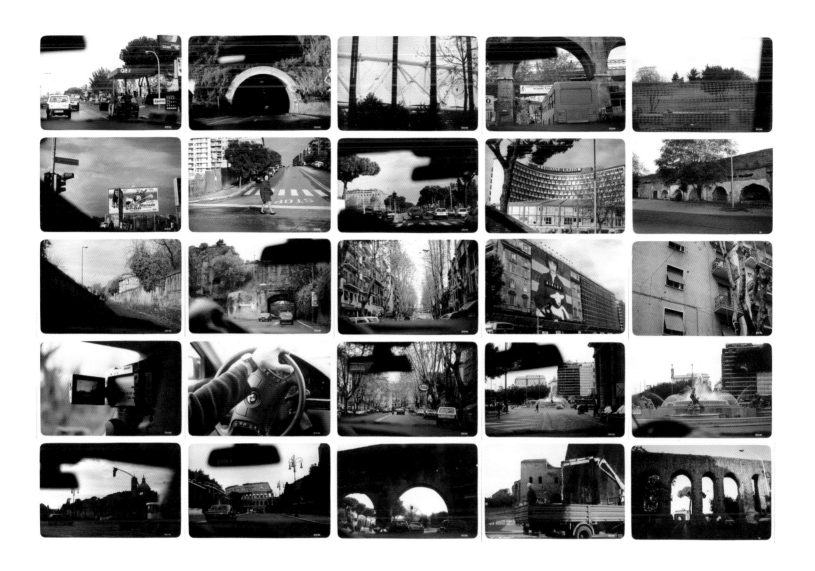

10:00 Circonvallazione, Via del Foro Italico — 10:32 Viale dello Stadio Olympico, Via Cipro, Via Leone XIII, Via del Casaletto, Via V. Ussani, Viale P. Colonna, Viale Guglielmo Marconi, Piazza del Lavoro, Via Cristoforo Colombo, **Piazza dei Navigatori,** Catacombes di Domitilla, Via dell' Almone, Porta Furba — 13:00 Via di Torpignattara, Via di Portonaccio, Via Galla Placidia, Via dei Monti Tiburtini — 13:17 Circonvallazione Salaria, Via del Foro Italico, Campi Sportivi, Viale dei Parioli, Via Cavour, Piazza della Repubblica, Piazza del Colosseo, Via Cristoforo Colombo, **Piazza dei Navigatori**

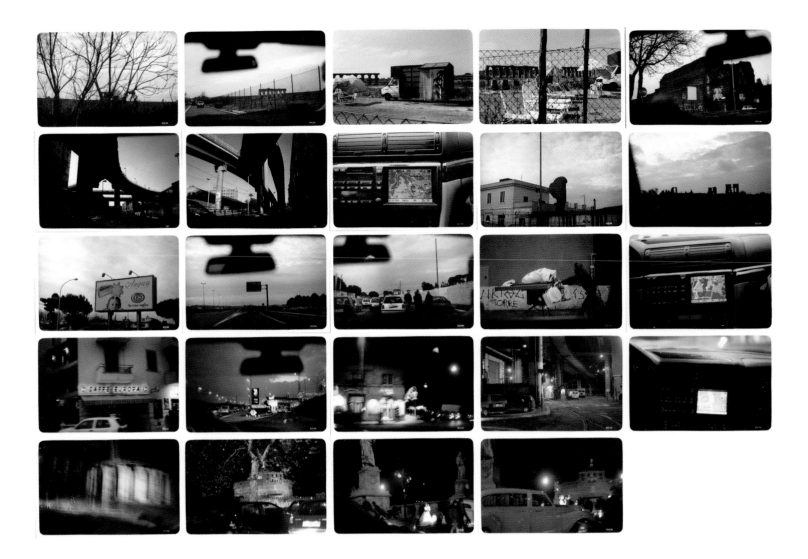

14:28 Via Appia Pignatelli, Via Demetriade, Via Tuscolana — 15:17 GRA Uscita 21, GRA Uscita 24, Via Ardeatina, Via de S. Sebastiano, Via Appia Pignatelli, Via Appia Nuova, **Arco di Travertino**, Porta Furba, Via Torpignattara — 15:54 Via Casilina, Via Enrico Giglioli, Via Walter Tobagi, Via D. Campari, Via Prenestina, Viale Palmiro Togliatti, Ple. Pino Pascali, Via della Rustica, GRA, Autostrada 24 Roma Centro, **Via di Portonaccio**, Via Prenestina, Via Labicana, Piazza del Colosseo, Via del Circo Massimo, Ponte Garibaldi, Viale di Trastevere, Via Garibaldi, **Via Aurelia Antica/Via Leone XIII** — 18:48 Ende der Fahrt / *End of journey.*

NORITOSHI HIRAKAWA

Noritoshi Hirakawa
The Blues on the Bimmer, Long Island, New York 1998
3-teilig, 2× 76,2 × 76,2 cm, 1× 76,2 × 152,4 cm
Cibachrome Prints und Computer-Ausdrucke
Inv.-Nr. F 2005-9

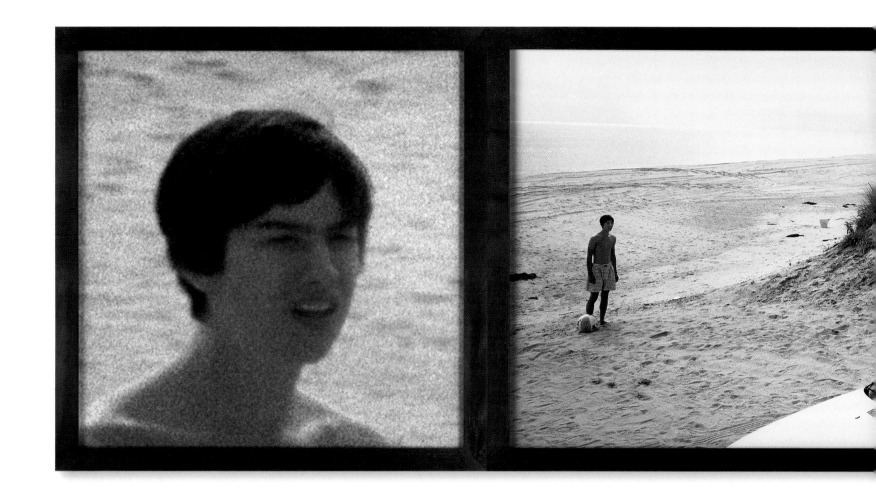

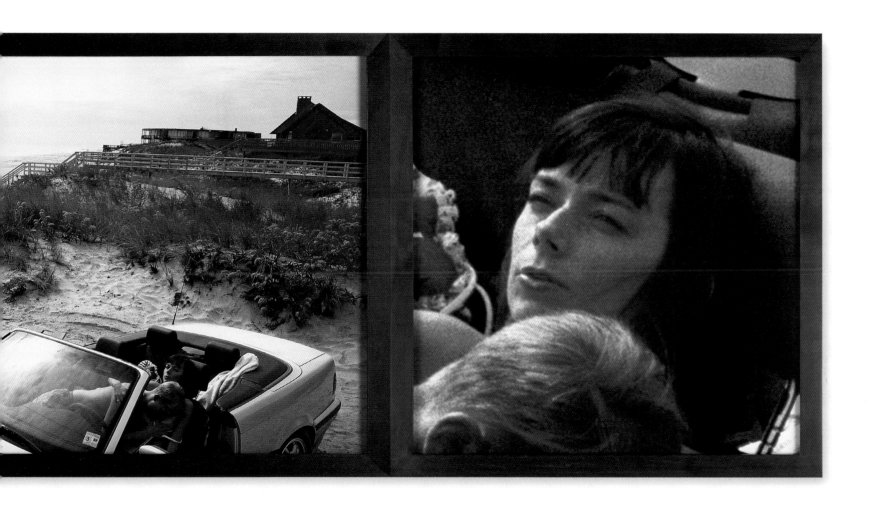

Noritoshi Hirakawa
The Blues on the Bimmer, Phra Nakhon, Bangkok 1998
3-teilig, 2× 76,2 × 76,2 cm, 1× 76,2 × 152,4 cm
Cibachrome Prints und Computer-Ausdrucke
Inv.-Nr. F 2005-10

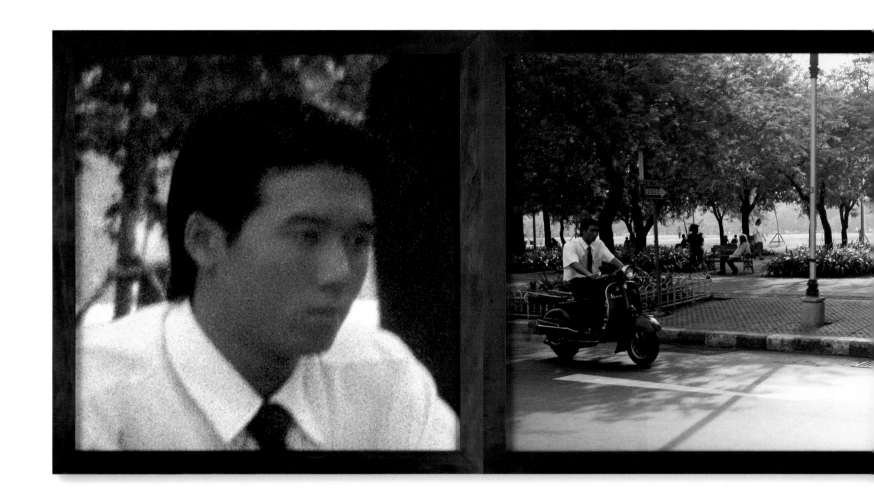

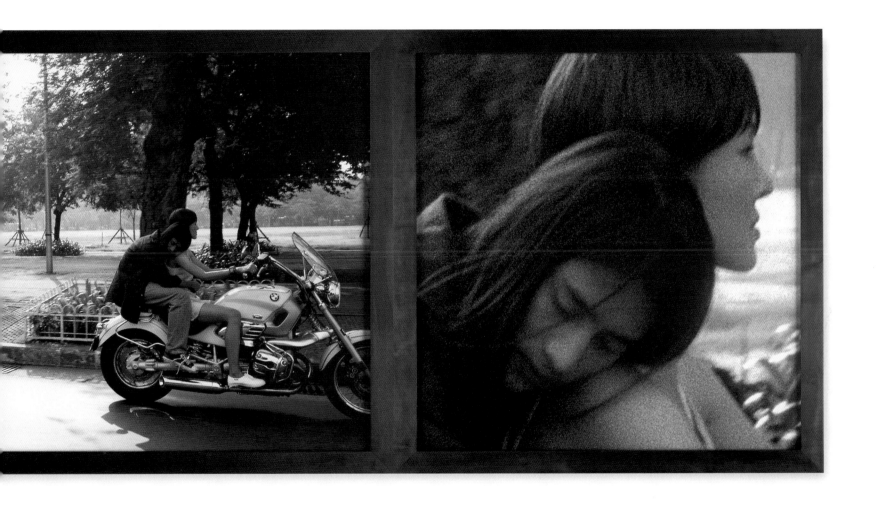

Noritoshi Hirakawa
The Blues on the Bimmer, Berlin-Mitte 1998
3-teilig, 2× 76,2 × 76,2 cm, 1× 76,2 × 152,4 cm
Cibachrome Prints und Computer-Ausdrucke
Inv.-Nr. F 2005-11

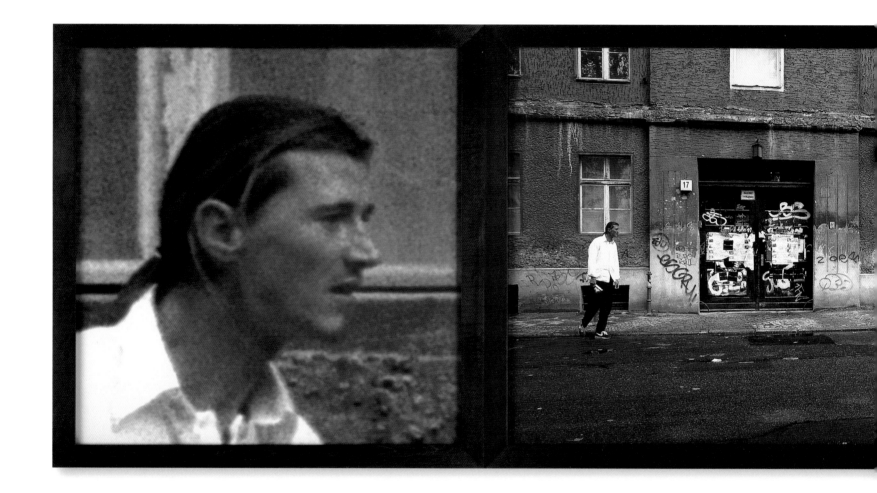

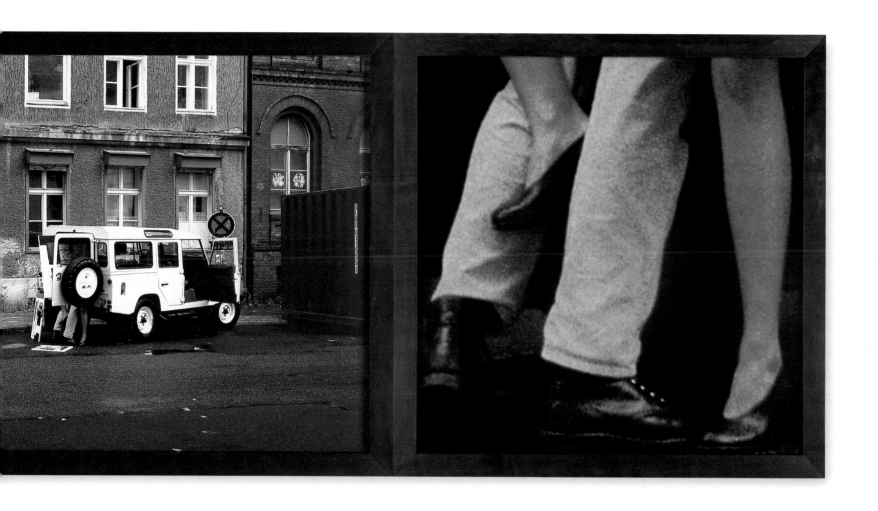

CANDIDA HÖFER

Candida Höfer
BMW München 2000
59,3 × 59,5 cm
C-Print
Inv.-Nr. F 2005-12

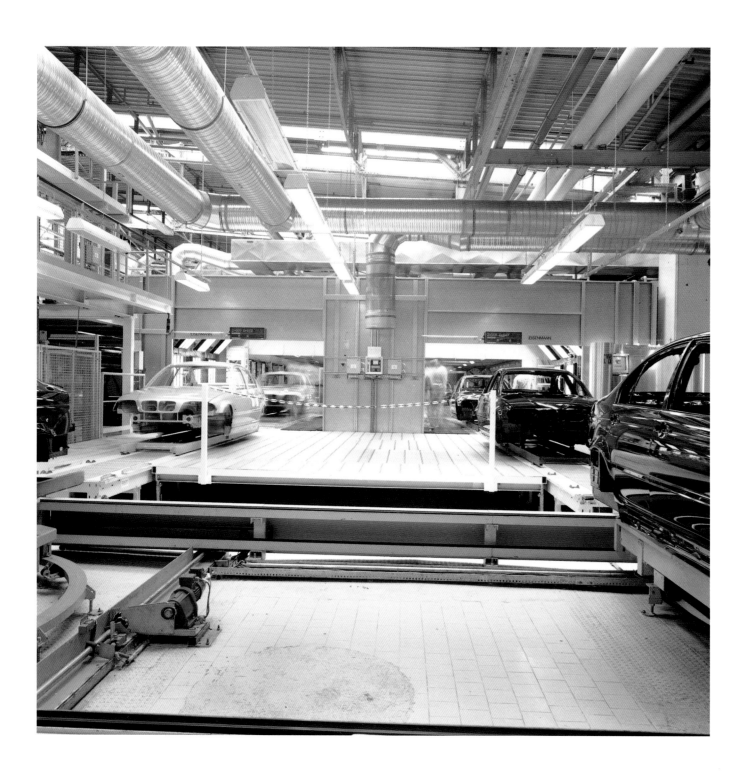

Candida Höfer
BMW München 2000
59,7 × 59,7 cm
C-Print
Inv.-Nr. F 2005-13

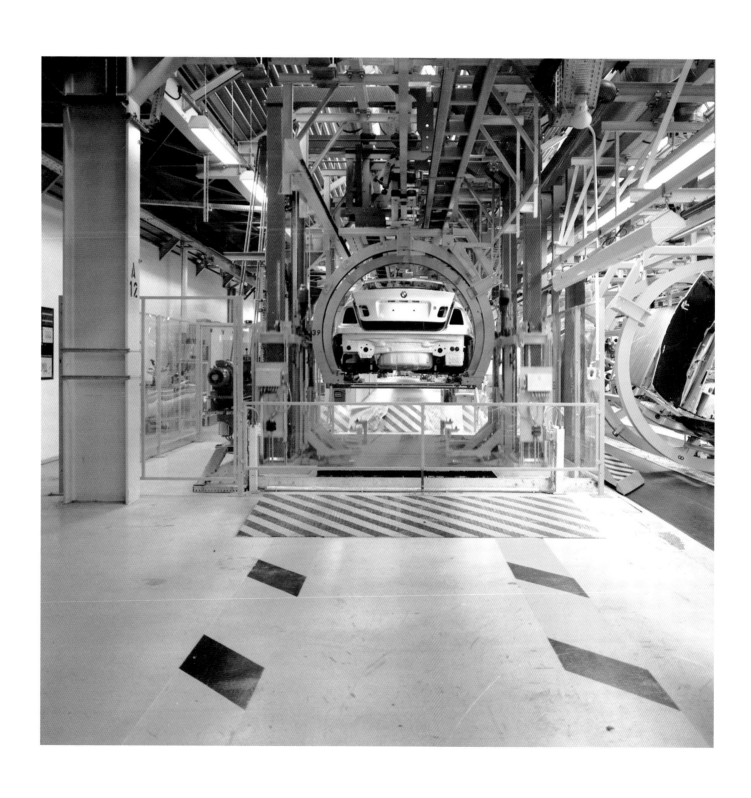

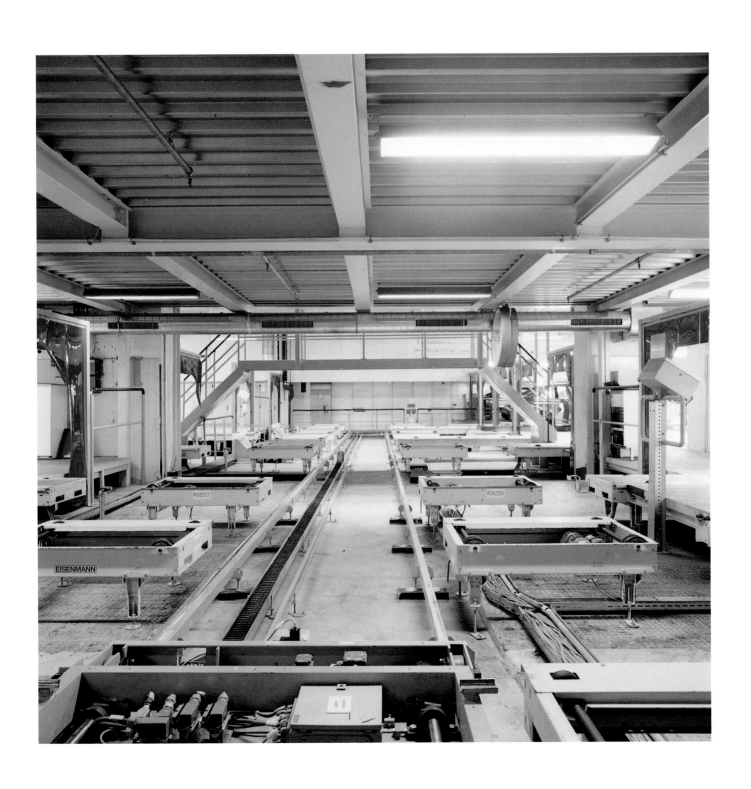

Candida Höfer
BMW München 2000
59,3 × 63,9 cm
C-Print
Inv.-Nr. F 2005-15

Candida Höfer
BMW München 2000
59,2 × 59,5 cm
C-Print
Inv.-Nr. F 2005-16

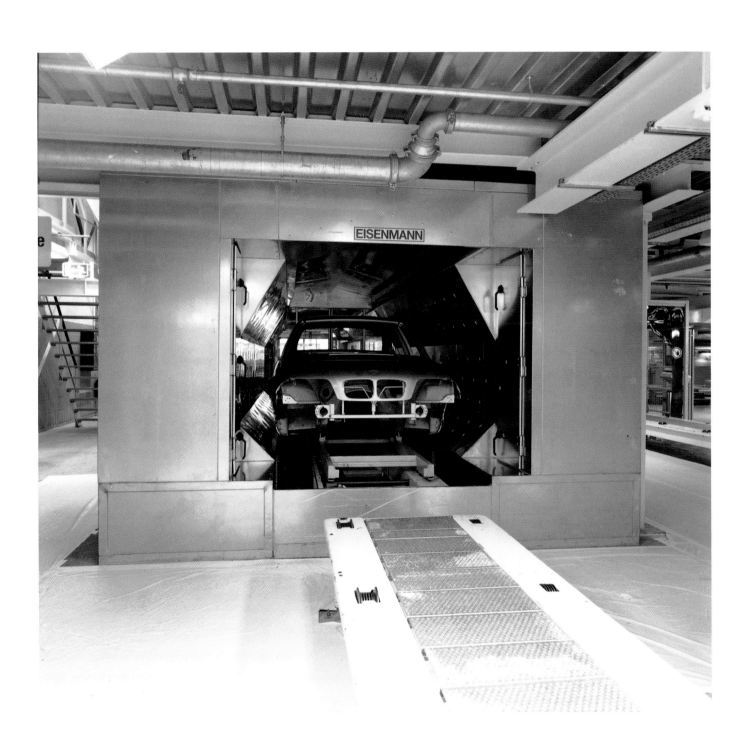

Candida Höfer
BMW München 2000
59,7 × 59,7 cm
C-Print
Inv.-Nr. F 2005-17

Candida Höfer
BMW München 2000
59,7 × 59,7 cm
C-Print
Inv.-Nr. F 2005-18

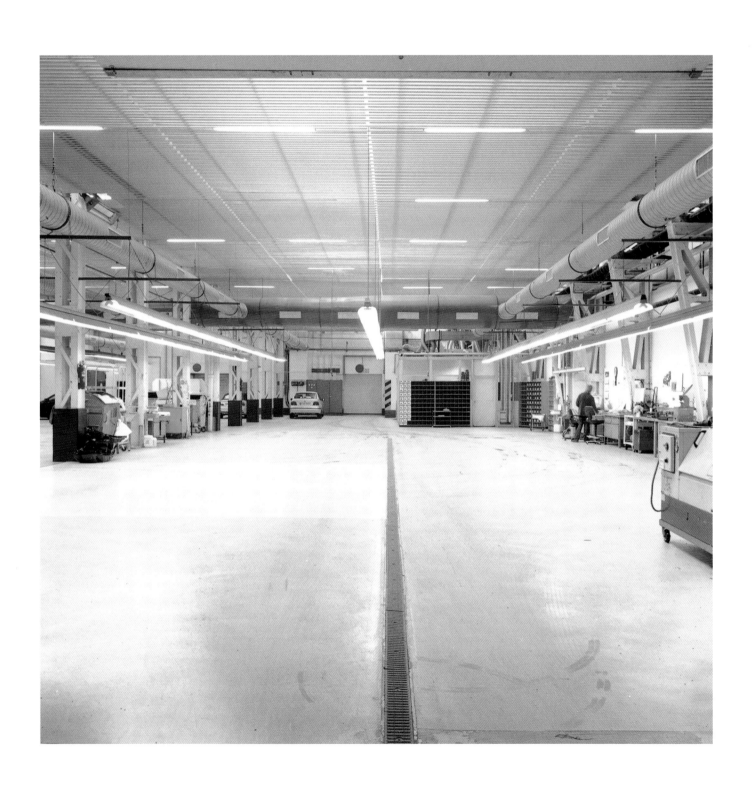

TOM HUNTER

Tom Hunter
Rose Water, Goa 1999
91,9 × 73,6 cm
C-Print
Inv.-Nr. F 2005-19

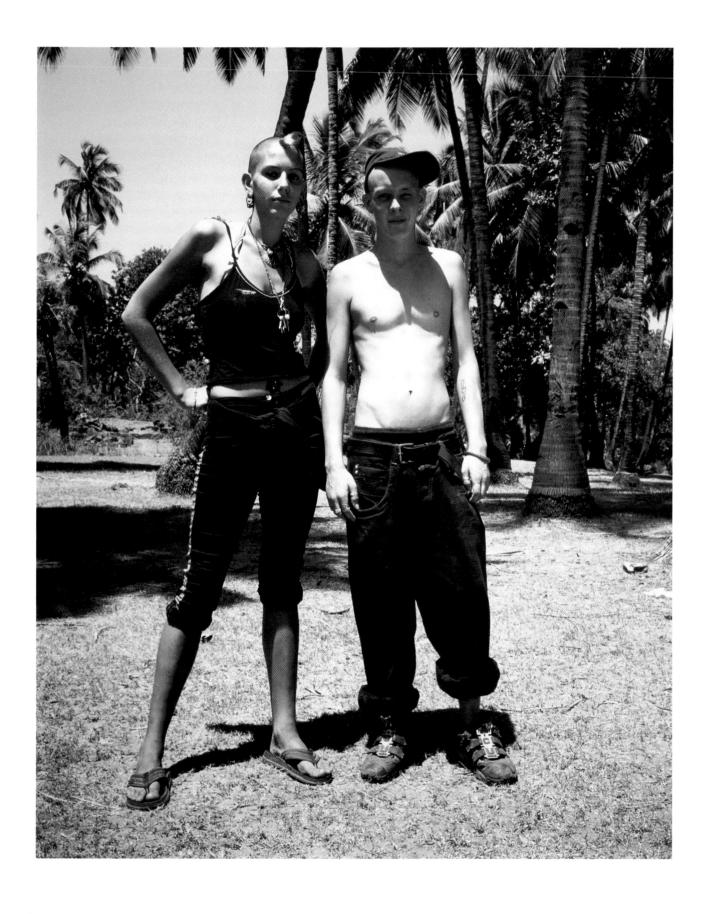

Tom Hunter
Ontik, Hackney 1999
72,1 × 93,1 cm
C-Print
Inv.-Nr. F 2005-20

Tom Hunter
Ohne Titel 1999
74,7 × 91,4 cm
C-Print
Inv.-Nr. F 2005-21

Tom Hunter
Ohne Titel 1999
73,1 × 92,6 cm
C-Print
Inv.-Nr. F 2005-22

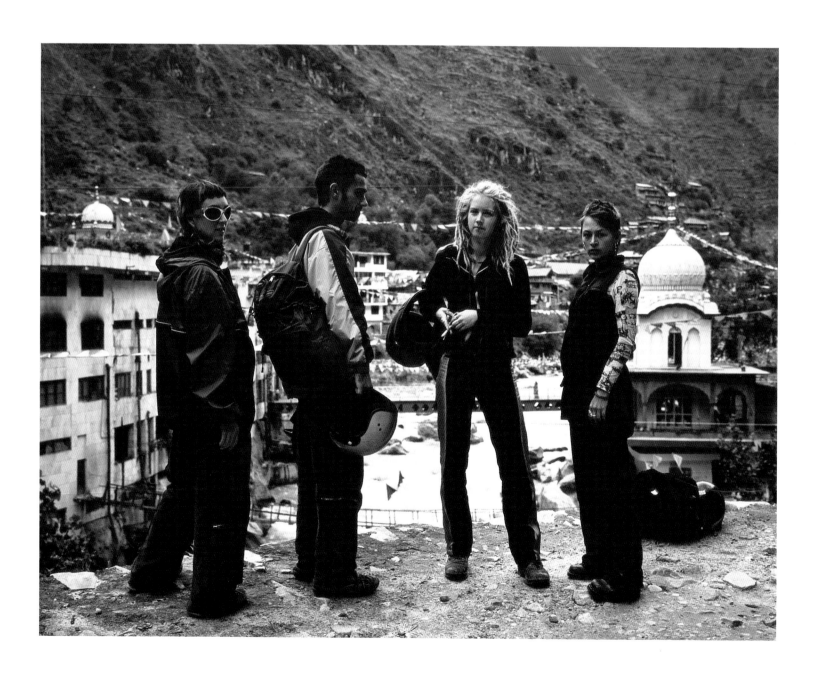

SARAH JONES

Sarah Jones
The Staircase (Charlton) I 1999
150,2 × 150,2 cm
C-Print
Inv.-Nr. F 2005-23

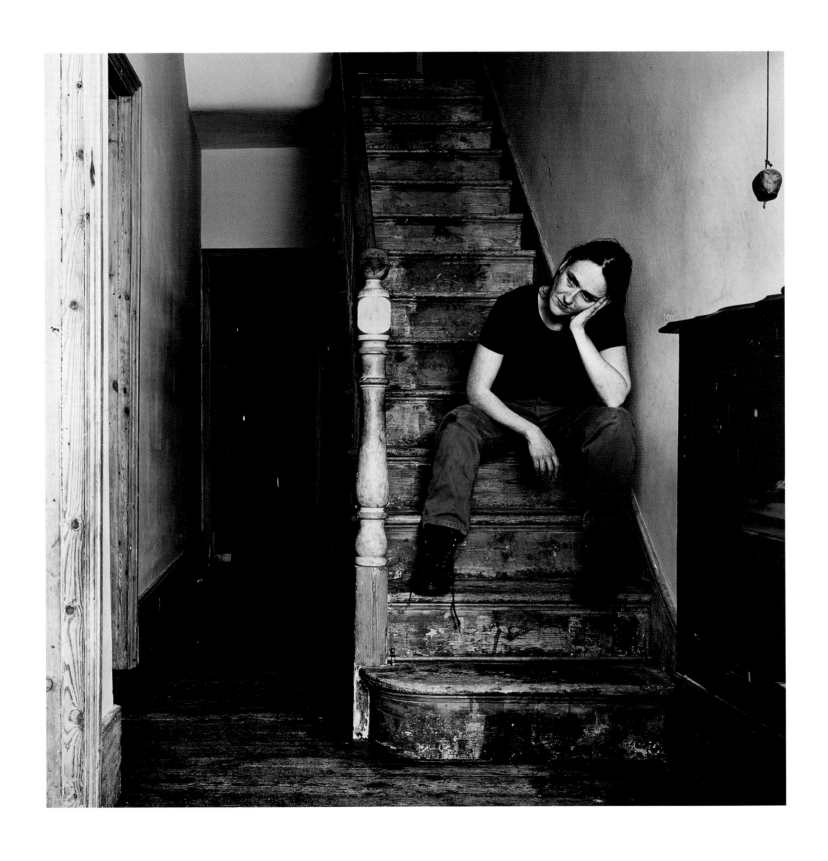

Sarah Jones
The Apple Tree (Charlton) II 1999
150,1 × 150,3 cm
C-Print
Inv.-Nr. F 2005-24

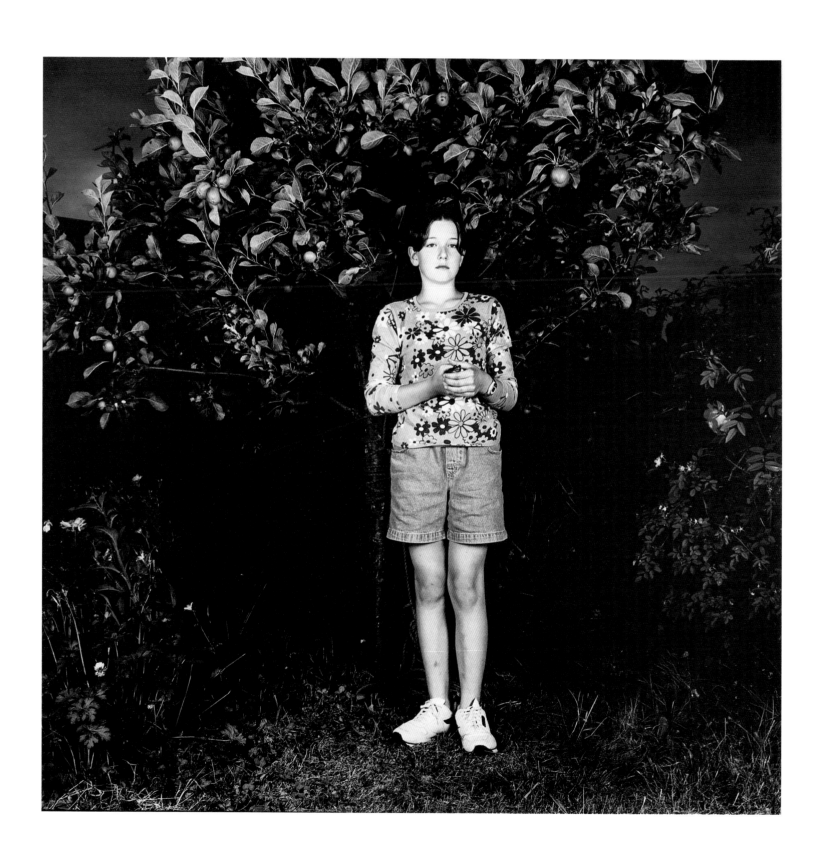

Sarah Jones
The Wall (Charlton) III 1999
150,1 × 150,3 cm
C-Print
Inv.-Nr. F 2005-25

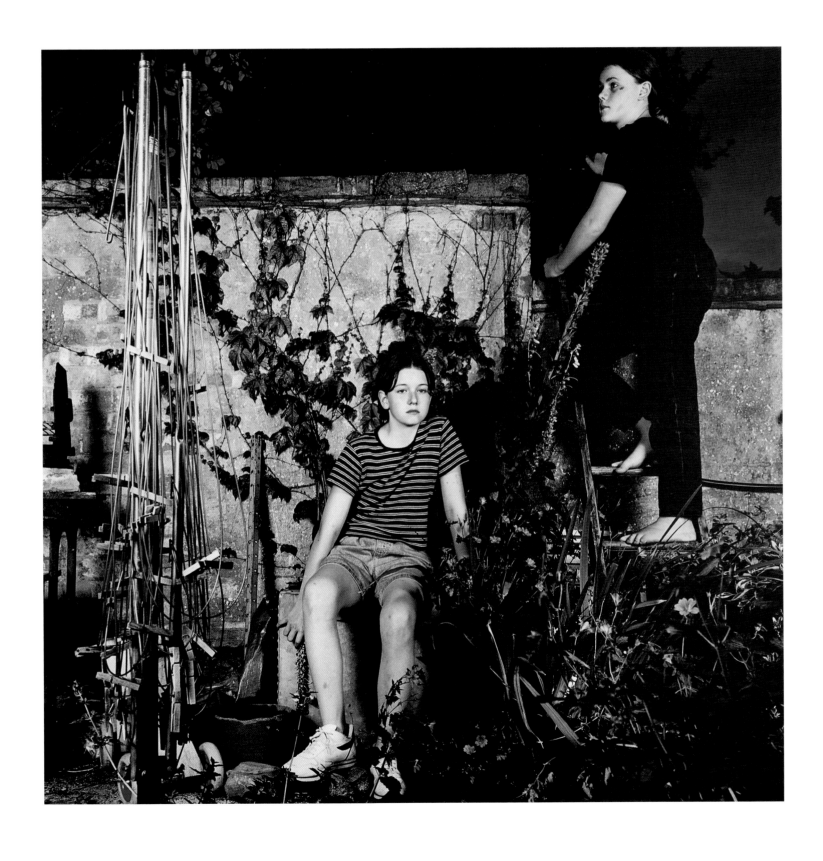

Sarah Jones
Back Garden (Charlton) IV 1999
150,2 × 150,3 cm
C-Print
Inv.-Nr. F 2005-26

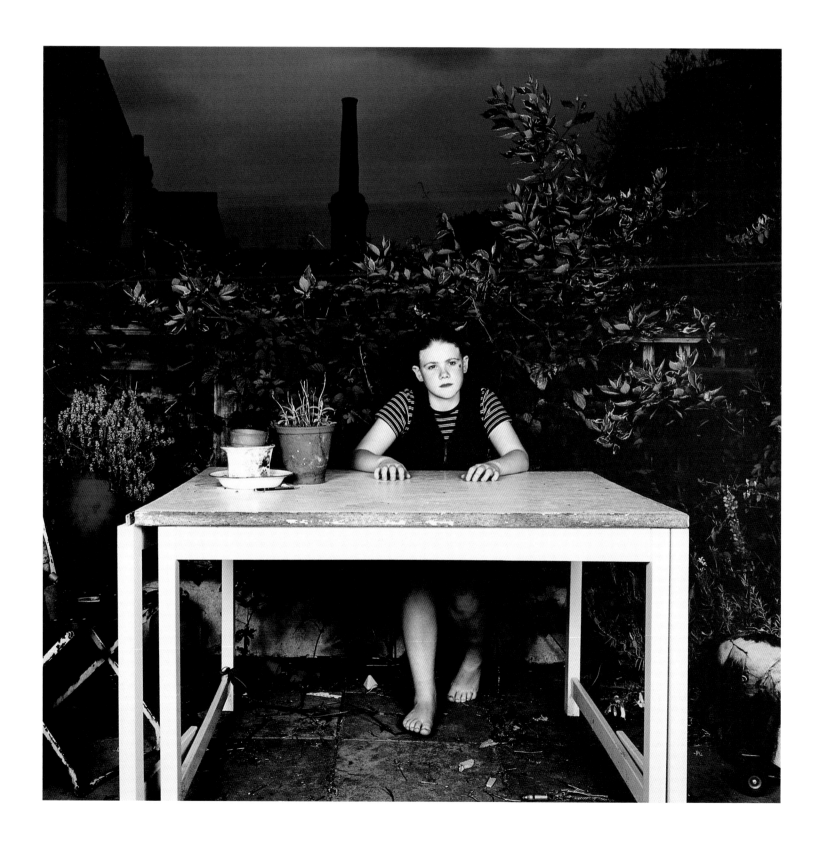

INEZ VAN LAMSWEERDE &
VINOODH MATADIN

Inez van Lamsweerde & Vinoodh Matadin
Speedscape 1 1998
125 × 280 cm
Digitaler Cibachrome Print
Inv.-Nr. F 2005-27

Inez van Lamsweerde & Vinoodh Matadin
Speedscape 2 1998
125 × 280 cm
Digitaler Cibachrome Print
Inv.-Nr. F 2005-28

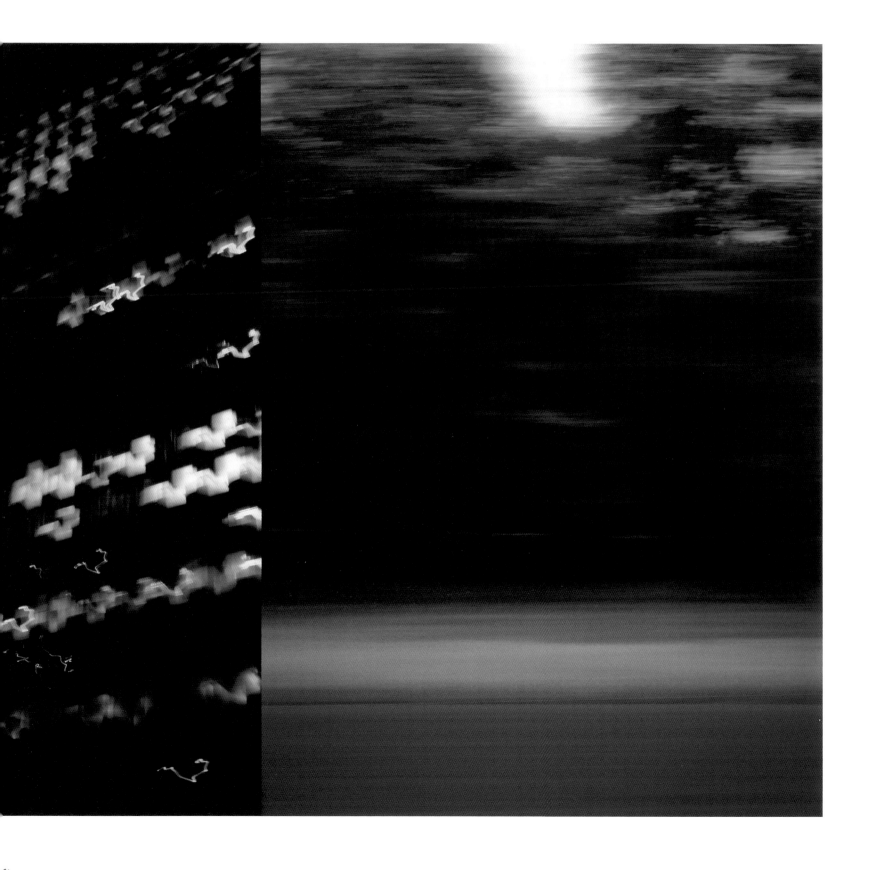

Inez van Lamsweerde & Vinoodh Matadin
Speedscape 3 1998
125 × 280 cm
Digitaler Cibachrome Print
Inv.-Nr. F 2005-29

GLENN LIGON

Glenn Ligon
South Carolina's Own 1 1998
20-teilig, 16× 20,3 × 25,4 cm, 4× 12,7 × 17,8 cm
Cibachrome Prints und Texttafeln
Inv.-Nr. F 2005-31

Text, Clockwise from Bottom, left:

The products need to reflect the consumer
base—in the ads as well as everything else.

An engineer can design all he wants for the plant
but if that guy on the line doesn't like a piece of
equipment or it doesn't work for him, he'll push
that piece of equipment aside and start doing it
manually. I've seen it happen so many times. So our
engineers have learned that they need to make that
person on the line an integral part of the design of
anything they do.

I've had people actually stop me—particularly other
woman—an say "Wow! Go ahead girl," and stuff like
that. I'm not sure what the BMW mystique is, but
the car is definitely a head turner.

I guess there is a sense of responsibility here.
None of us have "made it," but we are in a position
where we can give back. I say that 90% of us try to
do that. Not all of us but most of us try to do that.

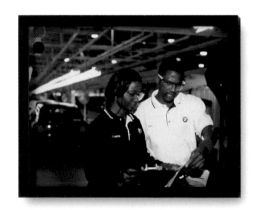
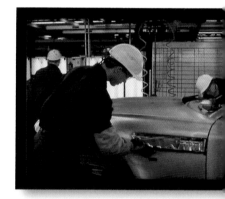
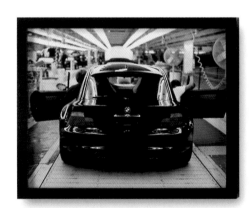
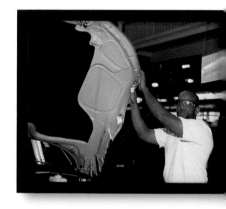

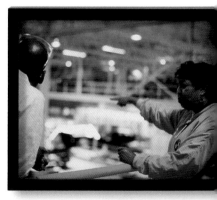

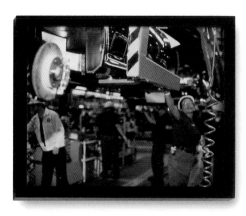
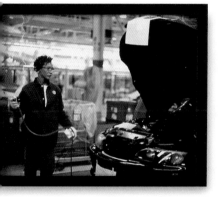

Text, von unten links im Uhrzeigersinn:

Die Produkte müssen die Wünsche der Käufer spiegeln, in der Werbung wie in allem anderen.

Ein Ingenieur mag noch so innovative Ideen für sein Produkt haben, wenn der Kunde an der Kasse irgendein Ausstattungsdetail nicht mag oder es für ihn keinen Nutzen hat, so wie er es sich wünscht, legt er es zur Seite – oder versucht, selbst Hand anzulegen. Ich habe das so oft beobachtet. Auf diese Weise haben unsere Ingenieure lernen müssen, dass sie diese Kundenerwartung in jeder Phase der Planung und Produktentwicklung berücksichtigen.

Mir sind wirklich Leute begegnet, vornehmlich andere Frauen, die mich angehalten haben, nur um mir zu sagen: »Wow, Mädchen, mach weiter so!« und ähnliches mehr. Ich bin bis heute nicht sicher, worin dieses Geheimnis von BMW wirklich liegt, aber dieses Auto ist ohne Zweifel etwas Besonderes, ein Auto, dem man nachschaut.

Ich denke, dass uns daraus auch eine große Verantwortung zuwächst. Niemand von uns hat dieses Image wirklich »gemacht«, aber es ist unsere Aufgabe, etwas davon zu bewahren und zurückzugeben. Ich behaupte, dass das 90 % von uns auch versuchen, nicht alle, aber die meisten von uns versuchen das zu tun.

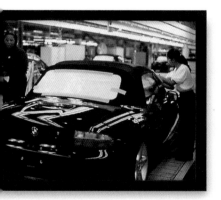
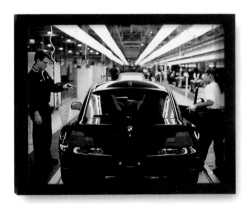

I've had people actually stop me—particularly other woman—and say "Wow! Go ahead girl," "Go girl," and stuff like that. I'm not sure what the BMW mystique is but the car is definitely a head turner.

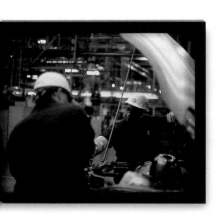
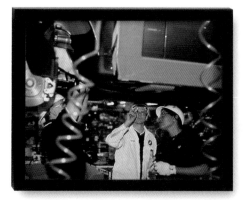

I guess there is a sense of responsibility here. None of us have "made it," but we are in a position where we can give back. I say that 90% of us try to do that. Not all of us but most of us try to do that.

Glenn Ligon
South Carolina's Own 2 1998
20-teilig, 16× 20,3 × 25,4 cm, 4× 12,7 × 17,8 cm
Cibachrome Prints und Texttafeln
Inv.-Nr. F 2005-31

Text, Clockwise from Bottom, left:

When we started up this plant, a lot of folks were knocking on our doors, and we had a variety of people bringing in their knowledge and experience with suppliers from all over the place, so we didn't always have the opportunity to say "Let's go through a selection process." We just called "Joe Blow" gets in here and people are satisfied with his products and services so we build up a relationship with him. Now you're going to start up a program for female and minority owned companies but it's hard to break up those already established relationships and hire someone who wasn't here from the git-go. It's a hurdle that you must get over.

We are among the best paid employees in the area, so, for me, my tolerance for people who are dis-satisfied with what they are doing ... I ain't trying to hear it. Your have to choose. You can cry about how things are going, you can take apart in changing them, or you can sit back and accept how things are and be happy that you are getting paid extremely well to make one of the most desirable cars-toys-in America.

In terms of diversity, we are where we are now be-cause of a movement from the grass-roots, not from the top down. It came from the bottom up.

A vice-president said, "There is no good ole boy network here." And because he was German, he didn't realize the full implications of what he was saying.

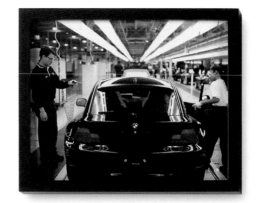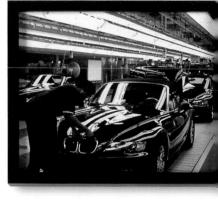

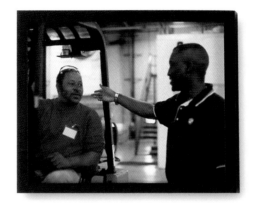

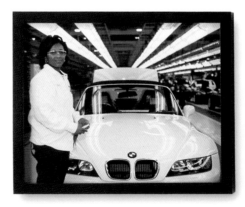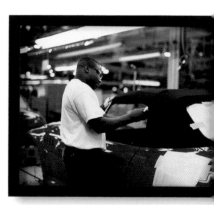

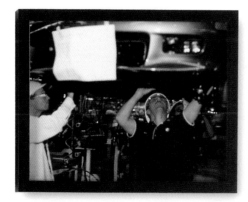
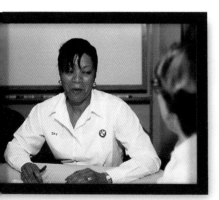
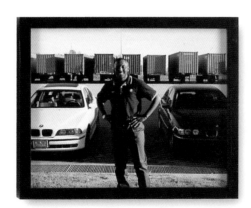
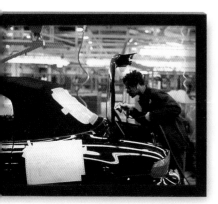
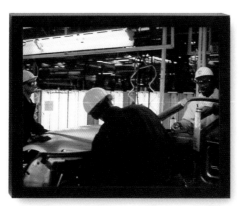

Text, von unten links im Uhrzeigersinn:

Als wir mit dem Aufbau dieses Werks begannen, klopfte eine Menge Leute an unsere Türen und die verschiedensten Menschen brachten ihre jeweiligen Kenntnisse und Erfahrungen mit Zuliefererfirmen aus allen Himmelsrichtungen ein, sodass wir keineswegs immer in der glücklichen Lage waren zu sagen: »Lasst uns das jetzt in einem planmäßigen Auswahlprozess optimal gestalten«. Es hieß meist nur »Herr Müller« ist jetzt mit an Bord, und wenn die Leute mit seinen Produkten und Leistungen zufrieden waren, schlossen wir einen Vertrag mit ihm. Inzwischen sind wir dabei, andere Programme zu starten, wie etwa die Kooperation mit weiblich oder minoritär geführten Unternehmen. Aber es ist sehr schwer, einmal gewachsene Strukturen aufzubrechen oder jemandem die Zusammenarbeit aufzukündigen, auch wenn er nicht von Anfang an mit dabei war. Diese Hürde ist noch nicht überwunden.

Wir gehören zu den bestbezahlten Beschäftigten unserer Region, und offen gestanden mag ich für meinen Teil das Gejammere von Leuten, die unzufrieden sind mit dem was sie tun, manchmal nicht mehr hören. Schließlich ist es jedem freigestellt, nur darüber zu jammern wie die Dinge laufen oder sie anzupacken und zu ändern oder sich einfach zurückzulehnen und sich darüber zu freuen, für die Herstellung eines der meistbewunderten Autos Amerikas überdurchschnittlich gut bezahlt zu werden.

Um das Entscheidende zu unterstreichen: Wir sind das geworden, was wir jetzt sind, weil wir von wirklich unten gewachsen sind und nicht von oben installiert wurden. Das Wachstum entwickelte sich von Grund auf.

Ein Vizepräsident bemerkte einmal: »Hier fehlt irgendwie völlig das übliche ›Altherren‹-Netzwerk ...« Da es ein deutscher Vizepräsident war, ahnte er vermutlich nicht einmal die ganze Tragweite und Implikationen seiner Worte.

In terms of diversity, we are where we are now because of a movement from the grassroots, not from the top down. It came from the bottom up.

A Vice-President said, "There is no good ole boy network here." And because he was German, he didn't realize the full implications of what he was saying.

Glenn Ligon
South Carolina's Own 3 1998
20-teilig, 16× 20,3 × 25,4 cm,4× 12,7 × 17,8 cm
Cibachrome Prints und Texttafeln
Inv.-Nr. F 2005-32

Text, Clockwise from Bottom, left:

When I got my BMW and started driving I was
getting all types of comments. Everybody
was saying "God, girl, you're really on. You've got
a —what's the new word—a 'Beamer'." A lot of
people say that it fits me, with my style and stuff,
when I am dressed with my jewelry-cruising
and whatnot. My husband said it was the best
move I made on my own without asking him.
He didn't realize I know to shop.

At first I was mad because I thought folks wasn't
speaking up about what was going on here at the
plant. Over time I realized that they didn't have
any power, and it was more important to be here
when the changes came.

It's something your grandmother told you, you
know, your momma told you: you've got to be twice
as prepared. It's what you had to do to survive.
And it's not a regional thing, it's just common
sense. In whatever vernacular of whatever tone she
said it in it meant the same thing: you need to be
ready, you need to be prepared.

My association with a luxury car like the Cadillac
is that it is the family car in a funeral. It's the car
you ride to the cemetery in. The BMW has a totally
different image.

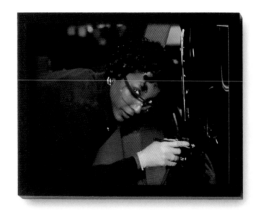
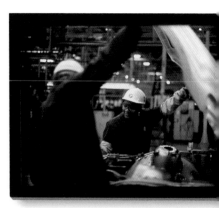
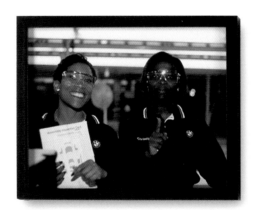
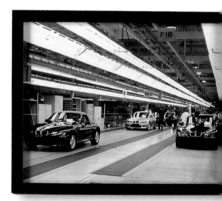
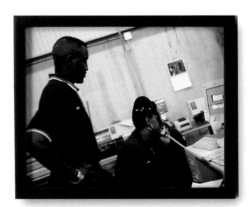
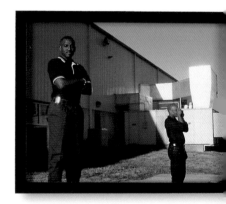

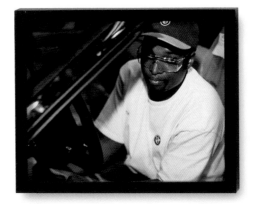

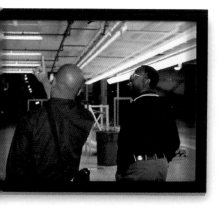
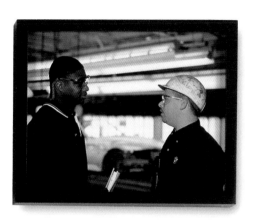

Text, von unten links im Uhrzeigersinn:

Als ich selbst in meinen ersten BMW stieg, gab es die verschiedensten Kommentare und Reaktionen. Die meisten meinten: »Mein Gott, Kind, jetzt hast du es geschafft, du fährst, wie man heute zu sagen pflegt, einen Beamer.« Viele meinten, dass dieser Wagen wirklich zu mir passt, zu meinem Stil, zu meiner Kleidung, ja sogar zu meinem Schmuck etc. Mein Ehemann meinte, es sei die wohl beste Entscheidung die ich jemals ohne ihn gefällt hätte. Er hatte wohl vergessen, dass ich vom Kaufen schon immer sehr viel verstanden habe.

Am Anfang machte es mich zwar ganz krank, dass die Leute kein Wort darüber zu verlieren schienen, welcher Aufbau da eigentlich in unserem Werk vor sich ging. Mit der Zeit aber nahm ich auch das hin und sagte mir, dass es schließlich darauf an-kommt, bei diesen Veränderungen dabei gewesen zu sein.

Es geht mir da ein wenig so, wie wenn die Groß-mutter dir erzählt, also die Oma mit ihrer Lebens-erfahrung dir ins Ohr flüstert: »Du musst einfach doppelt so gut wie die anderen sein – allein davon wird dein Überleben abhängen.« Es ist zwar ein Allgemeinplatz. Aber in welchem Dialekt oder Tonfall auch immer die Großmütter uns das mit-geben, es bedeutet immer dasselbe: Sei bereit, sei vorbereitet!

Meine persönliche Assoziation mit einem Luxusauto wie dem Cadillac war immer die einer großartigen Familienkutsche bei einer Beerdigung: Mit keinem anderen Auto fährt man so stilvoll in den Friedhof ein. Ein extrem anderes Image hat BMW.

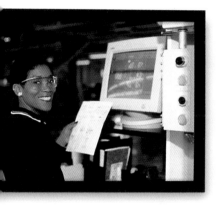
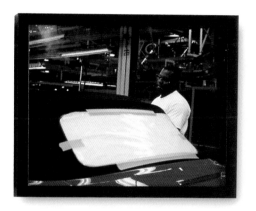

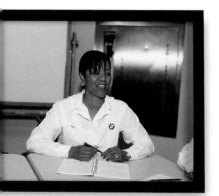
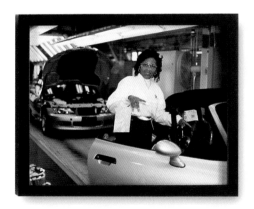

It's something your grandmother told you, you know, your momma told you: you got to be twice as prepared. It's what you had to do to survive. And it's not a regional thing, it's just common sense. In whatever vernacular or whatever tone she said it in it meant the same thing; you need to be ready, you need to be prepared.

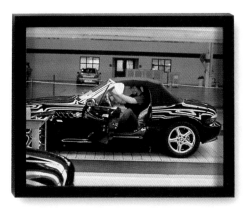

My association with a luxury car like the Cadillac is that it is the family car in a funeral. It's the car you ride to the cemetery in. The BMW has a totally different image.

SHARON LOCKHART

Sharon Lockhart
Kathy Edwards and Candi Coker /
BMW AG / Werk Spartanburg, USA 1998
60 × 76 cm
Silbergelantine Print
Inv.-Nr. F 2005-33

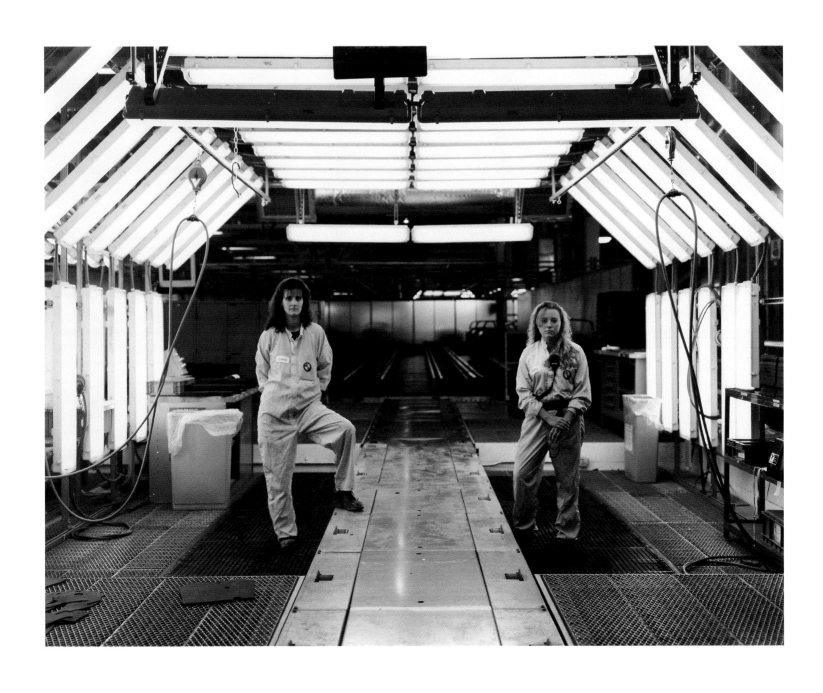

Sharon Lockhart
**Halime Gueler and Elke Gnewkow /
BMW AG / Werk Berlin** 1998
60 × 76 cm
Silbergelantine Print
Inv.-Nr. F 2005-34

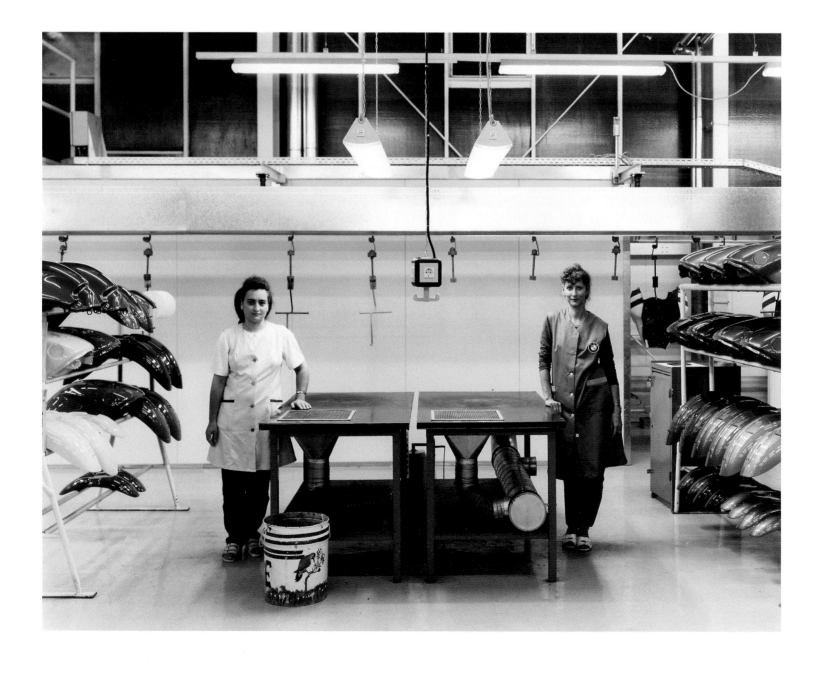

Sharon Lockhart
Lazaro Santos and Jorge Garcia Escobar /
BMW AG / Werk Toluca, Mexiko 1998
60 × 76 cm
Silbergelantine Print
Inv.-Nr. F 2005-35

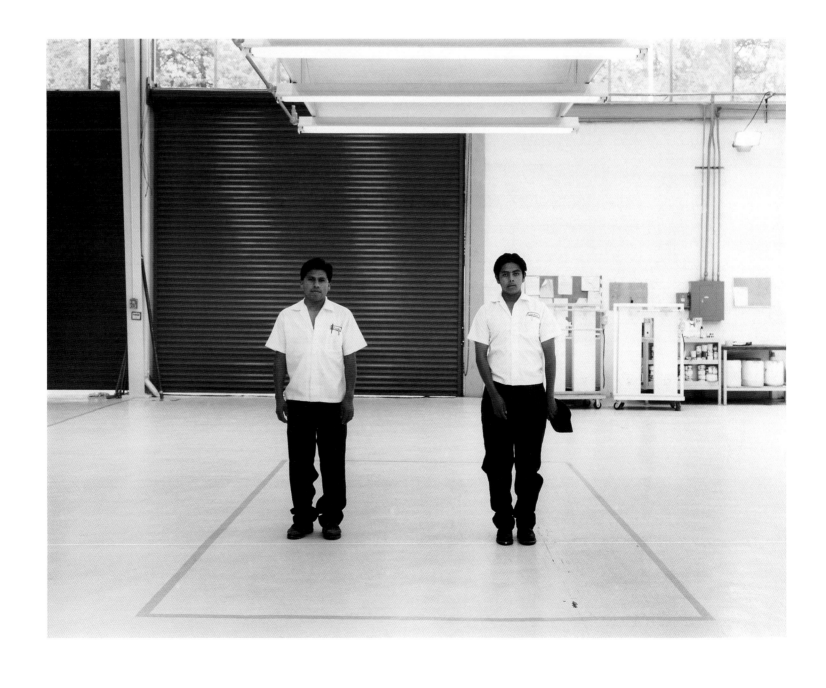

BORIS MICHAILOV

Boris Michailov
BMW (My Old Story) – The Line In My Brand 2000
22-teilig, insgesamt: 24,7 × 731,1 cm
s/w Prints mit Text
Inv.-Nr. F 2005-36

BMW
Eine Folge von Prioritäten

Das ist eine Geschichte über ein altes BMW Motorrad und zugleich eine sehr private Geschichte
aus dem Leben von B(oris) M(ichailov) W(ita),
überliefert durch Fotografien und Erinnerungen
an Vergangenes, an einstige Prioritäten und eine
brennende Liebe zu einer alten BMW Maschine,
durch die sich alle Wertvorstellungen wandelten.

Das ist unsere Garage.
Hier spielten sich von Liebe bis Mord viele unterschiedliche Dinge ab …
Früher, vor langer Zeit, stand hier das alte
BMW Motorrad.
Als W. in mein Leben trat, wurde auch ich zu
BWM – Boris Michailov Wita.
Und so kann auch ich mich, wie ein altes Motorrad,
an verschiedene Geschichten erinnern …

Die Kindheit hatte
ihre eigenen Wege,
ihre eigenen Orte,
ihre eigenen Prioritäten.

Heute scheint es mir, als ob sich der Großteil
unseres Lebens in diesem Hof, zwischen
Schuppen und Garage abspielte.

Jedermann fühlte sich angesichts des »Heldenhaften« und »Unheldenhaften« eingeschüchtert.
Unsere großen Helden mussten starke Muskeln
haben und schwere Hanteln stemmen können.

Nachdem ich unter einen Karren geraten bzw. von
diesem überfahren worden war, schämte ich mich,
jemandem davon zu erzählen.

Ein andermal, als ich erfolgreich den Rädern des
gewaltigen Lasters entkam, fühlte ich mich fast
wie ein Held.

Als ich mich zu erinnern begann, überlappte sich
Wirkliches mit Unwirklichem, gerieten Vergangenheit und Gegenwart durcheinander.

Der Satz: »Wenn ich in einen BMW steige,
wird der Wagen zur Verlängerung meiner Hände
und meines Fußes«, nahm in unserem Hof
eine eigene Bedeutung an.

Durch meine Begegnung mit W. wurde mir die
Wirkung des Visionären von BMW für mein Leben
völlig offenbar.

Erinnerungen, die sich mit der Garage verbanden,
wurden fast zwangsläufig wachgerufen.

An Reichtum klebt immer irgendwie Blut … So
wurde diese Garage ungerechtfertigt meinem Vater
überlassen, nachdem der letzte Besitzer des
alten BMW Motorrads den Sohn seiner Frau getötet
hatte und kurz darauf starb.

Später wurde der Ort zum Liebesnest und
manchmal am Abend wurde eine Frau dorthin
mitgenommen und irgendwelche Jungs, die
nicht mehr warten konnten, wurden dort zum Mann.

Da war auch ein Kellergeschoss … ein gleichaltriger
Motorradfahrer, der uns sein Können zeigen wollte
und das Motorrad ohne Erlaubnis nahm, fuhr in
dieses Kellergeschoss. Später verprügelten ihn
seine Kameraden dafür.

Und dann die Tramperin …, die zu einer Fahrt auf
dem Motorrad mitgenommen wurde, deren Kleid
zerrissen wurde und die halbnackt nach Hause
zurückkehren musste.

Und schließlich, das Wichtigste ist wahrscheinlich
das Thema Liebe oder (zumindest) Verlangen …
Zwei Männer tauchten unvermittelt in unserem Hof
auf. Sie waren Tag und Nacht beschäftigt …
Sie waren dauernd schmutzig und ölverschmiert …
Sie schienen nichts von dem wahrzunehmen, was
für uns in jener Zeit wichtig war. Sie nahmen keinen
zur Kenntnis, sie sahen überhaupt nichts. Es ging
dabei nicht um Geld. Sie konzentrierten sich auf
Details und machten etwas mit ihren Händen.
Ganze Tage verbrachten sie in der Garage. Andere
Tage wiederum widmeten sie ihren Motorrädern.
Das war ein neues Verlangen, das ich bisher nicht
kannte. Es war eine Liebe, die nicht von jedermann
verstanden wurde. Ihre Lady war eine alte BMW
Maschine.

Plötzlich hob der jüngste von ihnen die Hantel,
die selbst für den Stärksten von uns zu schwer war,
und er machte dies so mühelos … und wiederum
nahmen die Brüder niemanden wahr und waren in
der Garage beschäftigt …

Ich spürte zum ersten Mal, dass diese Muskeln für
etwas Wichtigeres als für eine imaginäre Vorstellung
da waren. Und dieser Kontakt mit dem schmutzigen
Metall der alten BMW Maschine weckte in mir
ein Verlangen, das ich bisher nicht gekannt hatte.

Das Wichtigste passierte erst vor kurzem:
Ein Bekannter von mir wusste etwas von einer alten
BMW Maschine in irgendeinem Dorf und wollte
sie kaufen. Plötzlich sah er dieses Motorrad die
Hauptstraße herunterkommen und durch ein überwachsenes Feld fahren. Er versuchte, ihm mit
seinem modernen »Jawa« zu folgen, schlitterte
jedoch dort, wo die alte BMW Maschine leicht
hinkam. Vielleicht sah er die entschwindende BMW
Maschine nur einen kurzen Augenblick wie in
einem flüchtigen Traum.

Boris Michailov
Charkow

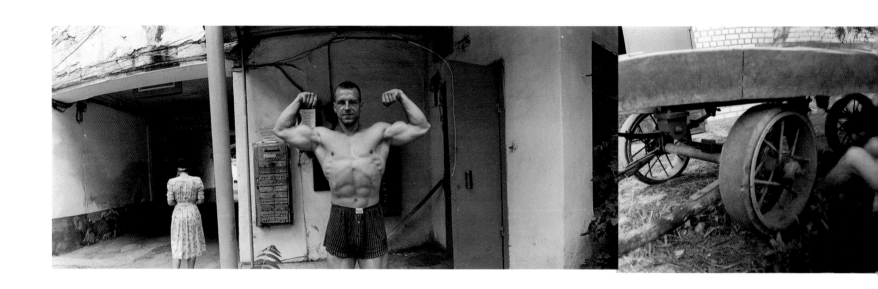

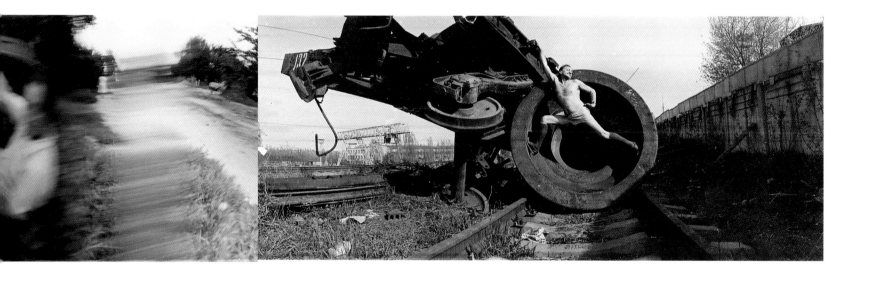

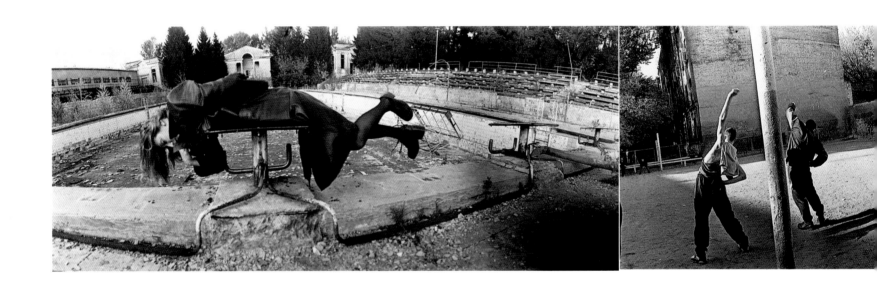

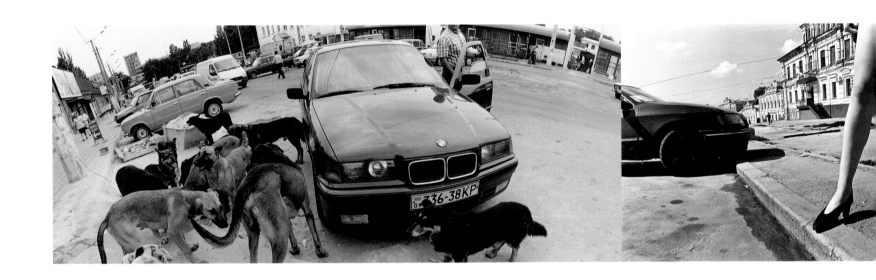

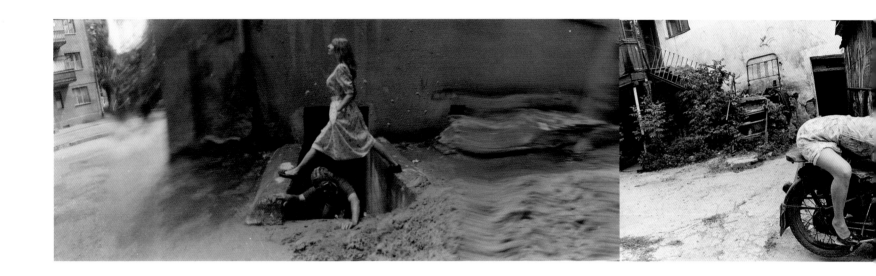

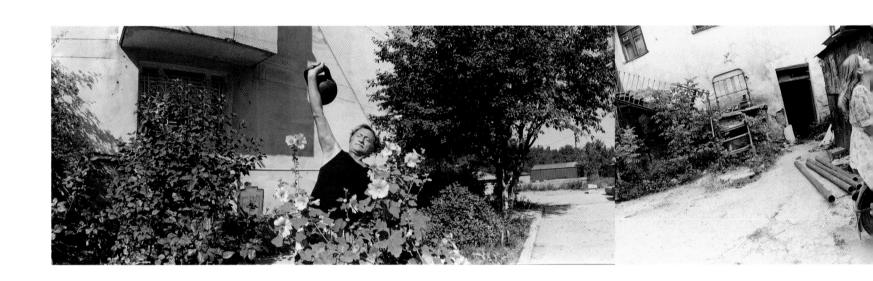

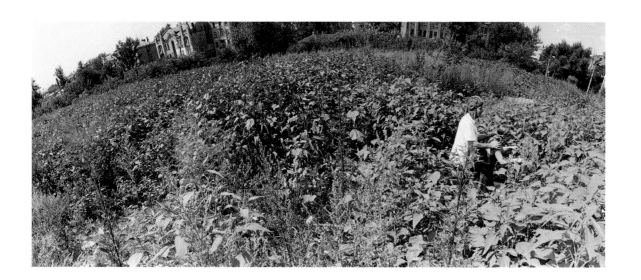

BMW
A Parade of Priorities

This is the story both of an old BMW motorbike and of the private life of B(oris) M(ichailov) W(ita), transfigured by photography, by his remembrance of the past and its priorities, and by his all-transcending love for that old bike, which led to a reevaluation of values.

This is our garage.
Lots of things happened near it, from love to murder …
A long time ago the old BMW bike used to stand here.
When W entered my life, I turned into a BMW myself.
And now, like an old motorbike, I recall the various stories …

Childhood had
its own ways,
its own places,
its own priorities.

It seems today that the best part of our life took place in that courtyard among the sheds and garages.

Everyone stood in the shadow of the "Hero" and the "Anti-Hero". Our prime heroes had to have big muscles and lift heavy dumbbells.

And when I got under a cart, or rather got run down by one, I was too ashamed to tell anyone.

Another time, escaping from the wheels of a big truck, I was proud of myself and felt like a real "Hero".

Whenever I start to remember, reality and fiction, past and presence intermingle.

The sentence "When I get into a BMW the vehicle becomes an extension of my hands and feet" starts to take on special meaning in the context of that courtyard.

When I met W the influence of the BMW phantom in my life stood revealed in all clarity.

Memories connected with the garage came back automatically.

Life's "riches" are always mixed with blood …
The garage was given unrightfully to my father.
Later, the last owner of the old BMW bike killed his wife's son, and died shortly afterwards.

Later, there was a dovecote, and in the evening sometimes a woman was brought to the dovecote. And some of the boys, who could not wait, became men.

There was also a basement. A crazy guy who wanted to show off took the old motorbike without asking and rode it into the basement. His mates beat him up for it later.

And then the hitchhiking girl … who got taken for a ride on the bike and got her dress torn and returned home half naked.

And finally, the men … This, I should add, is probably about Love, or at least Desire. Two men appeared in our courtyard … Forever covered in dirt and oil, they were busy day and night … They seemed oblivious to everything that was important for us then. They had eyes for no one and nothing. Nor was it a question of money. They attended to details and worked with their hands. They spent whole days in the garage, caring for nothing but the motorbike. I'd never seen this kind of Desire before, it was a Love none of us could understand. Their "Lady" was an old BMW motor-bike.

It was then I sensed that my muscles existed for something more important than imaginary priorities, and that contract with the oil of that old BMW motorbike meant the Desire I have never known before.

The most important thing, however, happened just recently. A friend of mine had heard about an old BMW and wanted to buy it. Suddenly he saw the bike leave the road and cross an overgrown field, so he tried to follow it on his "Jawa" but skidded, while the old BMW went on with no problems at all. He was just able to catch a glimpse of the old BMW motorbike as it disappeared as in a waking dream.

Boris Michailov
Charkow

JOHANNES MUGGENTHALER

Johannes Muggenthaler
Mille Miglia 2000
10-teilig, 2× 110,7 × 88,6 cm,
8× 110,7 × 76 cm
C-Prints
Inv.-Nr. F 2005-37

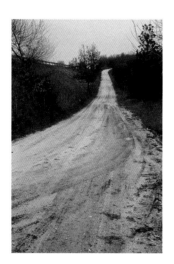
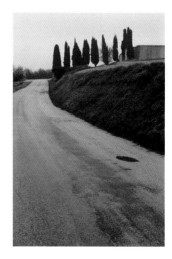
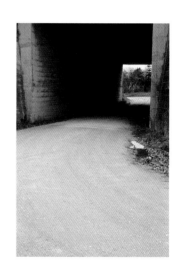

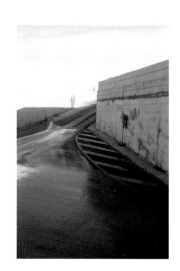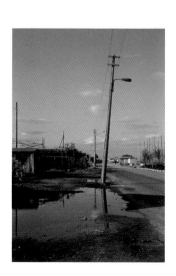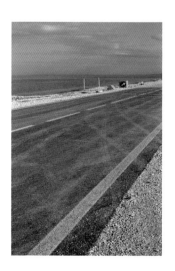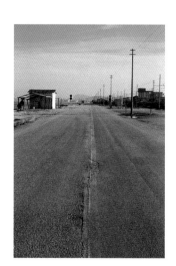

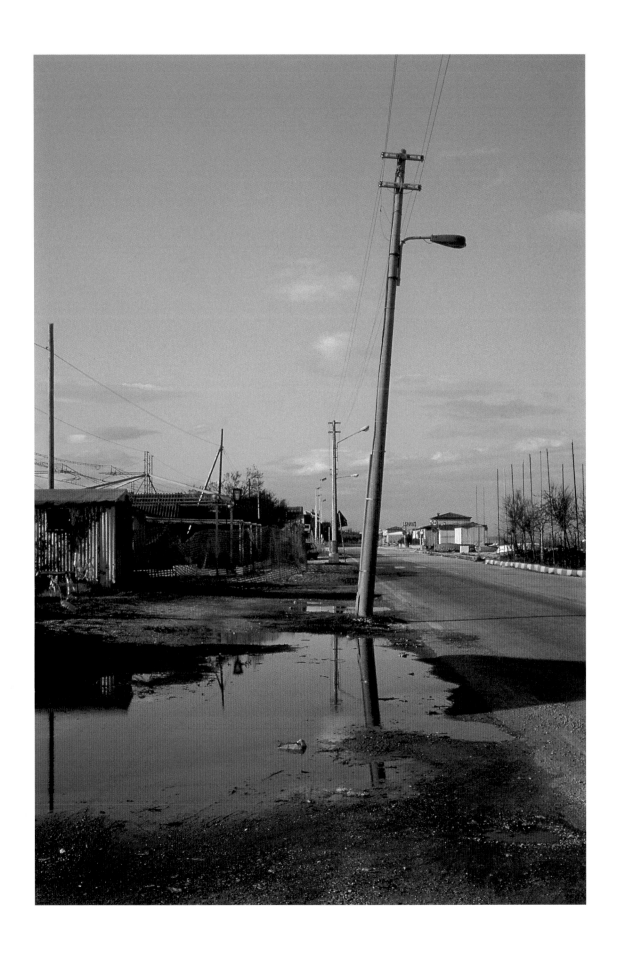

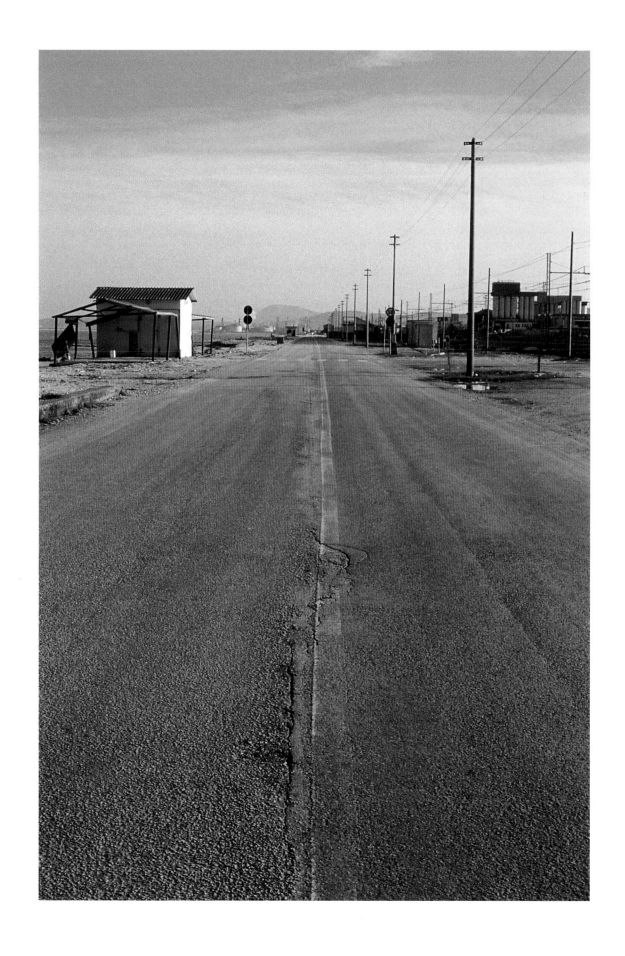

CATHERINE OPIE

Catherine Opie
Ohne Titel 1998
12-teilig, 1× 101 × 101 cm, 9× 47 × 59,5 cm, 2× 69,5 × 177 cm
Silbergelantine und Lightjet Prints
Inv.-Nr. F 2005-38

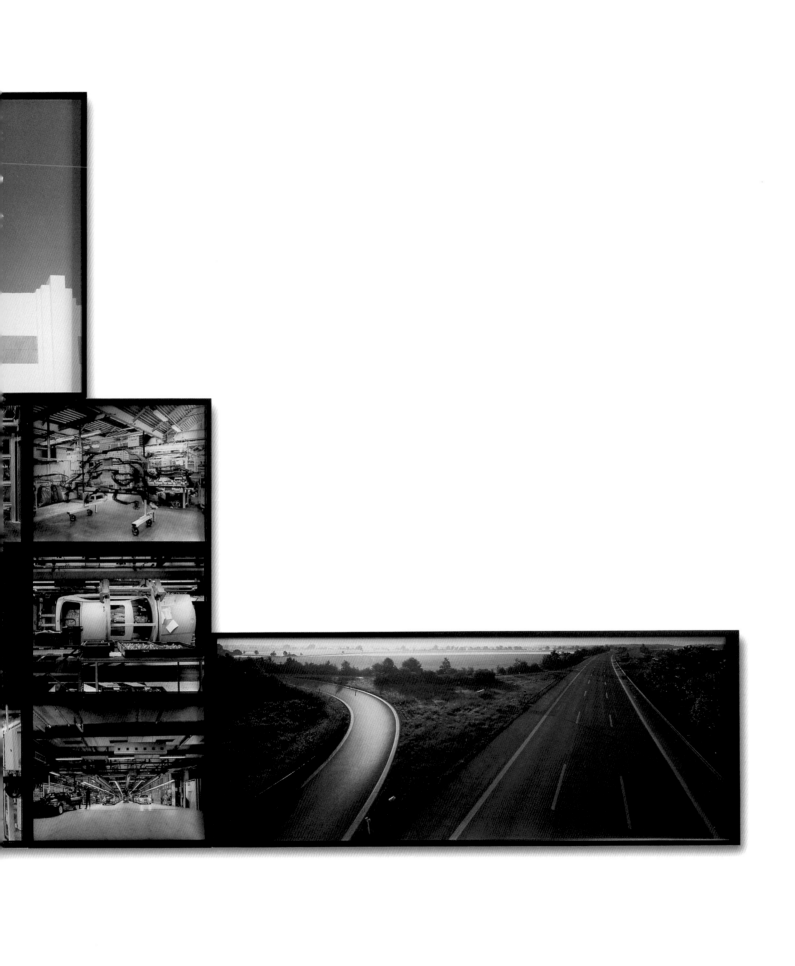

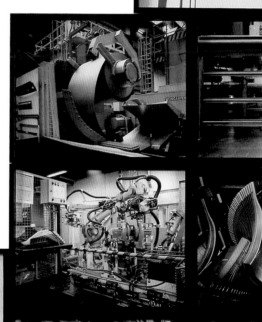

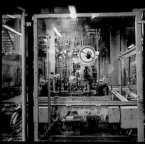

SOPHY RICKETT

Sophy Rickett
Ohne Titel 1 1999
2-teilig, je 76,2 × 76,1 cm
C-Prints
Inv.-Nr. F 2005-39

Sophy Rickett
Ohne Titel 2 1999
2-teilig, je 76,2 × 76,1 cm
C-Prints
Inv.-Nr. F 2005-40

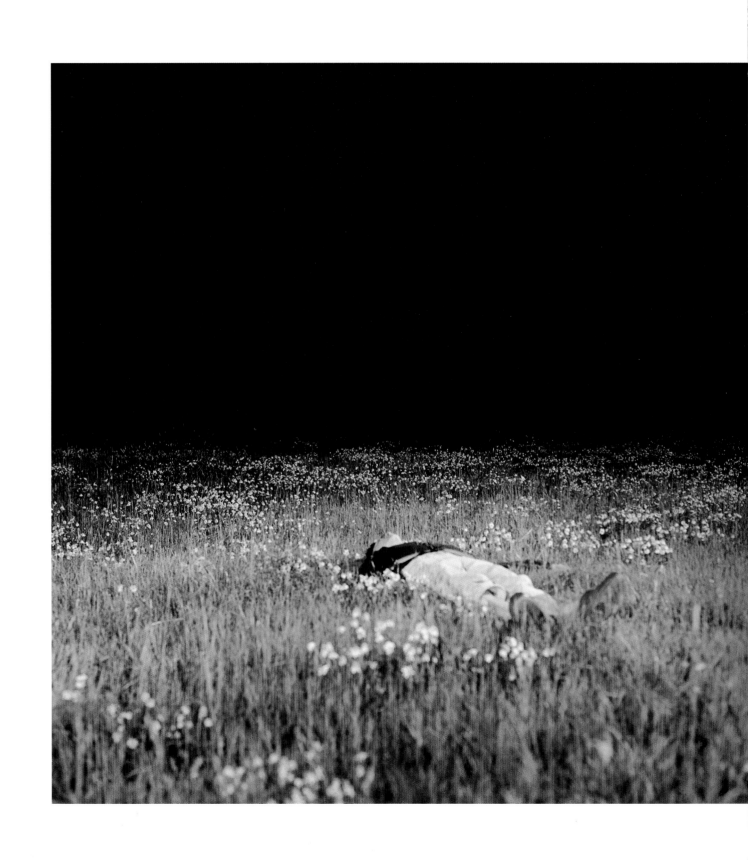

URSULA ROGG

Ursula Rogg
Ladies Training 2000
11-teilig,
1× 180,5 × 205,6 cm,
3× 104 × 100,3 cm,
7× 79,9 × 74,5 cm
C-Prints
Inv.-Nr. F 2005-41

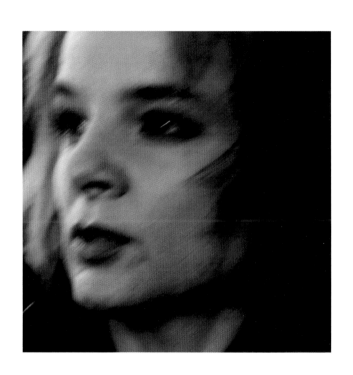
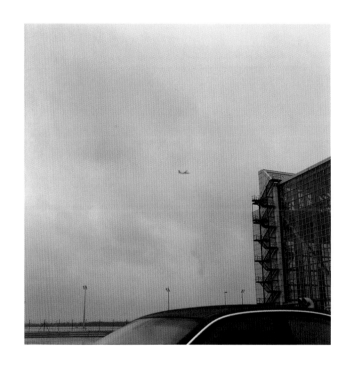

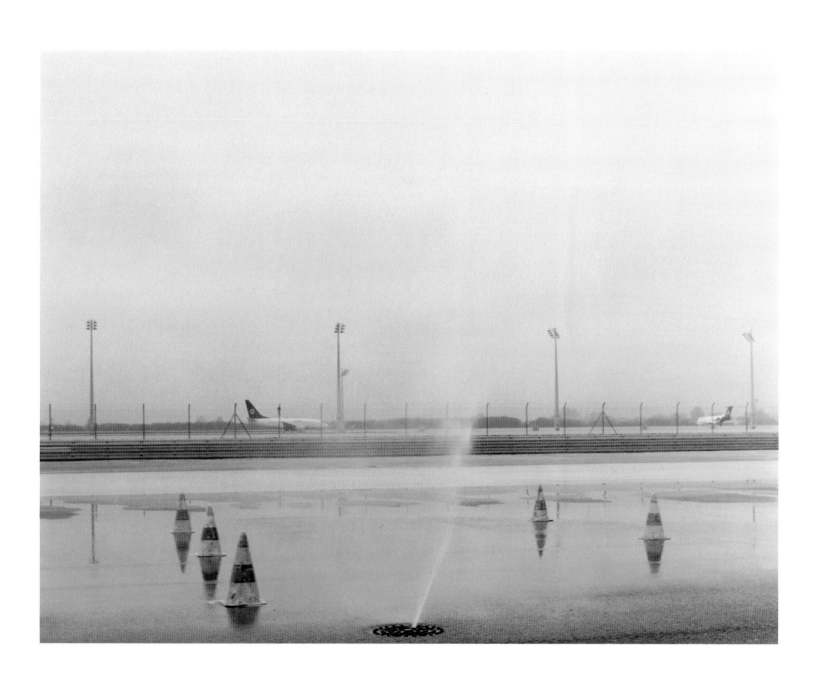

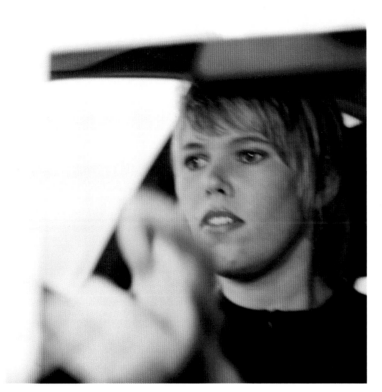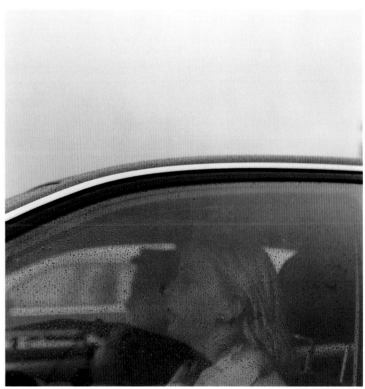

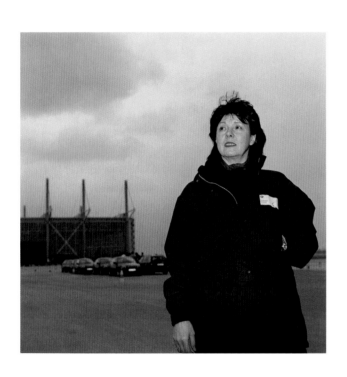

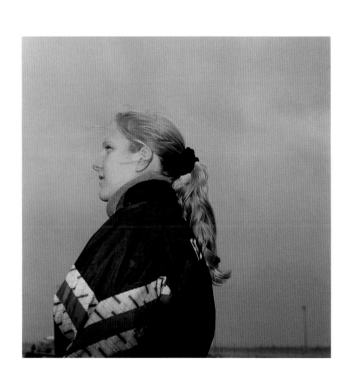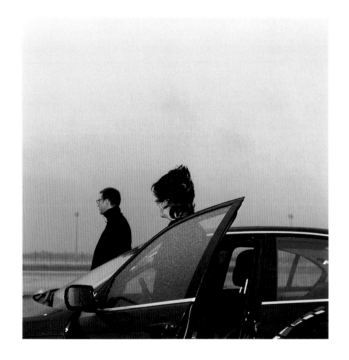

PAUL SEAWRIGHT

Paul Seawright
Ohne Titel 1 1998
149,7 × 149,8 cm
Digitaler C-Print
Inv.-Nr. F 2005-42

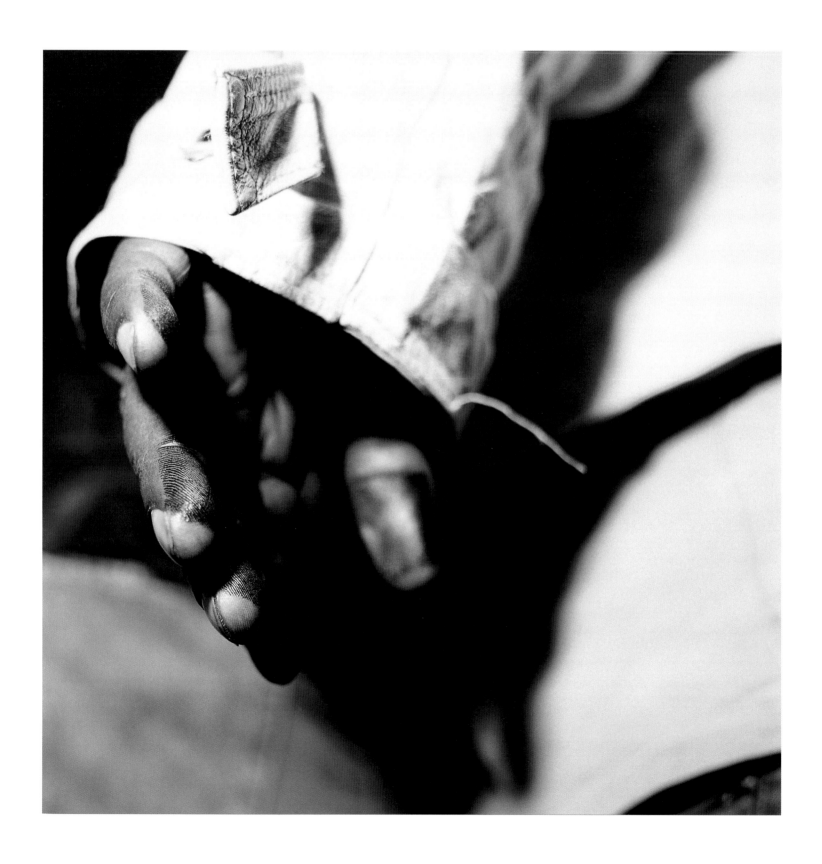

Paul Seawright
Ohne Titel 2 1998
100 × 100,1 cm
Digitaler C-Print
Inv.-Nr. F 2005-43

Paul Seawright
Ohne Titel 3 1998
149,8 × 149,7 cm
Digitaler C-Print
Inv.-Nr. F 2005-44

DAVID SHRIGLEY

David Shrigley
Carrots 1999
30 × 30 cm
C-Print
Inv.-Nr. F 2005-45

David Shrigley
Your Name Here 1999
39,5 × 50 cm
C-Print
Inv.-Nr. F 2005-46

David Shrigley
Welcome 1999
30 × 30 cm
C-Print
Inv.-Nr. F 2005-47

David Shrigley
This H 1999
30 × 30 cm
C-Print
Inv.-Nr. F 2005-48

BRIDGET SMITH

Bridget Smith
Glamour Studio (Locker Room) 1999
90,1 × 122,1 cm
C-Print
Inv.-Nr. F 2005-49

Bridget Smith
Glamour Studio (Stable) 1999
90,1 × 122,1 cm
C-Print
Inv.-Nr. F 2005-50

Bridget Smith
Glamour Studio (Chaise Longue) 1999
90,1 × 122,1 cm
C-Print
Inv.-Nr. F 2005-51

Bridget Smith
Glamour Studio (Bathroom Suite) 1999
90,1 × 122,1 cm
C-Print
Inv.-Nr. F 2005-52

HANNAH STARKEY

Hannah Starkey
Horsepower 1 1999
160 × 99,9 cm
C-Print
Inv.-Nr. F 2005-54

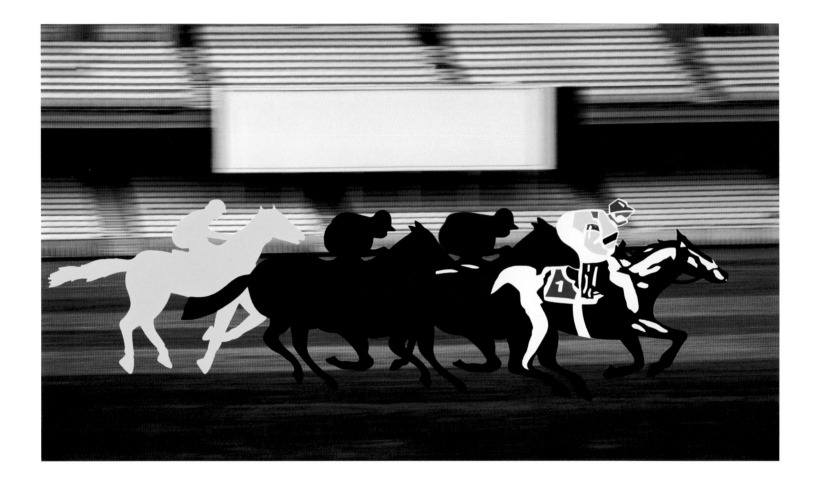

Hannah Starkey
Horsepower 2 1999
160 × 99,9 cm
C-Print
Inv.-Nr. F 2005-55

Hannah Starkey
Horsepower 3 1999
160 × 99,9 cm
C-Print
Inv.-Nr. F 2005-56

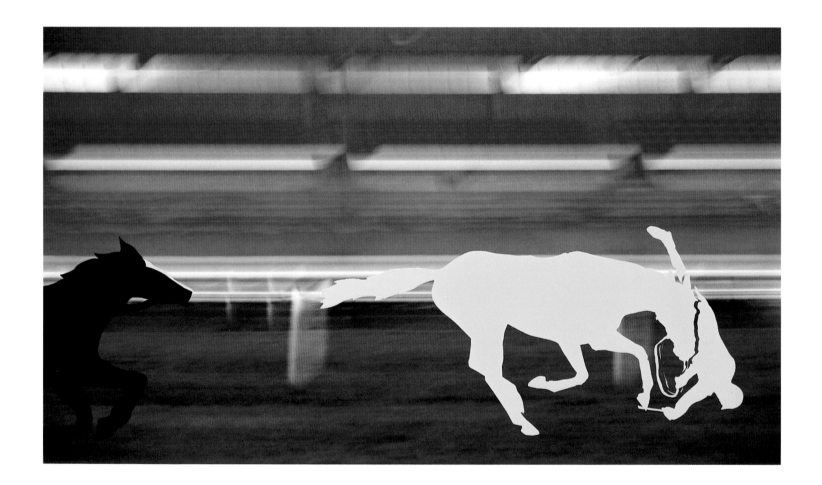

Hannah Starkey
Horsepower 4 1999
160 × 99,9 cm
C-Print
Inv.-Nr. F 2005-57

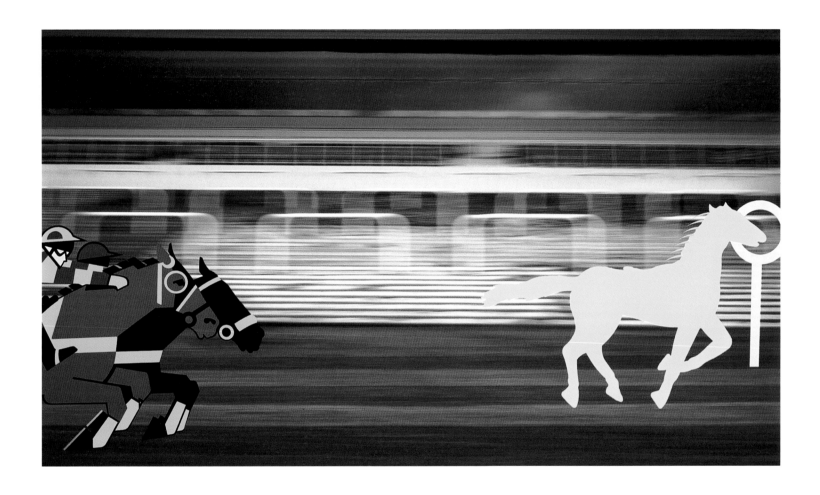

BEAT STREULI

Beat Streuli
Sydney / BMW 1998
150 × 200 cm
C-Print
Inv.-Nr. F 2005-58

Beat Streuli
Tokyo / BMW 1998
150 × 200 cm
C-Print
Inv.-Nr. F 2005-59

Beat Streuli
Sydney / BMW 1998
150 × 200 cm
C-Print
Inv.-Nr. F 2005-60

THOMAS STRUTH

Thomas Struth
El Capitan, Yosemite National Park / California 1999
168,3 × 214,5 cm
C-Print
Inv.-Nr. F 2005-62

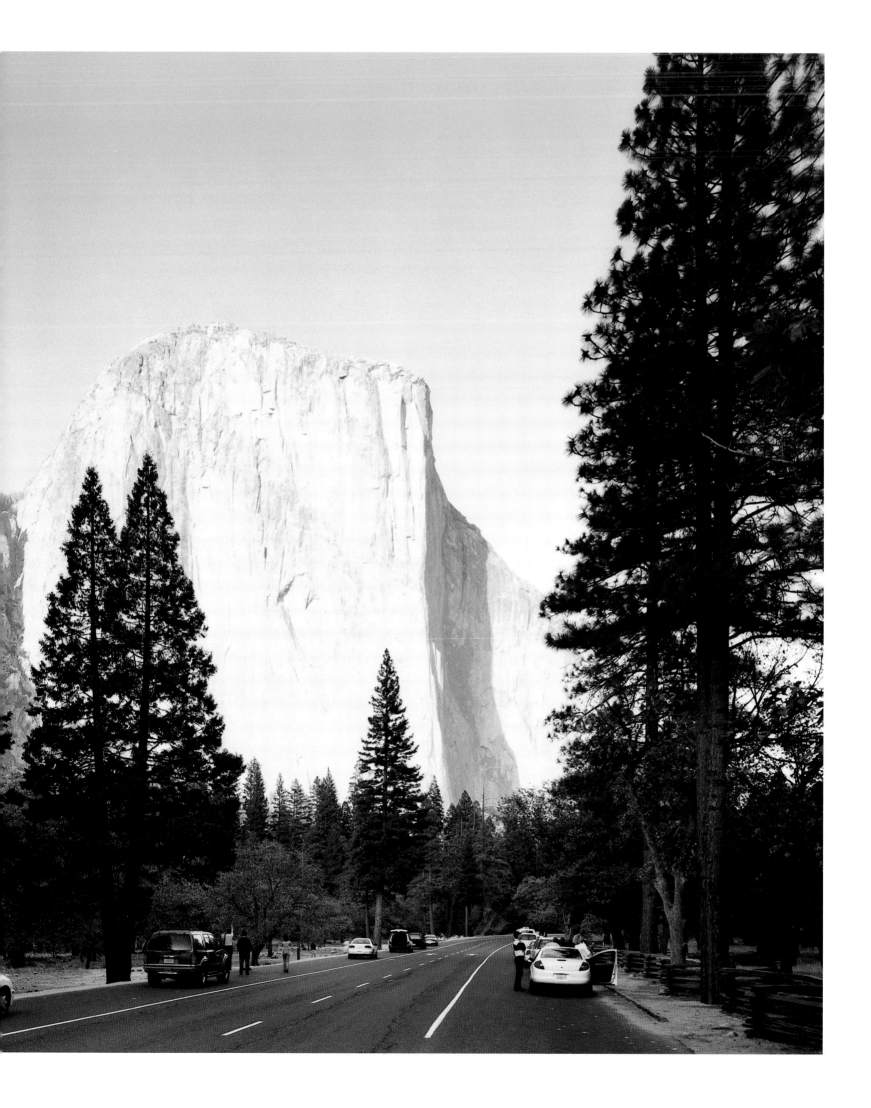

Thomas Struth
Straße in San Francisco, San Francisco 1999
45,5 × 57,7 cm
C-Print
Inv.-Nr. F 2005-61

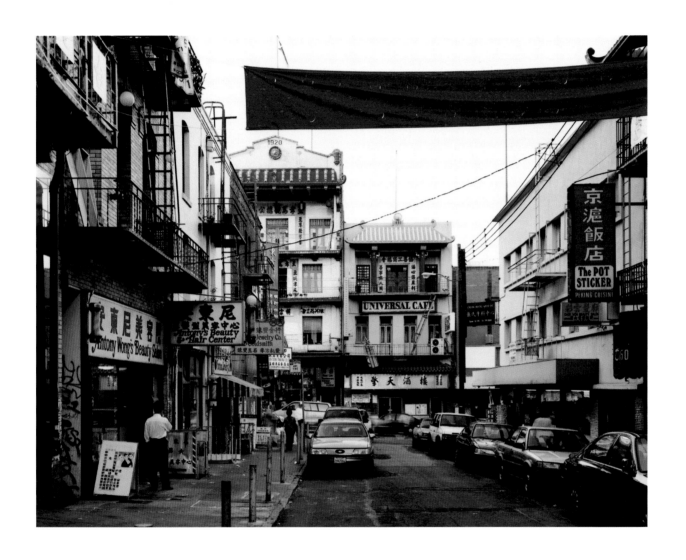

WOLFGANG TILLMANS

Wolfgang Tillmans
BMW Project II (Red) 1998
50,8 × 60,9 cm
C-Print
Inv.-Nr. F 2005-64

Wolfgang Tillmans
BMW Project III (Blue) 1998
50,8 × 60,9 cm
C-Print
Inv.-Nr. F 2005-65

ALEXANDER TIMTSCHENKO

Alexander Timtschenko
Love 2000
120 × 270 cm
Lambda-Ilfochrome-Print
Inv.-Nr. F 2005-66

Alexander Timtschenko
Joy 2000
120 × 270 cm
Lambda-Ilfochrome-Print
Inv.-Nr. F 2005-67

Alexander Timtschenko
Power 2000
120 × 270 cm
Lambda-Ilfochrome-Print
Inv.-Nr. F 2005-68

Alexander Timtschenko
Force 2000
120 × 270 cm
Lambda-Ilfochrome-Print
Inv.-Nr. F 2005-69

GILLIAN WEARING

Gillian Wearing
Shine 1998
100 × 75 cm
Screenprint
Inv.-Nr. F 2005-70

The reason I bought the BMW 318ti compact sport *is that all my close girlfriends, my sister and my sister in law are having babies and I was feeling broody and wanted a baby and noone was going to give me one so to distract myself and as conselation [sic] I bought myself a BMW I wanted to feel special; at 33 this is the kind of car a woman like me should be diving. It makes me feel in control although, others don't share the same feeling when I am at a junction people hardly ever give you way, especially women unless they have a better car than you or a BMW. There has been some reverse psychology-through doing something positive for myself, others have made me feel uncomfortable usually complete strangers. When I park my car people really stare-you know that where did she get that from, Is it hers or her boyfriend's, dad's, brother's, etc!*

Men tend to let you pass at junctions usually so that they can have a good look and suss out who you are and to see if you are as nice as the car is! I bought the car three or four months after starting my new job. One of the directors—a woman—came up to me and said "I was thinking to myself how can she afford a car like that?" My reply was "because I've worked hard, I'm successful and I deserve it." That shut her up. And then at Christmas a colleague at work bought me some fluffy dice—I felt insulted as I felt he was insinuating that I was a boy/girl racer flash cat type—but I'm not. I just like quality partnered with luxury!

My close friends, the ones I have known for ages, are really pleased that one of the "crew" has excelled to this level-there is a fair amount of status associated with driving and owing [sic] a BMW—and often it is more exceptional when it's a woman.

I find people want to race me. Obviously there is a lot of machoism on the roads that because generally you must be fairly ambitious and success-ful (+ possibly even rich) you must want to race surely – – – not! Black men and the stereotype in Birmingham holds a lot of truth—"they" tend to think you might respond to their on the road advances because you have a BMW too and sud-denly you share something "special".

When I had just bought the car a friends husband made me feel very vunerable [sic], he said that people would want to take my car, and that they would go to extreme lengths to get it—like even getting a forklift truck to lift it off my driveway. After spending around £17,000 on the car I initially became very paranoid and security concious [sic]. The car has many security devices and I have been asured [sic] that nothing's going to happen—I am more relaxed now that I have had the car for a few months.

My car has fulfilled all my expectations; a relation-ship is slowly building up—I wish it would talk back.

Text from Shine

Der Grund, warum ich mir den *BMW 318ti compact sport* kaufte, war schlicht, dass alle meine besten Freundinnen, meine Schwester und meine Schwä-gerin, bereits Babys hatten und ich mich traurig fühlte und mir auch ein Baby wünschte. Da es mir offenbar niemand schenken wollte und ich mich von diesem Umstand ablenken und selber trösten musste, kaufte ich mir kurzerhand einen BMW. Ich wollte mich eben auch als etwas Besonderes fühlen. Mit 33 erschien mir dieses Auto genau das, was sich eine Frau wie ich gönnen sollte. Es vermittelte mir das Gefühl, alles unter Kontrolle zu haben, auch wenn andere dieses Gefühl gar nicht teilten. An einer Straßenkreuzung beispielsweise hast du doch, speziell als Frau, kaum eine Chance die Nase vorn zu haben, solange du kein besseres Autos fährst – oder einen BMW. Aber da gab es auch immer noch dieses vertrackte Gefühl, dass ich mich gegenüber anderen, auch wenn es Fremde sind, irgendwie unbehaglich fühlte, wenn ich mir selbst etwas Gutes tat. Zum Beispiel, wenn ich mein Auto abstellte und – welche Frau kennt das nicht – mich alle Leute anstarrten: Woher sie wohl diesen Wagen hat, ist es das Auto ihres Freundes, des Vaters oder vielleicht des Bruders oder am Ende doch ihr eigenes?

Männer neigen doch dazu, Frauen an Straßen-kreuzungen vor allem deshalb die Vorfahrt zu lassen, um einen guten Blick auf dich werfen und abchecken zu können, ob die Fahrerin so gut aussieht wie das Auto. Ich arbeitete gerade vier oder fünf Monate in meinem neuen Job, als ich mir das Auto gekauft habe. Einer der Direktoren, eine Frau, kam eines Tages hoch zu mir ins Büro und sagte erstaunt: »Aber wie können Sie sich solch ein Auto leisten?« Ich entgegnete ihr: »Weil ich hart gearbeitet habe, bin ich erfolgreich und verdiene so ein Auto.« Darauf schwieg sie. Ein anderes Mal schenkte mir ein Arbeitskollege zu Weihnachten einige von diesen albernen bunten Stoffwürfel fürs Auto und ich fühlte mich peinlich berührt, weil er offenbar annahm, ich sei so ein weiblicher Tuning-Freak, der an nichts anderes als ihren Wagen denkt. Das bin ich aber überhaupt nicht. Ich möchte vielmehr gern, wo immer es geht, Qualität mit Luxus verbinden.

Meine besten Freunde, die ich über sehr viele Jahre kenne, waren dagegen wirklich stolz, dass eine aus ihrer Clique es so weit gebracht hat. Es ist offenbar doch ein erheblicher Statusgewinn mit dem Besitz und Fahren eines BMW verbunden, besonders wenn man eine Frau ist.

Oft wollen Leute natürlich auch ihre Kräfte mit mir messen. Es gibt ja eine Menge Machotum auf den Straßen, diese Vorstellung, dass wenn du besonders ehrgeizig und erfolgreich bist und viel Kohle verdienen willst, du einfach auch im Verkehr die Nase vorn haben willst. Am »Birmingham«-Stereotyp und den Klischees von bestimmten Farbigen, die wie »selbstverständlich« erwarten, dass du auf ihre Anmachrituale eingehst, nur weil du auch einen BMW fährst, ist ja leider etwas dran. So bist du also plötzlich, ob du willst oder nicht, schon wieder »etwas Besonderes«.

Ich hatte das Auto erst wenige Tage, da sorgte der Ehemann einer Freundin für eine tiefe Ver-unsicherung. Er wies mich nämlich darauf hin, dass das Auto sehr gefragt sei, leider auch bei Leuten, die keine Anstrengungen scheuen würden, es zu stehlen. Es sei so begehrt, dass sie es zur Not sogar mit einem Gabelstapler aus der Einfahrt hieven würden. Wenn du gerade £ 17 000 für das Auto hingeblättert hast, verfehlt dieser Hinweis seine Wirkung keineswegs und ich machte mir verstärkt Gedanken über Sicherheit auch in dieser Hinsicht. Glücklicherweise ist dieses Auto mit einer zuverlässigen Diebstahlsicherung ausgestattet und ich bin auch gut versichert. Inzwischen bin ich, da ich das Auto schon einige Monate fahre und es immer noch nicht gestohlen wurde, etwas ent-spannter.

Das Auto hat alle meine Erwartungen erfüllt. Es hat sich allmählich eine echte Beziehung entwickelt, die sich nur schwer in Worten ausdrücken lässt.

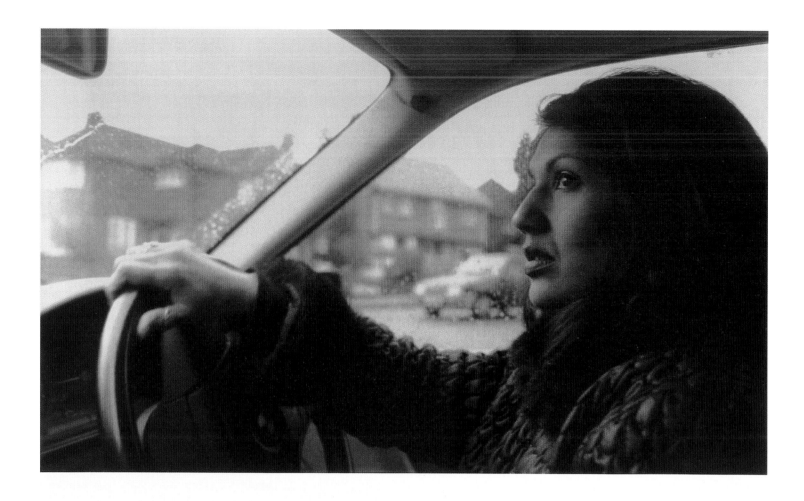

The reason I bought the BMW 318ti compact sport is that all my close girlfriends, my sister & my sister in law are having babies and I was feeling broody and wanted a baby and no-one was going to give me one so to distract myself and as consolation I bought myself a BMW. I wanted to feel special, even at 33 this is the kind of car a woman like me should be driving. It makes me feel in control although, others don't share the same feeling. when I am at a junction people hardly ever give you way, especially women unless they have a better car than you or a BMW. There has been some reverse psychology - enough doing something positive for myself others have made me feel uncomfortable usually complete strangers, when I park my car people really stare - you know that where did she get that from, is it hers or, her boyfriends dads, brothers etc.

Men tend to let you pass at junctions usually so that they can have a good look and suss out who you are and to see if you are as nice as the car is!

I bought the car three or four months after starting my new job, one of the directors - a woman - came up to me and said "I was thinking to myself how can she afford a car "like that" my reply was "because I've worked hard, I'm successful and I deserve it". that shut her up. and then at christmas a colleague at work bought me some thistle dye - I felt insulted as I felt he was insinuating that I was a boy/girl racer flash car type - but I'm not I just like, quality partnered with, luxury.

My close friends, the ones I have known for ages, are really pleased that one of the 'crew' has excelled to this level - there is a fair amount of stories associated with driving & owning a BMW - and often that it is more exceptional when its a woman.

I find people want to race me obviously, there is a lot of machoism on the roads and because generally you must be fairly ambitious and successful (+ possibly even rich) you must want to race surely - - - no! black men & the stereotype in Birmingham holds a lot of truth - they tend to think you might respond to their roar on the road advances

because you have a BMW too & suddenly you share something 'special'.

When I had just bought the car a friends husband made me feel very vunerable, he said that people would want to take my car, and that they would go to extreme lengths to get it - like even getting a forklift truck to lift it off my driveway. After spending around £17,000 on the car I initially became very paranoid and security concious. The car has many security devices and I have been assured that nothings going to happen - I am more relaxed now that I have had the car for a few months.

My car has fulfilled all my expectations, a relationship is slowly building building up - I wish it would talk back!

Gillian Wearing
Thomas 1998
100 × 75 cm
Screenprint
Inv.-Nr. F 2005-71

When I was little I lived in Ireland and I went to school and I had to get picked up by my mum and sometimes my uncle and had BMWs and sometimes he used to pick me up in his BMW and I used to sit there and play with his windows.

If my uncle did pass away now I would like him to give me his BMW because he knows how much I like them. He hasn't got any children anyway so he's got 110 one else that likes them so he'll probably leave them to me. They're fast and comfortable and big cars. I like the body shape, they're not exagerrated [sic]. You get some cars that are really exagerated [sic]. My favorite is the Z3. I think the Z3 is the best car on the Road. They are all the same but they can have different engine powers. If you don't want a real powerful car and you want cheap insurance you can still have a Z3. And you can have a really powerful car if you're rich and want high insurance. You won't want to wreck it anyway. If I had a BMW I would be a bit of a poseur. I would be going around in a car like that which means I would be rich.

It would not be a crappy BMW or anything like that. I would drive a nice BMW to pose; people would have to be jealous. It would suit me because I like to be flash and that's a flashcar. It attracts a lot of attention. I would like people to look at me and think yeah he's successful now, look at his BMW. A lot of the young ones [are] driving BMWs now. You look at them and they look back at you and you can see them getting a big hed because they think they're flash and they think I'm getting jealous but I'm not getting jealous because I'm going to have a BMW.

My number plate will have to be "Bad Boy." Because my dad's mate in Ireland who's a racing driver and spent £40,000 in extras on his porch [Porsche] and he had the number plate "Bad Boy" and he's really flash. I could imagine it would attract a lot of attention to the car. You would see a lot of people looking and telling their mates have you see [sic] that BMW with these number plates. It's something to be remembered by. I couldn't recognize a BMW until I was 5 but since 5 I have always wanted one. They have not changed much since then but they don't have to change. They're nice as they are. Ford escorts they changed their shape too much. At ten years old I started to learn about them about the speed they went what kind of wheels you can put on them to look their best. Now I would rather live in a BMW than a house or flat. I would just live in the car and eat McDonald's everyday. You won't have to pay bills or rent and you're in the thing you love the most of all the time. You might look a bit of a moran [sic] thought, but that is something you have to deal with. It would have to have a big system. I like big systems in cars and BMW have the room, they have a big boot and you can put a big system in there and listen to it comfortably. In some cars you sit in a get squashed in with the system, but with a BMW its right at the back of you. There was a yellow BMW in last month's Max power magazine and it and on the number plate it had "Max" because it won an award for max power and it showed the system in the antiriar. It had an oak dashboard and bucket seats and the speed clocks were nice white colours. It's things like this that make them the something you would have to deal with.

Everyones heard of a BMW everyone knows how to describe one they are the most popular car [sic]. If you were to say fiat uno tough people would go what's that. But a BMW clicks in the head straight away.

Text from Thomas

Als ich als Kind noch in Irland lebte, nahmen mich meine Mutter und manchmal auch mein Onkel, die beide BMW fuhren, mit dem Auto mit zur Schule. Ich mochte es sehr, in dem Auto zu sitzen und an den Fensterhebern herumzuspielen, so wie alle Kinder das eben tun. Müsste mein Onkel jetzt sterben, würde ich ihn wohl sehr gern bitten, mir seinen BMW zu überlassen, denn er weiß, wie sehr ich dieses Auto mag. Da er selbst keine Kinder hat, würden wohl noch hundert andere seinen BMW haben wollen, aber überlassen würde er ihn vielleicht doch am ehesten mir. Es sind die letzten sehr komfortablen und großartigen Autos. Ich mag ihre Linienführung, die nirgends übertrieben ist. Allerdings gibt es auch durchaus extravagante BMWs. Mein eigentliches Lieblingsmodell ist der Z3. Es ist für mich das beste Auto überhaupt. Die Z3 sehen zwar alle gleich aus, aber es gibt sie in den verschiedensten Motorisierungen. Wer nicht zuviel Versicherung zahlen möchte, kommt hier mit einem sparsamen Motor ebenso auf seine Kosten wie derjenige, für den die Kosten keine Rolle spielen und der einen wirklichen Kraftprotz sucht. Aber zu Schrott fahren willst du dieses Auto ohnehin unter keinen Umständen. Als BMW-Fahrer verkörperst du immer auch eine Haltung. Ich würde mich mit einem BMW so fortbewegen wie es vornehme, reiche Leute tun.

Ich würde niemals einen ungepflegten BMW fahren. Dieses Auto kann ich mir nur in gepflegtem Zustand vorstellen. Die Leute dürfen ruhig etwas neidisch sein. Das passt zu mir, denn ich lege Wert auf Wirkung und der BMW ist immer ein blendendes und beeindruckendes Fahrzeug, ein Hingucker. Er zieht immer eine Menge Aufmerksamkeit auf sich. Ich würde es genießen, wenn die Leute mir nachschauen und denken: »Mann, der Kerl hat's geschafft, er fährt jetzt einen BMW.« Du siehst sie an, sie schauen dich an und machen große Augen, weil sie sich für einen Augenblick geblendet fühlen. Sie argwöhnen vielleicht, du wärst ein Snob. Aber dazu hätte ich keinen Grund, denn ich hätte ja einen BMW.

Auf meinem Nummernschild müsste »Bad Boy« stehen, denn ein Kumpel meines Vaters, ein Rennfahrer, der allein £40 000 in das Tuning seines Porsche gesteckt hat, hat auch »Bad Boy« auf seinem Nummernschild stehen. Ein wirklich blendender Mann. Ich denke, das würde die Aufmerksamkeit noch mehr auf den Wagen lenken. Eine Menge Leuten würde stehen bleiben und ihren Kumpels erzählen: »Mann, habt ihr schon diesen heißen Schlitten mit diesem Nummerschild gesehen!« Das würde sich jedem einprägen. Bevor ich 5 Jahre alt war, konnte ich noch keinen BMW von einem anderen Wagen unterscheiden. Aber seit ich 5 bin, steht für mich fest, dass ich nur dieses Auto haben will. Seitdem haben sich die Autos nicht einmal sehr verändert und das ist auch gut so. So wie sie sind, sind sie genau richtig. Sehr verändert hat sich der Ford Escort. Als

ich 10 Jahre alt war, begann ich dann diese Sachen zu lernen, wie schnell sie fahren, welche Reifen wohl am besten aussehen und so weiter. Heute, das ist mein Ernst, möchte ich lieber in einem BMW als in einem Haus oder in einer Wohnung leben. Einfach immer in diesem beweglichen Wohnzimmer sitzen und jeden Tag bei McDonald's essen. Du zahlst keine Rechnung und Miete mehr und du bist immer in deinem heiß geliebten Teil. Natürlich schauen dich die Leute wie einen Schwachsinnigen an, aber damit könnte ich leben. Es müsste natürlich schon eine riesige Musikanlage drin sein, das ist klar. Der BMW hat ja viel Platz, eine große Ablage, da kann man schon ein fettes Teil einbauen und komfortabel Musik hören. Nicht wie in anderen Autos, wo du zwischen der Anlage eingequetscht hockst, in einem BMW liegt alles schön ordentlich hinter dir. In der letzten Max-power-Sendung war dieser gelbe BMW, auf dessen Nummernschild auch »Max« stand, mit diesem Wahnsinns-System im Kofferraum. Der Wagen hatte ein Armaturenbrett aus Eichenholz, Flugzeugschalensitze und auffällig weiße Meßinstrumente. Solche Sachen sind es, weshalb du das unbedingt haben musst.

Von BMW hat jeder schon gehört, jeder hat dazu seine Meinung, warum es das beliebteste Auto ist. Wenn man aber Fiat Uno hört, fragen toughe Leute: Was ist das denn? Aber wenn sie BMW hören, fällt direkt der Groschen.

When I was little I lived in Ireland and I went to school and I had to get picked up by my mum and sometimes my uncle and he had BMWs and sometimes he used to pick me up in his BMW and I used to sit there and play with his windows. If my uncle did pass away now I would like him to give me his BMW because he knows how much I like them. He hasn't got any children anyway so he's got no one else that likes them so he'll probably leave them to me. There fast and comfortable and big cars I like the body shape there not exagerrated you get some cars that are really exagerrated, my Favourite is the Z5 I think the Z5 is the best car on the Road they are all the Same but they can have different engine powers. if you don't want a real powerful car and you want cheap insurance you can still have a Z5

And you can have a really powerful car if your rich and want high insurance, you won't want to wreck it anyway. If I had a BMW I would be a bit of a poseur I would be going around in a car like that which means I would be rich.

It would not be a crappy BMW or anything like that I would drive a nice BMW to pose, people would have to be jelous. it would suit me because I like to be flash and thats a flash car it attracts alot of attention. I would like people to look at me and think yeah he's sucessful now, look at his BMW. Alot of the young ones driving BMWs now, you look at them and they look back at you and you can see them getting a big hed because they think their flash and they think I'm getting jelous but Im not getting jelous because Im going to have a BMW

My number plate will have to be 'Bad Boy' Because my dads mate in Ireland whose a racing driver and spent £40,000 in extras on his porch and he had the number plate 'Bad Boy' and he's really flash I could imagine it would attract alot of attention to the car you would see alot of people looking and telling their mates have you see that BMW with these number plates - its Something to be remebered by, I couldn't recognise a BMW until I was 5 but since 5 I have always wanted one they have not changed much since then but they don't have to change there nice as they are, Ford escorts they changed their shape too much, At ten years old I started to learn about them about the speed they went what kind of wheels you can put on them to look their best. Now I would rather live in a BMW than a house or flat I would just live in the Car and eat mcdonalds everyday you won't have to pay bills or rent and your in the thing you love the most of all

the time you might look a bit of a moran thought but that is something you have to deal with. It would have to have a big system I like big systems in cars and BMW have the room they have a big boot and you can put a big system in there and listen to it comfortably in some cars you sit in a get squashed in with the system but with a BMW Its right at the back of you There was a yellow BMW in last months Max power magazine and it and on the number plate it had Max because it won an award for max power and it showed the system in the intirrian It had an oak dashboard and bucket seats and the speed clocks were nice white colours, its things like this that make them the something you would have to deal with.

Everyones heard of a BMW everyone knows how to describe one they are the most popular car if you were to say fiat uno though people would go whats that. But a BMW clicks in the head staight away.

Gillian Wearing
Paul 1998
100 × 75 cm
Screenprint
Inv.-Nr. F 2005-72

My BMW is pretty important to me, it's important to my work, but as it's white it's also a lot of work to keep it clean. Like in the summer I clean it nearly every day, and in the winter, once a week. I go right down to the minor details like glass on the tires, on the dashboard, etc. So it's really hard work I've got all the professional cleaning products like Hydrocloric [sic] acid to clean the alloys and waxes to bring out that deep shine.

I think my neighbors and mates are surprised by my obsession I've always been into BMWs from a very young age, but when I could first drive I couldn't get the insurance which was frustrating. Now I'm over this stepping stone I have a 325i sport, and have done the following:

1) full leather interior
2) alloy wheels (16")
3) full respray—alpine white
4) de-cromed [sic] the front grille for full colour coated grille
5) added new bumpers
6) engine rebuild
7) Stage 1 chip
8) lowered the suspension for better handling, (except in the suburbs all the bumps cause problems)

The wheels are the biggest highlights. At 16" they're larger than the standard wheel, but it's the design that catches the eye. A lot of people stop me and ask questions, someone even crashed into another car whilst gawking at them. They are real shiners, I got them from Italy.

The best feeling is when people stop you and ask about the car or the wheels. I must say one of the reasons I get stopped so much is all the hard work that I've put into it. It makes me want to hold onto the car much longer. At the same time I don't want anyone using me for my car, so if a girl asks me what I drive I say I don't drive because I would hate someone choosing the car before me.

I don't like it if people get jealous of me, I've already been a victim of that. Someone obviously used some sort of instrument to dent my car, but that's life.

Apart from my health, I cherish the car. Obviously in the future when I have responsibilities like a family and mortgage the car will probably go into 2nd place, but now it's my number one obsession. I subscribe to Performance BMW *where like-minded people have articles about themselves and their cars, these people aren't the city suits. I find the other magazines boring but people in* Performance BMWs *aren't as stiffbacked and seem more normal.*

My Dad always says "If you've got it flaunt it," and because you take the car out in the public it's good when that's what you do I think this love of cars is hereditary because my Dad is now doing his car up, but he has gone a bit over the top. I think he's trying to be young again I think I started at a younger age than him, but he's obviously one of my inspirations.

I'm now waiting to get an M3 convertible, but that's not the end of my journey because there's always something you can do to them like put on a little anadised valve cap, because inside the car is a white/ blue theme. It's a never ending story I could go on and on and there will always be something I could do to fix the car up And like a person checking to see if the baby's asleep, I will always check my car before I go to sleep. I'm very proud of it.

Text from Paul

Mein BMW ist ziemlich wichtig für mich, wichtig insbesondere für meine Arbeit. Aber weil an dem Wagen alles in Weiß ist, kostet das Sauberhalten auch ne Menge Arbeit. Im Sommer wird er eigentlich täglich gereinigt, im Winter ungefähr einmal in der Woche. Ich mache das immer sehr gründlich, auch die Reifen, die Ritzen am Armaturenbrett usw. Das ist wie gesagt ein hartes Stück Arbeit, auch an all die professionellen Reinigungsmittel zu kommen, die Spezialmittel für die Metallic-Lackie oder ganz besondere Wachse, um die Spiegelungen in der Tiefe der Lackierung so richtig herauszuarbeiten.

Wahrscheinlich sind die Nachbarn und Bekannten schon etwas irritiert angesichts meiner Obsession für BMW, die mich seit meiner frühesten Jugend begleitet. Für meinen ersten BMW konnte ich noch nicht die Versicherung aufbringen. Das war ziemlich frustrierend. Aber jetzt ist das kein Thema mehr und ich bin Besitzer eines *325i sport.* Das Fahrzeug hat folgende Sonderausstattung:

1) Vollständige Lederausstattung
2) 16"-Chromfelgen
3) Eine vollständige Neulackierung in Alpinweiß
4) Entchromter und neu lackierter Frontgrill
5) Zusätzliche Spoiler
6) Modifizierter Motor
7) Computergesteuerter Motor
8) Tiefergelegte Radaufhängung (obwohl das auf den holprigen Vorstadtstraßen auch Probleme mit sich bringt)

Die Räder sind wahrscheinlich das größte Highlight. Mit 16" sind sie breiter als die Standardreifen, aber es ist das Design, das sie zu einem absoluten Eyecatcher macht. Oft werde ich angehalten und gefragt, wo ich sie her habe. Einmal hat sie sogar jemand so fasziniert angestarrt, dass er in ein anderes Fahrzeug gefahren ist. Es sind eben absolute Blender, ich habe sie aus Italien importiert.

Ich mag es, wenn Leute mich anhalten und nach dem Wagen oder der Bereifung fragen. Aber ich muss sagen, dass der Grund, warum ich so oft angehalten und gefragt werde, nicht zuletzt darin liegt, dass es mit so viel Arbeit und Hingabe verbunden war und ist. Ich habe viel investiert und möchte deshalb auch noch lange etwas von dem Wagen haben. Andererseits geht es mir manchmal auch auf die Nerven, dauernd auf den Wagen angesprochen zu werden. Wenn mich etwa eine Anhalterin fragt, ob ich zufällig hier- oder dorthin fahre, verneine ich meistens. Schließlich will ich nicht immer nur erleben, dass die Leute mein Auto mehr bewundern als den Besitzer.

Ich mag es auch nicht, wenn Leute neidisch auf mich sind. Ich bin schließlich auch oft ein Opfer, etwa von Leuten, die mit gewissen Hilfsmitteln hässliche Spuren auf der Lackierung hinterlassen. Aber so ist das Leben. Abgesehen von meiner Gesundheit, liegt mir an dem Auto sicher das meiste. Wenn in Zukunft jedoch Verantwortungen wie Familie oder Haushypotheken auf mich zukommen sollten, wird das Auto möglicherweise an die zweite Stelle rücken müssen. Aber jetzt ist es zweifellos die Nummer Eins meiner Leidenschaften. Ich habe das Magazin *Performance BMW* abonniert, wo gleich gesinnte Leute Erfahrungsberichte über sich und ihr Auto schreiben, also nichts für Leute, die die übliche Konfektionsware mögen. Die anderen Zeitschriften langweilen mich eher, aber die Leute in *Performance BMW* scheinen mir nicht so altbacken, irgendwie besser.

Mein Vater hat mir immer gesagt: »Wenn du es geschafft hast, musst du das auch allen zeigen.« Und womit kann man das in der Öffentlichkeit besser zeigen als mit dem Auto, das du fährst. Das ist schon in Ordnung. Wahrscheinlich bin ich da einfach erblich vorbelastet, denn mein Vater tunt auch gerade wieder sein Auto auf. Er ist dabei zwar meiner Meinung nach etwas über das Ziel hinausgeschossen, aber es ist eben seine Art, sich wieder jung zu fühlen. Ich habe ja auch viel früher damit anfangen können als er. Jedenfalls ist er für mich ein wichtiger Ratgeber gewesen.

Im Moment warte ich gerade auf einen *M3*-Austauschmotor, aber das ist sicher noch nicht das Ende der Fahnenstange, weil da immer etwas am besten Stück zu tun sein wird, und seien es nur neue, farbig anadisierte Reifenventil-Verschlusskappen, die optimal zu dem Innenraumdesign in Weißblau passen. Das ist eben eine endlose Geschichte. Ich kann tun und machen was ich will, es bleibt immer noch was an dem Auto zu verbessern oder aufzuwerten. Und so wie andere abends noch ein letztes Mal nachsehen, ob das Kind nebenan auch schläft, kann ich eben nicht ruhig einschlafen ohne zuvor einen letzten prüfenden Blick auf mein Auto geworfen zu haben. Ich bin schon sehr stolz auf diesen Wagen.

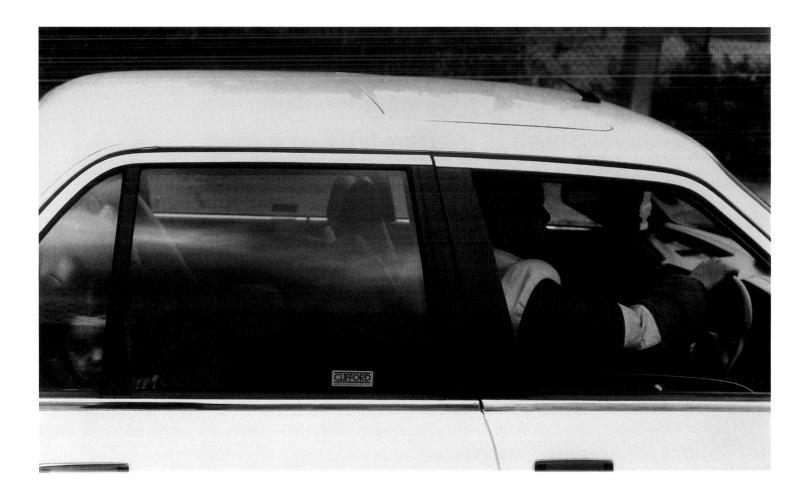

My BMW is pretty important to me, it's important to my work, but as it's white it's also alot of work to keep it clean. Like in the summer I clean it nearly every day, and in the winter, once a week. I go right down to the minor details like the glass on the tyres, on the dashboard etc. So it's really hard work. I've got all the professional cleaning products like hydrochloric acid to clean the alloys, and waxes to bring out that deep shine.

I think my neighbours and mates are surprised by my obsession. I've always been into BMW's from a very young age, but when I could first drive I couldn't get the insurance which was frustrating. Now I'm over this stepping stone I have a 325i Sport, and have done the following.

1) Full leather interior
2) alloy wheels (16")
3) Full respray: alpine white
4) de-cromed the front grille for full colour coated grille
5) added m-tec bumpers
6) engine rebuild
7) Stage 1 chip *
8) lowered the suspension for better handling, (except in the winter all the bumps cause problems)

The wheels are the biggest highlights. At 16" they're larger than the standard wheel, but its the design that catches the eye. Alot of people stop me and ask questions, someone even crashed into another car whilst gawping at them. They are real showers, I got them from Italy.

The best feeling is when people stop you and ask about the car or the wheels. I must say one of the reasons I get stopped so much is all the hard work that I've put into it. It makes me want to hold onto the car much longer. At the same time I don't want anyone using me for my car, So if a girl asks me what I drive I say I don't drive because I would hate someone chosing the car before me.

I don't like it if people get jealous of me. I've already been a victim of that, someone obviously used some sort of instrument to dent my car, but that's life.

Apart from my health, I cherish the car, obviously in the future when I have responsibilities like a family and mortgage the car will probably go into 2nd place but now its my number one obsession. I subscribe to Performance BMW where like-minded people have articles about themselves and their cars. Most people aren't the city suits. I find the other magazines boring but people in Performance BMW aren't as stiffnecked and seem more normal.

My Dad always says: "If you've got it, flaunt it" and because you take the car out into the public it's good when both what you do. I think this love of cars is hereditary because my Dad is now doing his

car up, but he has gone a bit over the top. I think he's trying to be young again. I think I've started at a younger age than him, but he's obviously one of my inspirations.

I'm now looking to get an M3 convertible, but that's not the end of my journey because there's always something you can do to them like put on a like anodised valve cap, because inside the car it's a white/blue flame. It's a never ending story. I could go on and on and there will always be something I could do to fix the car up. And like a parent checking to see if the baby's asleep, I will always check my car before I go to sleep. I'm very proud of it

Biografien / *Biographies*

zusammengestellt von / *compiled by* Jone Elissa Scherf

1966 geboren / *born* in Augsburg,
 lebt / *lives* in Berlin

1986–1995 Akademie der Bildenden Künste
 München, München
 Hochschule für bildende Künste
 Hamburg, Hamburg
 Hochschule der Künste Berlin, Berlin

1997–1999 Royal College of Art, London,
 MA Fine Art

2001–2003 Lehrauftrag am / *Lecturer at the*
 Art Center College of Design,
 Pasadena / Kalifornien / *California*

2005 Professur für Fotografie an der /
 Professor for photography at the
 National Academy of the Arts, Bergen /
 Norwegen / *Norway*

Einzelausstellungen (Auswahl) /
Solo Exhibitions (Selection)

1997 · AUTO SCOPE,
 Frankfurter Kunstverein,
 Frankfurt/Main

1998 · Galerie Barbara Weiss, Berlin
 · betweenies, Raum Aktueller Kunst
 Martin Janda, Wien

1999 · parallax, Entwistle Gallery, London

2000 · paraphrasen,
 Galerie Barbara Weiss, Berlin
 · Art Statements,
 Galerie Barbara Weiss, Art Basel
 · Video Works, Singapore Art Museum,
 Anderson Gallery, Singapur

2001 · Kunst-Werke Berlin, Berlin
 · Museo Paco das Artes, São Paulo

2003 · American Skies,
 Galerie Barbara Weiss, Berlin

2005 · Blaue Nacht,
 Kunsthalle Nürnberg, Nürnberg
 · Panorámica, Museo Tamayo
 Arte Contemporáneo, Mexico City

Gruppenausstellungen (Auswahl) /
Group Exhibitions (Selection)

1996 · Laboratorium Berlin in Moskau,
 Contemporary Art Center, Moskau
 · nach Weimar,
 Kunstsammlung zu Weimar, Weimar

1997 · s/light, Malmö Konstmuseum, Malmö
 · Dialog-In, Log-in X,
 Pavillion an der Volksbühne, Berlin
 · Goldrausch VIII,
 Kunstamt Kreuzberg/Bethanien, Berlin
 · büro orange,
 Siemens Hauptverwaltung, München
 · P.S.1 Open, opening exhibition, P.S.1
 Contemporary Art Center, New York
 · ars viva 97/98, Staatsgalerie Stuttgart,
 Stuttgart / Städtisches Museum
 Abteiberg, Mönchengladbach

1998 · ars viva 97/98, Hamburger Bahnhof –
 Museum für Gegenwart, Berlin /
 Kunsthalle zu Kiel, Kiel
 · Le future du Passé, LAC,
 Lieux d'art contemporain, Sigean
 · new contemporaries, Tea Factory,
 Liverpool / Camden Art Center,
 London / The Hatton Gallery,
 Newcastle
 · Berlin/Berlin, Berlin Biennale, Berlin
 · SiteConstruction,
 South London Gallery, London

1999 · video cult/ures, multimediale
 Installationen, ZKM | Museum für Neue
 Kunst, Karlsruhe
 · nur zeigen, was ist, Künstlerwerkstatt
 Lothringer Straße, München
 · Structures Transverses – Struktur-
 veränderungen, Kunst-Forum d'Art,
 Château de Vaudrémont,
 Colombey-les-Deux-Eglises
 · Rotation: Luft(zug),
 Museum Kurhaus Kleve, Kleve
 · Chausseestraße 23 –
 die Medienfassade des VEAG, Berlin
 · Children of Berlin, P.S.1 Contempo-
 rary Art Center, New York

2000 · Das Versprechen der Fotografie,
 Sammlung der DG Bank,
 Akademie der Künste, Berlin
 · Children of Berlin,
 Museum Folkwang Essen, Essen
 · AutoWerke, European and
 American Photography,
 Deichtorhallen Hamburg, Hamburg
 · ArtWORKS,
 Whitechapel Gallery, London
 · Fragment oder die Gegenwart des
 Zweifels, Brecht-Haus Weißensee,
 Berlin
 · Behind the Scenes, Museum of
 Contemporary Photography, Chicago

2001 · 010101: Art in Technological Times,
 SFMOMA, San Francisco
 · Sport in der zeitgenössischen Kunst,
 Kunsthalle Nürnberg, Nürnberg
 · Loop – Alles auf Anfang,
 Kunsthalle der Hypo-Kulturstiftung,
 München / P.S.1 Contemporary
 Art Center und Museum of Modern Art,
 New York
 · Überraschung,
 Studio Galleria, Budapest

2002 · heimat.de. Fotografische Sichten auf
 ein besetztes Thema,
 Kunsthaus Dresden, Dresden
 · Zwischenspiel III: Nach der Natur,
 Berlinische Galerie, Berlin
 · en route, Serpentine Gallery, London
 · Loop – Back to the Beginning,
 Contemporary Arts Center Cincinnati,
 Ohio

2003
- Production Unit, Arte Fiera, Bologna
- actionbutton. Neuerwerbungen zur Sammlung zeitgenössischer Kunst der Bundesrepublik Deutschland 2000–2002, Hamburger Bahnhof – Museum für Gegenwart, Berlin
- raum-zeit-fotografie. Architektur in der zeitgenössischen Fotografie aus der Sammlung der DG Bank, Oldenburger Kunstverein und Landesmuseum für Kunst- und Kulturgeschichte im Augusteum, Oldenburg

2004
- Code Unknown, Palais de Tokyo, Paris
- doku/ficition. Mouse on Mars reviewed & remixed, Kunsthalle Düsseldorf, Düsseldorf
- Brooklyn Euphoria, Volume, Brooklyn/New York
- actionbutton. Neuerwerbungen zur Sammlung zeitgenössischer Kunst der Bundesrepublik Deutschland 2000–2002, Marmorpalast, State Russian Museum, St. Petersburg
- Move Your Body! Stretch Your Mind!, Kunstmuseum Liechtenstein, Vaduz
- MoMA Reopen, Yoshiko and Akio Morito Gallery, Museum of Modern Art, New York

2005
- Scape, CAC Contemporary Art Center, Vilnius
- Difference and Repetion, G Fine Art Gallery, Washington

Bibliografie (Auswahl) / *Bibliography (Selection)*

Heike Baranowsky: En Face I, En Face II, in: Intervall 95. Perspektiven, Ausst.-Kat. Hochschule der Künste Berlin 1995

AUTO SCOPE, Ausst.-Kat. Frankfurter Kunstverein, Frankfurt/Main 1997

Bojana Pejic, Heike Baranowsky: Entre-deux, in: ars viva 97/98 – Medienkunst, hrsg. vom Kulturkreis der deutschen Wirtschaft im Bundesverband der Deutschen Industrie e.V., Köln 1997

Peter Herbstreuth, Heike Baranowsky in der Galerie Barbara Weiss, in: Kunstbulletin 5/1998, S. 38

Jutta Schenk-Sorge, Heike Baranowsky, in: Kunstforum 141/1998, S. 349–350

Paul Kilsby, Heike Baranowsky, in: new contemporaries, Ausst.-Kat. Tea Factory, Liverpool / Camden Art Center, London / The Hatton Gallery, Newcastle 1998, S. 10–11

Peter Herbstreuth, Heike Baranowsky, in: Flash Art International 202/1998, S. 128

Patricia Bickers, Das Kapital, in: Art Monthly, Dezember/1998, S. 1–5

Ellen Heider, Heike Baranowsky. AUTO SCOPE 1996/97, in: video cult/ures. multimediale Installationen der 90er-Jahre, hrsg. von Ursula Frohne, Ausst.-Kat. ZKM | Museum für Neue Kunst, Karlsruhe 1999, S. 164–167

Bojana Pejic, Heike Baranowsky, in: Structures – Transverses. Strukturveränderungen, Ausst.-Kat. Colombey-les-Deux-Eglises 1999, S. 18–19

Heidi Fichtner, Heike Baranowsky, in: Flash Art International, Mai/Juni 2000, S. 119

Jone Elissa Scherf, Heike Baranowsky. Radfahrer – Hase und Igel, in: AutoWerke II, Ausst.-Kat. Deichtorhallen Hamburg 2000, S. 23

Jone Elissa Scherf, Mediale Bildstrategien der Gegenwart, in: AutoWerke II, Ausst.-Kat. Deichtorhallen Hamburg 2000, S. 10–11

Jörn Merkert, Heike Baranowsky, in: Fragment oder die Gegenwart des Zweifels, Ausst.-Kat. Brecht-Haus Weißensee, Berlin 2000

John S. Weber, Heike Baranowsky, in: 010101: Art in Technological Times, Ausst.-Kat. SFMOMA, San Francisco 2001, S. 32–36

Thomas Wulffen, Nichtlineare Projektionen. Die Videoarbeiten von Heike Baranowsky, in: Kunstforum 155/2001, S. 141–143

Niklas Maak, Ausbruch aus der Tretmühle. Bewegter Stillstand: Die Ausstellung Loop in der Münchener Hypo-Kunsthalle, in: Frankfurter Allgemeine Zeitung, 29.09.2001

Loop – Alles auf Anfang, hrsg. von Klaus Biesenbach, Ausst.-Kat. Kunsthalle der Hypo-Kulturstiftung München / P. S. 1 Contemporary Art Center und Museum of Modern Art, New York 2001

Sport in der Zeitgenössischen Kunst, hrsg. von Ellen Seifermann, Ausst.-Kat. Kunsthalle Nürnberg 2001

Jennifer Allen, Heike Baranowsky. Kunst-Werke, in: Artforum, Januar/2002, S. 181–182

Hans-Jürgen Hafner, Loop – Alles auf Anfang, in: Kunstforum 158/2002, S. 350–352

Martin Blättner, Sport in der zeitgenössischen Kunst, in: Kunstforum 158/2002, S. 354–355

Craig Garrett, Loop. P.S. 1, New York, in: Flash Art 223/2002, S. 64

Jordan Kantor, Loop. P.S. 1, in: Artforum International, April/2002, S. 137–138

Zwischenspiel III: Nach der Natur, Ausst.-Kat. Berlinische Galerie, Berlin 2002

Heike Baranowsky, Kolibri, Frankfurt/Main 2003

en route, Ausst.-Kat. Serpentine Gallery, London 2003

Production Unit, Ausst.-Kat. Arte Fiera 2003, Bologna 2003, S. 4–5

Niklas Maak, Minimal Mensch, in: Frankfurter Allgemeine Zeitung, 22.03.2003

Kirsty Bell, Heike Baranowsky. Galerie Barbara Weiss, Berlin, in: Frieze 75/2003, S. 98

actionbutton. Neuerwerbungen zur Sammlung zeitgenössischer Kunst der Bundesrepublik Deutschland 2000–2002, Ausst.-Kat. Hamburger Bahnhof – Museum für Gegenwart, Berlin 2003, S. 84

Thomas Wulffen, Nichtlineare Projektionen. Die Videoarbeiten von Heike Baranowsky, in: Rollenwechsel, hrsg. von Hermann Korte, Berlin 2004, S. 48–51

Scape, Ausst.-Kat. CAC Contemporary Art Center, Vilnius 2005

doku/fiction. Mouse on Mars reviewed & remixed, Ausst.-Kat. Kunsthalle Düsseldorf 2004, S. 84–85

Wolfgang Brauneis, Überkreuzt, in: Texte zur Kunst 54/2004

Faktor X. Zeitgenössische Kunst in München, hrsg. von Angelika Nollert, Florian Matzner, Birgit Sonna, München 2005, S. 154

1964	geboren in München / *born in Munich*, lebt / *lives* in Berlin, London
1989–1992	Kunstakademie Düsseldorf, Düsseldorf
1993–1994	Goldsmiths College, London

Einzelausstellungen (Auswahl) /
Solo Exhibitions (Selection)

1996	· Galerie de l'ancienne Poste, Calais
1997	· Max Protech Gallery, New York · Galerie Tanit, München
1997	· Victoria Miro Gallery, London · Galerie Monika Sprüth, Köln
1998	· Kunsthalle Zürich, Zürich · Monica de Cardenas, Mailand · Kunsthalle Bielefeld, Bielefeld · Kunstverein Freiburg, Freiburg/Breisgau · Galerie Schipper & Krome, Berlin · 303 Gallery, New York
1999	· Art Now 16: Tunnel, Tate Gallery, London
2000	· Galerie Monika Sprüth, Köln · Fondation Cartier, Paris · Victoria Miro Gallery, London · Report, Galleri K, Oslo · Sprengel Museum Hannover, Hannover
2001	· Yard, 35mm, 2001, Galerie Schipper & Krome, Berlin
2002	· Thomas Demand con Caruso St. John architetti, Galleria d'arte moderna di Palazzo Pitti, Florenz · Yard, 35mm, 2001, Städtische Galerie im Lenbachhaus, München
2003	· Castello di Rivoli, Turin · Taka Ishii Gallery, Tokio · Galeria Helga de Alvear, Madrid · Dundee Contemporary Arts, Dundee
2004	· Phototrophy, Kunsthaus Bregenz, Bregenz · Louisiana Museum of Modern Art, Humlebæk/Dänemark · Städtische Galerie im Lenbachhaus, München · Four newest photographs and most recent films, 303 Gallery, New York · 26th Biennal Internacional de São Paulo, São Paulo
2005	· Museum of Modern Art, New York · Victoria Miro Gallery, London

Gruppenausstellungen (Auswahl) / Group Exhibitions (Selection)

1990 · Gezweigt in sieben Mosigwellen, Galerie Lohrl, Mönchengladbach

1991 · Quellen und Ergänzungen, Galerie der Künstler, München

1993 · Het Intelectuele Geweeten van de Kunst, Galerie D'Eendt, Amsterdam

1994 · Scharf im Schauen, Haus der Kunst, München

1995 · Ars Viva 1995: Frankfurter Kunstverein, Frankfurt/Main

1996 · New Photography, Museum of Modern Art, New York
· Raumbilder – Bildräume, Museum Folkwang Essen, Essen
· Campo 6: The Spiral Village, Galleria Civica d'Arte Contemporaneo, Turin
· Passions Prospect '96, Frankfurter Kunstverein, Frankfurt/Main
· Radical Images, Neue Galerie am Landesmuseum Joanneum, Graz
· Ritratti di interno, Studio la Citta, Verona
· Fotografia nell'arte tedesca contemporanea, Galleria Gian Ferrari, Mailand

1997 · Elsewere, Carnegie Museum of Art, Pittsburgh
· Stills: Emerging photography in the 1990's, Walker Art Center, Minneapolis
· Positionen künstlerischer Photographie in Deutschland seit 1945, Berlinische Galerie, Berlin
· Defamiliar, Regen Projects, Los Angeles
· Campo 6: The Spiral Village, Bonnefanten Museum, Maastricht
· Strange days, Gian Ferrari, Mailand
· Transit, Centre National des Arts plastiques/EnsbA, Paris
· Kunstpreis Böttcherstrasse, Kunstverein Bonn, Bonn

1998 · Berlin/Berlin, Berlin Biennale, Berlin
· View One (Neville Wakefield), Mary Boone Gallery, New York
· Everyday, Sydney Biennial, Sydney
· Artificial, MOCBA, Barcelona
· The End ist the Beginning, Bricks & Kicks, Wien
· Site Construction, South London Gallery, London
· être nature, Fondation Cartier pour l'art contemporain, Paris
· Vollkommen gewöhnlich, Kunstverein Freiburg, Freiburg/Breisgau / Germanisches Nationalmuseum, Nürnberg / Kunstverein Braunschweig, Braunschweig / Kunsthalle zu Kiel, Kiel

1999 · Große Illusionen, Kunstmuseum Bonn, Bonn / Museum of Contemporary Art, North Miami
· Wohin kein Auge reicht, Deichtorhallen Hamburg, Hamburg
· Reconstructing Spaces, Architectural Association, London
· Anarchitecture, De Appel Stichting, Amsterdam
· Kraftwerk Berlin, Arhus Kunstmuseum, Arhus
· Carnegie International 1999/2000, Carnegie Museum of Art, Pittsburgh
· fotografie und archive. Gestern war heute, Stadthaus Ulm, Ulm
· Children of Berlin, P.S.1 Contemporary Art Center, New York
· Objects in the rear view mirror may appear closer than they are, Galerie Max Hetzler, Berlin
· The Mirror's Edge, Bild Museet, Umea / Vancouver Art Gallery, Vancouver / Castello di Rivoli, Turin / Tramway, Glasgow

2000 · La forma del mondo/la fine del mondo, PAC Padiglione Arte Contemporanea, Mailand
· Age of influence: Reflections in the Mirror of the American Culture, Museum of Contemporary Art, Chicago
· AutoWerke, European and American Photography, Deichtorhallen Hamburg, Hamburg
· Open Ends. 11 Exhibitions of Contemporary Art from 1960 to Now, Sets and Situations, Museum of Modern Art, New York
· Die scheinbaren Dinge, Haus der Kunst, München
· Deep Distance. Die Entfernung der Fotografie, Kunsthalle Basel, Basel
· Cross-Roads. Artists in Berlin, Sala Plaza de Espana de la Comunidad, Madrid
· Small world: Dioramas in Contemporary Art, Museum of Contemporary Art, San Diego

2001 · AutoWerke, Hedengaagse Europese en Amerikaanse fotografie, Frans Hals Museum, Haarlem
· Und keiner hinkt, Kunsthalle Düsseldorf, Düsseldorf
· Ich bin mein Auto, Staatliche Kunsthalle Baden-Baden, Baden-Baden
· Big Nothing, Staatliche Kunsthalle Baden-Baden, Baden-Baden
· Trade, Fotomuseum Winterthur, Winterthur

2002 · Everyday Utopias, PAC Padiglione Arte Contemporanea, Mailand
· True Fictions, Ludwig Forum, Aachen
· non-places, Frankfurter Kunstverein, Frankfurt/Main
· La Natura della natura morta di Manet dai nostri giorni, Galleria D'Arte Moderna, Bologna
· Great Theatre of the World, 2002 Taipei Biennal, Taipei Fine Art Museum, Taipei
· andere räume, other spaces, Kunstverein in Hamburg, Hamburg
· Moving Pictures, Solomon R. Guggenheim Museum, New York
· Screen Memories, Contemporary Art Center, Art Tower Mito, Tokio
· In Szene gesetzt, ZKM I Museum für Neue Kunst, Karlsruhe
· Paarungen, Berlinische Galerie, Berlin
· Balsam – Exhibition der Fussballseele, Helmhaus, Zürich

2003 · Fred Sandback, Karl Blossfeldt, Pinakothek der Moderne, München
· Adorno – zum 100. Geburtstag, Frankfurter Kunstverein, Frankfurt/Main
· Outlook: International Art Exhibition 2003, Athen
· Strange Days, Museum of Contemporary Art, Chicago
· Berlin–Moskau / Moskau–Berlin 1950–2000, Martin-Gropius-Bau, Berlin
· True Fictions, Stadtgalerie Saarbrücken, Saarbrücken
· 50. Biennale di Venzia 2003, Venedig
· Horizonte, museum franz gertsch, Burgdorf
· The Office, The Photographers' Gallery, London
· Einblicke in Privatsammlungen, Museum Folkwang Essen, Essen

2004 · artparis 2004, Paris
· Biennale São Paulo 2004, São Paulo
· Die Zehn Gebote, Deutsches Hygiene-Museum, Dresden
· 10 Year Anniversary Exhibition, Taka Ishii Gallery, Tokio
· Sammlung Plum, Museum Kurhaus Kleve, Kleve
· Paisaje y Memoria, La Casa Encendida, Madrid
· Berlin–Moskau / Moskau–Berlin 1950–2000, Tretjakow Galerie, Moskau
· Sculptural Sphere, Sammlung Goetz, München
· Skulptur. Prekärer Realismus zwischen Melancholie und Komik, Kunsthalle Wien, Wien
· ArchiSkulptur – Modelle, Skulpturen und Gemälde, Fondation Beyeler, Basel
· Late/Hate. From Magritte to Cattelan, Masterpieces from the Museum of Contemporary Art, Chicago / Villa Manin-Center of Contemporary Art, Passarino
· Memory and Landscape, La Casa Encendida, Madrid

2005 · Fondazione Sandretto Re
Rebaudengo, Turin
· Covering the Real – Kunst und Presse-
bild, Kunstmuseum Basel, Basel
· Monuments for the USA, CCA Wattis
Institute for Contemporary Arts,
San Francisco
· Zur Vorstellung des Terrors,
Kunst-Werke Berlin, Berlin
· Atlantic & Bukarest,
Kunstmuseum Basel, Basel
· On/Of, Museum Kurhaus Kleve, Kleve
· Contemporary Visions,
City Art Museum, Oulu
· Paysages: Constructions et
simulations, Casino Luxembourg,
Forum d'art contemporain, Luxemburg

Bibliografie (Auswahl) / *Bibliography (Selection)*

Prospect '96, Photographie in der Gegenwarts-
kunst, Ausst.-Kat. Frankfurter Kunstverein,
Frankfurt/Main 1996

Joshua Decter, take away the apparent order
established through systems of cultural distinction,
and things begin to fall apart in the loveliest ways
imaginable, in: Thomas Demand, Ausst.-Kat.
Galerie de l'ancienne Poste, Calais 1996

Douglas Fogle, Jenelle Porter, Stills: Emerging
Photography in the 1990s, Ausst.-Kat. Walker Art
Center, Minneapolis 1997

Thomas Demand, Ausst.-Kat. Kunstverein Freiburg,
Freiburg/Breisgau 1998

Thomas Demand, Ausst.-Kat. Kunsthalle Zürich /
Kunsthalle Bielefeld, Zürich 1998

Herve Chandes u. a., être nature, Ausst.-Kat.
Fondation Cartier pour l'art contemporain Paris,
Arles 1998

Grosse Illusionen – Demand – Gursky – Ruscha,
Ausst.-Kat. Kunstmuseum Bonn / Museum of
Contemporary Art Miami, Köln 1999

AutoWerke II, hrsg. von Jone Elissa Scherf,
Ostfildern 2000

Dean Sobel u. a., Thomas Demand, Ausst.-Kat.
Aspen Museum of Art, Aspen 2001

Thomas Demand, Ausst.-Kat. Städtische Galerie im
Lenbachhaus, München 2002

Thomas Demand, Phototrophy, Ausst.-Kat. Kunst-
haus Bregenz, München 2004

Thomas Demand, Ausst.-Kat. Museum of Modern
Art, New York 2005

1959	geboren / *born* in Sittard/Nieder-lande / *Netherlands,* lebt / *lives* in Amsterdam
1981–1986	Gerrit Rietveld Akademie, Amsterdam

Einzelausstellungen (Auswahl) / *Solo Exhibitions (Selection)*

1984
· Paradiso Portraits,
de Moor, Amsterdam

1988
· Het Onstaan van Vorm,
de Moor, Amsterdam

1994
· Kunstaamoedingsprijs Amstelveen,
Aemstelle, Amstelveen

1995
· Time Festival,
Museum van Hedendaagse Kunst,
Gent
· Stedelijk Museum Bureau Amsterdam,
Amsterdam

1996
· Galerie Sabine Schmidt, Köln
· Galerie Bob van Orsouw, Zürich
· Galerie Paul Andriesse, Amsterdam
· Le Consortium, Dijon

1997
· Galerie Mot & Van den Boogaard,
Brüssel
· Location, The Photographers' Gallery,
London

1998
· Menschenbilder, Museum Folkwang
Essen, Essen / Galerie der Hochschule
für Grafik und Buchkunst, Leipzig
· About the world,
Sprengel Museum Hannover, Hannover
· Museum Boijmans Van Beuningen,
Rotterdam

1999
· Annemiek,
Antony d'Offay Gallery, London
· The Buzzclub, Mysteryworld Zaandam,
MACBA, Barcelona
· Israel Portraits,
The Herzliya Museum of Art, Herzliya
· Portraits, DAAD Galerie, Berlin

2000
· Antony d'Offay Gallery, London

2001
· Galerie Max Hetzler, Berlin
· The French Foreign Legion and
The Tiergarten Series,
Frans Hals Museum, Haarlem
· Focus: Rineke Dijkstra,
The Art Institute of Chicago, Chicago
· Portraits, ICA, Boston
· The French Foreign Legion,
Galerie Jan Mot, Brüssel

2003
· The Buzzclub, Kunstverein für die
Rheinlande und Westfalen, Düsseldorf

2005
· Porträts, Fotomuseum Winterthur,
Winterthur
· Portaits, Jeu de Paume, Paris

Gruppenausstellungen (Auswahl) / *Group Exhibitions (Selection)*

1996
· Prospect '96, Frankfurter Kunstverein,
Frankfurt/Main
· Aufnahmen der Normalität/
Shots of Normality,
Kunstverein Schwaz, Schwaz
· 100 foto's uit de collectie, Stedelijk
Museum, Amsterdam

1997
· Future, present, past, Corderie,
La Biennale de Venezia 42, Venedig
· Rotterdam 97 Festival:
Museum Boymans Van Beuningen,
Rotterdam
· New Photography 13,
Museum of Modern Art, New York
· Pose, foto's uit de collectie,
Stedelijk Museum, Amsterdam

1998
· Wounds: Between democracy and
redemption in contemporary art,
Moderna Museet, Stockholm
· Museum van Hedendaagse Kunst,
Gent
· Berlin/Berlin, Berlin Biennale, Berlin
· Remix, Images Photographiques,
Musée des Beaux-Arts, Nantes
· Global Vision, New Art From the 90's,
Parts III, Deste Foundation, Athen
· XXIV Bienal Internacional de
São Paulo, São Paulo
· Singularités Croissées,
Musée Départemental d'Art
Contemporain, Rochechouart
· Sightings, New Photography Art,
ICA, London

1999
· The Citibank Private Bank
Photography Prize,
The Photographers' Gallery, London
· Objects in the rear view mirror may
appear closer than they are,
Galerie Max Hetzler, Berlin
· Macht und Fürsorge, Das Bild der
Mutter in der zeitgenössischen Kunst,
Trinitätskirche, Köln
· Regarding Beauty in Performance and
the Media Arts, Hirshhorn Museum and
Sculpture Garden, Washington D.C.
· Modern Starts: People, Places, Things,
Museum of Modern Art, New York

2000
· Eurovision,
The Saatchi Gallery, London
· Let's entertain,
Walker Art Center, Minneapolis
· Close up, Kunstverein Freiburg,
Freiburg/Breisgau
· Some parts of this world,
Helsinki Photography Festival, Helsinki
· How you look at it. Fotografien des
20. Jahrhunderts,
Sprengel Museum Hannover, Hannover
· AutoWerke, European and American
Photography, Deichtorhallen Hamburg,
Hamburg

2001
· At Sea, Tate Liverpool, Liverpool
· KinderBlicke, Childhood and Modern Art from Klee to Boltanski, Städtische Galerie, Bietigheim-Bissingen
· Uniform – ordine e disordine, Pitti Immagine, Florenz / P.S.1 Contempor-ary Art Center, New York
· Platform of Humankind, Biennale di Venezia, Venedig
· Ohne Zögern – Without Hesitation, Views of the Olbricht Collection, Neues Museum Weserburg Bremen, Bremen
· Let's Entertain, Miami Art Museum, Miami
· This Side of Paradise, Marian Goodman Gallery, New York
· Jongens van Jan de Witt, De Nieuwe Kerk, Amsterdam
· Recente Aanwinsten, Stedelijk Museum, Amsterdam
· Autowerke, Hedendaagse Europese en Amerikaanse Fotografie, Frans Hals Museum, Haarlem
· Work, Dutch Woman Photographers / Collection Randstad Netherlands, Holland Tunnel, Brooklyn/New York
· Tirana Biennale, Tirana
· The Beauty of Intimacy, Kunstraum Innsbruck, Innsbruck

2002
· L'Herbier & le Nuage, Musée des Arts Contemporains grand Hornu, Hornu
· Fotodocs, Museum Boijmans Van Beuningen, Rotterdam
· Lila, weiß und andere Farben, Galerie Max Hetzler, Berlin
· On the waterfront: mode – beeldende kunst – vormgeving, Stedelijk Museum Schiedam, Schiedam
· Maskers af!, Stedelijk Museum, Amsterdam
· De Groote Hoop: Nederlandse Kunst 1960–2003, Stedelijk Museum Schiedam, Schiedam / Fries Museum Leeuwarden, Leeuwarden
· Lost Past 2001–1914, Parcours tentoonstelling, Leper
· Spread in Prato, Dryphoto arte contemporanea, Prato
· Moving Pictures, Solomon R. Guggenheim Museum, New York
· Remix, Tate Liverpool, Liverpool
· Walk Around Time: Selection from the permanent Collection, Walker Art Center, Minneapolis
· The Beach, The Gallery at Windsor, Vero Beach/Florida
· Performing Bodys, Moderna Musset, Stockholm

2003
· Die Realität der Bilder – Zeitgenössische Kunst aus den Niederlanden, Stadtgalerie Kiel, Kiel
· Foto Biennale Rotterdam, Nederlands Fotomuseum, Rotterdam
· Imagine, you are standing here in front of me (Caldic Collection), Museum Boijmans Van Beuningen, Rotterdam

2004
· Emotion Eins, Frankfurter Kunstverein, Frankfurt/Main
· Faces, Places,Traces: New Acquisitions of the Photographs Collection, The National Gallery of Canada, Ottawa
· Historias, Photo Espagna, Real Jardin Botanico, Madrid
· Je t'envisage. La Disparition du Portrait, Musée de L'Elysée, Lausanne
· Light and Atmosphere, Miami Art Museum, Miami
· Lonely Planet, Contemporary Art Center, Mito
· Monument to Now, The Dakis Joannou Collection, Desta Foundation, Athen
· Roots, Amsterdams Centrum voor Fotografie, Amsterdam
· Secrets of the 90s. Keuze uit de Collectie van het Stedelijk Museum Amsterdam, Museum voor Moderne Kunst, Arnhem
· Strange days, Museum of Contemporary Art, Chicago

2005
· Coolhunters. Jugendkulturen zwischen Medien und Markt, ZKM zu Gast in der Städtischen Galerie, Städtische Galerie, Karlsruhe

Bibliografie (Auswahl) / *Bibliography (Selection)*

Rineke Dijkstra, Ausst.-Kat. Kunstcentrum Niggendijker, Groningen 1995

Beaches, Ausst.-Kat. Galerie Bob van Orsouw, Zürich 1996

Location, Ausst.-Kat. The Photographers' Gallery, London 1997

PhotoWork(s) in Progress, Constructing Identity, Ausst.-Kat. Nederlands Foto Instituut, Rotterdam 1997

Futuro, Presente, Passato, Ausst.-Kat. La Biennale di Venezia 42, Venedig 1997

Über die Welt/About the world, Rineke Dijkstra, The Buzzclub/Mysteryworld, Ausst.-Kat. Sprengel Museum Hannover 1998

Rineke Dijkstra – Menschenbilder, Ausst.-Kat. Museum Folkwang Essen 1998

C. Bischop, Rineke Dijkstra, The Naked Immediacy of Photography, in: Flash Art, November/Dezember 1998

ModernStarts, people, places, things, Ausst.-Kat. Museum of Modern Art, New York 1999

AutoWerke II, hrsg. von Jone Elissa Scherf, Ostfildern 2000

Eurovision, Ausst.-Kat. The Saatchi Gallery, London 1999/2000

Die Berliner Zeit, Ausst.-Kat. DAAD Galerie Berlin 2000

Let's entertain, Ausst.-Kat. Walker Art Center, Minneapolis 2000

Israel Portraits – Rineke Dijkstra, Ausst.-Kat. The Herzliya Museum of Art, Herzliya, Tel Aviv 2001

Rineke Dijkstra – Beach Portraits, hrsg. von Thomas C. Heagy, James N. Wood, Carol Ehlers, James Rondeau, LaSalle Bank, Chicago 2002

Rineke Dijkstra, Portraits, hrsg. von Urs Stahel, Hripsimé Visser, München 2004

1963 geboren / *born* in Cleveland/Ohio,
 lebt / *lives* in New York

 studied at Cooper Union, New York

Einzelausstellungen (Auswahl) /
Solo Exhibitions (Selection)

1998 • Paula Allen Gallery, New York

1999 • Visions Brasilia,
 Robert Miller Gallery, New York

2000 • Wired/Wired,
 Robert Miller Gallery, New York

2001 • White/Wired,
 Galerie Thaddaeus Ropac, Paris

Gruppenausstellungen (Auswahl) /
Group Exhibitions (Selection)

1999 • The Unprivate House,
 Museum of Modern Art, New York

2000 • Crossing the Line: Photography
 Reconsidered,
 The Art Institute of Chicago, Chicago
 • Brasilia de 0 a 40 Anos: Duas Visöes.
 Fotografias de Robert Polidori e
 Todd Eberle, Brasilia
 • Photography Now,
 Contemporary Arts Center,
 New Orleans
 • AutoWerke, European and American
 Photography,
 Deichtorhallen Hamburg, Hamburg

2001 • AutoWerke, Hedengaagse Europese en
 Amerikaanse fotografie,
 Frans Hals Museum, Haarlem

Bibliografie (Auswahl) / *Bibliography (Selection)*

Donald Judd Furniture Retrospective, Ausst.-Kat.
Museum Boymans Van Beuningen, Rotterdam 1993

Todd Eberle, in: Vanity Fair, Februar/1999

J. Hogrefe, Two Photographers Who've Seen the
Future, in: The New York Observer, 29.03.1999

Todd Eberle, in: NY Arts 5/1999

McDonough, Re-Visioning Brasilia, in: Art in
America, Januar/1998

Brasilia de 0 a 40 Anos: Duas Visöes. Fotografias
de Robert Polidori e Todd Eberle. Brasilia: From
0 to 40: Two Visions. Photographs by Robert
Polidori and Todd Eberle, Ausst.-Kat. Brasilia 2000

AutoWerke, hrsg. von Christa Aboitiz u. a.,
Ostfildern 2000

NINA FISCHER

1965 geboren / *born* in Emden, lebt / *lives* in Berlin

1987–1992 Studium Visuelle Kommunikation an der / *Studies of visual communication at* Hochschule der Künste Berlin, Berlin

1989–1990 Studium Audiovisuel an der / *Studies of visual communication at* Gerrit Rietveld Akademie, Amsterdam

MAROAN EL SANI

1966 geboren in / *born in* Duisburg, lebt / *lives* in Berlin

1988–1995 Studium der Kommunikationswissenschaften und Film an der / *Studies of communication sciences and film at* Freien Universität Berlin, Berlin (MA)

Künstlerische Zusammenarbeit seit 1993 / *Artistic collaboration since 1993*

Einzelausstellungen (Auswahl) / *Solo Exhibitions (Selection)*

1995 · Förderkoje, Art Cologne '95, Köln

1996 · Galerie Meile, Luzern
· Galerie L, Moskau
· Galerie P-House, Tokio

1998 · Galerie Eigen + Art, Berlin
· Tokyo Metropolitan Museum of Photography, Tokio

1999 · Tsunami and other secrets, Städtische Galerie für Gegenwartskunst, Kunsthaus Dresden, Dresden

2000 · Goethe-Institut, Paris

2001 · Artists, Platform, Vaasa
· Galerie Eigen + Art, Leipzig

2002 · Klub der Republik, Galerie Eigen + Art, Berlin

2004 · Galerie Eigen + Art, Leipzig

2005 · 273,15 Grad Celsius = 0 Kelvin, Yamaguchi Center for Arts and Media, Yamaguchi/Japan

Gruppenausstellungen (Auswahl) / *Group Exhibitions (Selection)*

1993 · Galerie Eigen + Art, Berlin
1994 · Minima Media, Medienbiennale '94, Leipzig
· Independent Art Space, London

1995 · Urbane Legenden-Berlin, Staatliche Kunsthalle Baden-Baden, Baden-Baden
· Film Cuts, Galerie neugerriemschneider, Berlin
· Beyond the Borders, Kwangju Biennial '95, Südkorea

1996 · Blick ins 21. Jahrhundert, Kunstverein Düsseldorf, Düsseldorf
· Discord – Sabotage of Realities, Kunsthaus und Kunstverein Hamburg, Hamburg
· Unikumok, Ernst Muzeum, Budapest
· After Dark, Stichting de Appel, Amsterdam
· On Camp/Off Base, Tokyo Big Sight, Tokio
· Surfing Systems, Kasseler Kunstverein, Museum Fridericianum, Kassel
· Smart Show, project room, Art Fair, Stockholm
· Disneyland After Dark, Kunstamt Kreuzberg, Berlin

1997 · Correspondences: Berlin – Scotland, National Galleries of Scotland, Edinburgh
· Korrespondenzen: Schottland – Berlin, Berlinische Galerie, Berlin
· In medias res, Grenzenlos, Berlin Photography in Istanbul, Dolmabahce Palast, Istanbul

1998 · Plattform, Berlin Biennale, Berlin
· ISEA, Liverpool / Manchester
· art club berlin, Mies van der Rohe Pavillon, Barcelona
· Transmission, Espace des Artes, Chalon-sur-Sâone

1999 · Liverpool Biennial of Contemporary Art, Liverpool
· Welcome to the Art World, Badischer Kunstverein, Karlsruhe
· Chronos & Kairos, Museum Fridericianum, Kassel
· FilmArt, Art Basel, Basel
· IDEAL – eine Videothek, ship on the Vierwaldstädter Lake, Luzern
· Sampling, Ronald Feldman Gallery, New York
· ambi in /out, Haus des Lehrers, Berlin
· art club Berlin, au base, New York

2000 · art club Berlin, W 139, Amsterdam
· [re: songlines], Halle für Kunst, Lüneburg
· Heldenfrühstück, Kunstverein Rosenheim, Rosenheim
· Berlin-Binnendifferenz, Benger Areal, Bregenz / 7-Kapellen Areal, Innsbruck
· Galerie Krinzinger, Wien
· AutoWerke, European and American Photography, Deichtorhallen Hamburg, Hamburg
· QUOBO, Kunst in Berlin 1989 bis 1999, IFA, Hongkong Arts Centre, Hongkong
· Artistenmetaphysik – Friedrich Nietzsche in der Kunst der Nachmoderne, Haus am Waldsee, Berlin
· Artroom Berlin, Centrum Sztuki Wspolczesnej Zamek Ujazdowski, Warschau
· Durchreise, Künstlerhaus Bethanien, Berlin

2001 · Anstoss, Kunstverein Nürnberg, Nürnberg
· QUOBO, Art in Berlin 1989–1999, IFA, Hamburger Bahnhof – Museum für Gegenwart, Berlin / National Museum, Jakarta
· Waikato Museum of Art and History, Hamilton/Neuseeland
· AutoWerke, AutoWerke, Hedengaagse Europese en Amerikaanse fotografie, Frans Hals Museum, Haarlem
· Berlin_London_2001, ICA, London

2002	· Sommer bei Eigen + Art, Galerie Eigen + Art, Leipzig · (The Wold May Be) Fantastic, Biennale of Sydney, Sydney · P_A_U_S_E, 4th Gwangju Biennale, Gwangju/Südkorea · Die Stadt, Städtische Galerie, Delmenhorst · Present Tense, Bard College, Center for Curatorial Studies, New York · QUOBO, Art in Berlin 1989–1999, IFA, Sungkok Art Museum, Seoul / Museum of Contemporary Art, Tokio · manifesta 4, European Biennial for Contemporary Art, Frankfurt/Main · Berlino Nuova Città D'Arte, Opera Paese, Rom	

Bibliografie (Auswahl) / *Bibliography (Selection)*

Nina Fischer, Ebbe und Flut, Buch-Edition, Berlin 1990

Nina Fischer, Jahreslabor – ein Bericht, Ausst.-Kat. Berlinische Galerie, Berlin 1992

Nina Fischer, Maroan el Sani, Neue Produkte aus der Chaosforschung, Broschüre, limit. Auflage, Berlin 1993

Minima Media, Ausst.-Kat. Medienbiennale Leipzig 10/94, 1994

Nina Fischer, Maroan el Sani, Nahubek, Ausst.- Kat. Galerie Fragnera, Prag 1994

Art Cologne 95, Ausst.-Kat. Köln 1995, S. 493

Kwangju Biennale '95, Korea 1995, S. 142–143

Urbane Legenden – Berlin, Ausst.-Kat. Staatliche Kunsthalle Baden Baden 1995

Unfrieden – Sabotage von Wirklichkeiten, Ausst.-Kat. Kunsthaus und Kunstverein Hamburg 1996

Nina Fischer & Maroan el Sani, The Desire of Making the Invisible Visible, Berlin 1996

Krystian Woznicki, Don't trust technology, Gallery P-House, Tokio 1996

Surfing Systems, Ausst.-Kat. und CD-ROM, Kasseler Kunstverein, Museum Fridericianum, Kassel, Frankfurt/Main 1996

In Media Res, Grenzenlos, Berlin Photography, Ausst.-Kat. Dolmabahce Palast, Istanbul 1997

Korrespondenzen, 12 Künstler aus Schottland und Berlin, Ausst.-Kat. Berlinische Galerie, Berlin 1997

revolution 98, exhibitions and events accompaning the ninth International Symposium on Electronic Art, Liverpool 1998

Nina Fischer, Maroan el Sani, Klub2000, Rom – Paris – Marzahn, Berlin 1998

Nina Fischer & Maroan el Sani, Aura Research – between light and darkness, Ausst.-Kat. Metropolitan Museum of Photography, Tokio 1998

Nina Fischer & Maroan el Sani, Roma/Amor, Leporello, hrsg. von der Deutschen Akademie Villa Massimo, Rom 1999

Trace, Ausst.-Kat. The Liverpool Biennial of Contemporary Art and Tate Gallery, Liverpool 1999

Nina Fischer, Maroan el Sani, Tsunami, Ausst.-Kat. Kunst Haus Dresden, Städtische Galerie für Gegenwartskunst, Dresden 1999

Nina Fischer, Maroan el Sani, Ideal, Eine Videothek auf dem Kursschiff MS Waldstätter, Vierwaldstättersee, Ausst.-Kat. Luzern 1999

Quobo, Kunst in Berlin 1989-1999, Ausst.-Kat. Institut für Auslandsbeziehungen e.V., Stuttgart 2000

AutoWerke II, hrsg. von Jone Elissa Scherf, Ostfildern 2000

trans plant, Living vegetation in contemporary art, hrsg. von Barbara Nemitz, Ostfildern 2000

Artistenmetaphysik – Friedrich Nietzsche in der Kunst der Nachmoderne, Ausst.-Kat. Haus am Waldsee, Berlin 2000

(The World May Be) Fantastic, Ausst.-Kat. Biennale of Sydney 2002

P_A_U_S_E, Ausst.-Kat. 4. Gwangju Biennale, Korea 2002

Die Stadt, Ausst.-Kat. Städtische Galerie, Delmenhorst 2002

Manifesta 4, Ausst.-Kat. European Biennial for Contemporary Art, Frankfurt/Main 2002

arcadia – the other life of video games, published on the occasion of the exhibition at Govett-Brewster Art Gallery, New Plymouth 2003

BerlinskajaLazur, Junge Fotokunst aus Berlin, Ausst.-Kat. Neuer Berliner Kunstverein, Martin-Gropius-Bau, Berlin 2003

Jill Winder, Fischer & el Sani. Palast der Republik, in: Die Aufgabe der Zeit, hrsg. von Carina Plath, Ausst.-Kat. Westfälischer Kunstverein Münster 2003, S. 24–29

2003	· 40 Jahre das kleine Fernsehspiel ZDF, Filmmuseum Berlin, Berlin · Sommer bei Eigen + Art, Galerie Eigen + Art, Berlin · QUOBO, Art in Berlin 1989–1999, Museo de Arte Carillo Gil, Carillo Gil/Mexico City · Die Räume der Macht/Die Macht der Räume, Schloss Sacrow, Sacrow · From Dust to Dusk – Art Between Light and Dirt, Charlottenborg, Kopenhagen · 1site2places, Galerie der Stadt Sindelfingen, Sindelfingen
2004	· Made in Berlin, Sonderausstellung zum Art Forum Berlin, Berlin · Die Zukunft ist nicht, was sie einmal war, Galerie für Zeitgenössische Kunst, Leipzig · QUOBO, Art in Berlin 1989–1999 Museo de Artes Visuales, Santiago Centro/Chile · Fondacion Proa, Buenos Aires · Ueberreichweiten, ACC Galerie, Weimar · Senats-Stipendiaten-Ausstellung, Kunstbank, Berlin · Berlin's Sky Blue / Berlinskaja Lazur. Junge Fotokunst aus Berlin, Martin-Gropius-Bau, Berlin / House of Photography, Moskau
2005	· Superstars – Das Prinzip der Prominenz in der Kunst, Kunsthalle Wien und Kunstforum, Wien · Circa Berlin im Nikolaj Contemporary Art Center, Kopenhagen · Portrait, Galerie Eigen + Art, Berlin · Überreichweiten Motorenhalle, Projektzentrum für zeitgenössische Kunst, Dresden

1960 geboren / *born* in Fukuoka/Japan,
lebt / *lives* in New York

Einzelausstellungen (Auswahl) /
Solo Exhibitions (Selection)

1988 · Passing Moments,
Gallery Tamaya, Tokio
· Out of Breath,
Gallery Parergon II, Tokio

1989 · Entropaia,
Citicorp Citibank Shinjuku, Tokio
· Yeaning of Montezumam,
Taipei Fine Arts Museum, Taipei
· Influenza, Art Gallery of the Faculty of
Painting, Sculpture and Graphic Art in
Silpakom University, Bangkok

1990 · Frostbite, Gallery Surge, Tokio Placebo
is Missing, W139, Amsterdam

1991 · Entropaia, Gallery Fukuyama, Tokio
· To Become Dharma, de Vleeshal,
Middelburg
· Dreams of Tokio, Galerie d'Eendt,
Amsterdam

1992 · Meaning Rely On Your Attitude,
Gallery Fukuyama, Tokio
· A Temptation to be a Man,
Marc Jancou Gallery, Zürich
· Je veux être amoureux de vous,
MA Galerie, Paris

1993 · The Greatest, Gallery HAM, Nagoya

1994 · Just before the Last Moment in the
Twentieth Century,
American Fine Arts Co., New York
· Frostbite, Art & Public, Genf
· Women, Children and the Japanese,
Wako Works of Art, Tokio

1995 · Why do the Japanese dislike the lapa-
nese?, Gallery HAM, Nagoya
· A Destination of Ego,
Galerie d'Eendt, Amsterdam
· L'Autre Permanent,
Galerie Emmanuel Perrotin, Paris

1996 · Frostbite/Women, Children and
Japanese, Wako Works of Art, Tokio
· Complex of Pieter Bruegel, Zeno X
Gallery, Antwerpen

1997 · Garden of Nirvana,
Deitch Projects, New York
· Reconfirmation, Galerie Gabriele Rivet,
Köln
· La Vertu dans le Uce,
Galerie Emmanuel Perrotin, Paris
· S, Centre d' Art Neuchatel, Neuchatel

1998 · Galleria Massimo De Carlo, Mailand
· The Reason of Life,
Deitch Projects, New York
· The Flame of Wandering,
Wako Works of Art, Tokio
· Forty Years Behind Paris,
Taka Ishü Gallery, Santa Monica

1999	· Serge Ziegler Galerie, Zürich
2002	· Wako Works of Art, Tokio
2004	· Zeno X Gallery, Antwerpen
2005	· Salon 94, New York

Gruppenausstellungen (Auswahl) / *Group Exhibitions (Selection)*

1993	· Dreams of Tokio, Museum für Moderne Kunst, Frankfurt/Main
1996	· A Window of Society, Hiroshima Museum of Contemporary Art, Tokio
1998	· Crossings – Kunst zum Sehen und Hören, Kunsthalle Wien, Wien
1999	· Voor het verdwijnt en erna, Stedelijk Museum voor Actuele Kunst, Gent · Collections, Museum of Contemporary Art, Tokio
2000	· The very first, Galerie Gabriele Rivet, Köln · AutoWerke, European and American Photography, Deichtorhallen Hamburg, Hamburg
2001	· AutoWerke, Hedengaagse Europese en Amerikaanse fotografie, Frans Hals Museum, Haarlem · Casino 2001: 1st Quadrennial, Stedelijk Museum voor Actuele Kunst, Gent · The very last, Galerie Gabriele Rivet, Köln
2002	· Formen der Gewalt, Galerie Gabriele Rivet, Köln
2003	· Das lebendige Museum, Museum für Moderne Kunst, Frankfurt/Main · Fondazione Sandretto Re Rebaudengo, Turin
2004	· Memorable Memory, Migros Museum Collection, Neue Kunsthalle, St. Gallen · Black & White, Galerie Gabriele Rivet, Köln · Dwelling, Tina Kim Fine Art, New York · Grasduinen I, Stedelijk Museum voor Actuele Kunst, Gent · Mixed farming, Nederlands Foto Instituut, Rotterdam · Aufruhr der Gefühle. Leidenschaften in der zeitgenössischen Fotografie, Museum für Photographie, Braunschweig / Kunsthalle Göppingen, Göppingen

Bibliografie (Auswahl) / *Bibliography (Selection)*

In the garden of Nirvana: Interview with Noritoshi Hirakawa, in: Parachute. Contemporary Art Magazine, Oktober/1997

Peter Weiermair, Gerald Matt, Japanese Photography: Desire and Void, Zürich 1997

Joshua Decter, Noritoshi Hirakawa, in: Flash Art 32/1999, S. 97–99

AutoWerke, hrsg. von Christa Aboitiz u. a., Ostfildern 2000

1944	geboren / *born* in Eberswalde, lebt in / *lives* in Köln / *Cologne*
1973–1976	Kunstakademie Düsseldorf, Düsseldorf
1997–2000	Professur an der / *Professor at the* Staatlichen Hochschule für Gestaltung, Karlsruhe

Einzelausstellungen (Auswahl) /
Solo Exhibitions (Selection)

1975	· Galerie Konrad Fischer, Düsseldorf
1979	· Galerie Arno Kohnen, Düsseldorf
1982	· Photographische Sammlung, Museum Folkwang Essen, Essen
1984	· Innenraum Fotografien 1979–1984, Rheinisches Landesmuseum Bonn, Bonn
1985	· Räume, Galerie Rüdiger Schöttle, München
1988	· Galerie Johnen & Schöttle, Köln
1989	· Galerie Faust, Genf · Galerie Westersingel 8, Rotterdam · Galerie Wilma Tolksdorf, Hamburg · Kunstverein Bremerhaven, Bremerhaven
1990	· Franz Paludetto, Turin · Galerie Rüdiger Schöttle, München · Galerie Wilma Tolksdorf, Hamburg · Nicole Klagsburn, New York
1991	· Galerie Walcheturm, Zürich
1992	· Photographie, Hagener Kunstverein, Hagen · Galerie Grita Insam, Wien · Galerie Johnen & Schöttle, Köln · Karl Ernst Osthaus-Museum, Hagen · Nicole Klagsburn, New York · Portikus, Frankfurt/Main · Städtische Galerie Haus Seel, Siegen
1993	· Zoologische Gärten, Galerie Walcheturm, Zürich / Hamburger Kunsthalle, Hamburg · F-Stop Gallery, Bath · Anderson O'Day Gallery, London · Galerie Wilma Tolksdorf, Hamburg · Leonhardi Museum, Dresden
1994	· Anderson O'Day Gallery, London · Castello di Rivoli, Turin · Galerie Meyer, Karlsruhe · L'Aquarium, Galerie d'Ecole des Beaux-Arts de Valenciennes, Valenciennes · Neuer Aachener Kunstverein, Aachen
1995	· Galerie Rüdiger Schöttle, München · Galleri Tommy Lund, Odense · Sonnabend Gallery, New York
1996	· Rena Bransten Gallery, San Francisco
1997	· Intérieurs, Galerie Condé, Paris · Centre Photographique d'Ile de France, Pontault-Combault

1998	· Galerie Wilma Tolksdorf, Frankfurt/Main · Kunstverein Recklinghausen, Recklinghausen
1999	· Galerie Friedrich, Bern · Galerie Karlheinz Meyer, Karlsruhe · Kunsthalle Basel, Basel
2000	· Espais, Galeria Visor, Valencia · Fotografien, Produzentengalerie Hamburg, Hamburg · Museumsbilder, Kupferstich-Kabinett, Dresden · Natuurruimten, Natuurmuseum Rotterdam, Rotterdam · Neue Fotoarbeiten, Galerie Rüdiger Schöttle, München · Orte. Jahre. Photographien 1968–1999, Kunsthalle Nürnberg, Nürnberg · The National Targeting images, objects + ideas, Museum of Contemporary Photography, Chicago · Galeria Fucares, Madrid · Galerie Johnen & Schöttle, Köln · Gregorio Magnani, London · Karyn Lovegrove Gallery, Los Angeles · Modulo, Centro Difusor de Arte, Lissabon · Palacio del Embarcadero, Santander · Rena Bransten Gallery, San Francisco · Douze. Twelve, Musée des Beaux-Arts et de la Dentelle, Calais · Photographs, Rose Art Museum, Brandeis University, Waltham · Photographies recentes, Galerie Laage-Salomon, Paris · Galerie Hauser und Wirth, Zürich · Galleri K, Oslo · Karyn Lovegrove Gallery, Los Angeles · Patrick De Brock Gallery, Knokke · Rena Bransten Gallery, San Francisco · Sonnabend Gallery, New York
2002	· Kunstforum Bâloise, Basel · Altonaer Museum in Hamburg, Hamburg · Galerie Karlheinz Meyer, Karlsruhe · Leseräume II, Krefelder Kunstmuseen, Kaiser Wilhelm Museum, Krefeld · Zwölf – Twelve, Documenta 11, Kassel · Zwölf, Georg-Kolbe-Museum, Berlin
2003	· 50th Venice Biennale, Deutscher Pavillion, Venedig · Antiquariat Grundel Gelbert, Köln · Galerie Rüdiger Schöttle, München · Galerie Johnen & Schöttle, Köln · New Photographs, Rena Bransten Gallery, San Francisco · Dresden series and other works, Galleri K, Oslo · Kunsthalle Bremen, Bremen

2004 · Candida Höfer in ethnographischen
Sammlungen, Völkerkundemuseum,
Zürich
· Schloss St. Emmeran Regensburg,
Marstall des Fürstlichen Schlosses,
Regensburg
· Traces – Spuren,
Goethe Institut, New York
· Arte Contemporanea Alberto Peola,
Turin
· Galerie Rudiger Schöttle, München
· Sonnabend Gallery, New York
· Kunsthalle zu Kiel, Kiel

2005 · Architecture of Absence, University
Art Museum, Long Beach
· Rena Bransten Gallery, San Francisco
· The Sheldon Art Galleries, St. Louis
· Kupferstich-Kabinett, Dresden
· Museum of Photography,
Det KGL Bibliothek, Kopenhagen
· Kestner Gesellschaft, Hannover

Gruppenausstellungen (Auswahl) /
Group Exhibitions (Selection)

1976 · Nachbarschaft,
Kunsthalle Düsseldorf, Düsseldorf

1978 · Europa und Vorderasien,
Museum für Völkerkunde, Hamburg

1979 · In Deutschland – Aspekte
gegenwärtiger Dokumentarfotografie,
Rheinisches Landesmuseum Bonn,
Bonn
· Schlaglichter. Eine Bestandsaufnahme
aktueller Kunst im Rheinland 1979,
Rheinisches Landesmuseum Bonn,
Bonn

1981 · Galerie Konrad Fischer (Förder-
programm für junge Kunst), Köln
· Internationaler Kunstmarkt, Köln

1982 · Work by Young Photographers from
Germany, Art Galaxy, New York

1983 · 22 Fotografinnen. Ein Querschnitt
Zeitgenössischer Fotografie,
Hahnentorburg, Köln

1984 · Aus den Trümmern, Rheinisches
Landesmuseum Bonn, Bonn

1986 · Fotografie und Skulptur,
Hansaallee, Düsseldorf
· Sieben Fotografen,
Galerie Rüdiger Schöttle, München
· Ausstellungsraum Brukenstrasse,
Düsseldorf

1987 · Foto/Realismen, Kunstverein
München, München / Nationalgalerie
im Kunstforum der Grundkreditbank,
Berlin / Villa Dessauer, Bamberg

1988 · Fotografen, APAC, Nevers
· Klasse Bernhard Becher,
Galerie Johnen & Schöttle, Köln
· Galerie Rüdiger Schöttle, München

1989 · Accrochage II,
Galerie Meert/Rihoux, Brüssel
· Sei Artisti Tedeschi,
Castello di Rivoli, Turin
· Shifting Focus, Arnolfini Gallery,
Bristol / Serpentine Gallery, London

1990 · German Photography. Documentation
and Introspection, Aldrich Museum
of Contemporary Art, Ridgefield
· Kunstverein Ulm, Ulm
· Perspectives on Place – Attitudes
Toward the Built Environment,
University Art Gallery, San Diego

1991 · Aus der Distanz, Kunstsammlung
Nordrhein-Westfalen, Düsseldorf
· Paesaggi – La Scuola di Rivara,
Castello di Rivoli, Turin
· Typologies: Nine Contemporary
Photographers,
Newport Harbor Art Museum,
Newport Beach

1992 · Finale,
Josef-Haubrich-Kunsthalle, Köln
· Four Visions of Interior and Exterior
Landscapes,
Galerie Lehmann, Lausanne
· Humpty Dumpty's Caleidoscope:
A New Generation of German Artists,
Museum of Contemporary Art, Sydney

1993 · Distanz und Nähe,
Neue Nationalgalerie, Berlin
· Photographie in der deutschen
Gegenwartskunst,
Museum Ludwig, Köln

1994 · Architektur in der Photographie,
Galerie Wilma Tolksdorf, Hamburg
· Deutsche Kunst mit Photographie.
Die 90er Jahre,
Rheinisches Landesmuseum Bonn,
Bonn
· Los Gerneros de la Pintura,
Centro Atlantico de Arte Moderna,
Las Palmas

1995 · Beyond Recognition, Contemporary
International Photography,
National Gallery of Australia, Canberra
· Five Photographers,
Rena Bransten Gallery, San Francisco
· Giovani Artisti Tedeschi,
Centro d'Arte Contemporanea,
Castello di Rivoli, Turin
· Zimmerdenkmäler,
Blumenstrasse, Bochum

1997 · Salzburger Kunstverein, Salzburg
· Normotic, One Great Jones, New York

1998 · Spread,
Rena Bransten Gallery, San Francisco
· Stilleben,
Kunstverein Göppingen, Göppingen

1999 · Not There,
Rena Bransten Gallery, San Francisco

2000 · Ansicht Aussicht Einsicht, Krakau
· Architecture without shadow,
Centro de Cultura Contemporanea,
Barcelona
· Inside Out: Reality or Fiction?,
Sean Kelly Gallery, New York
· Of the Moment: Contemporary Art from
the Permanent Collection, SFMOMA,
San Francisco
· Paper Cuts,
Rena Bransten Gallery, San Francisco
· Kunsthalle Kornwestheim, Stuttgart
· Museum of Contemporary Photo-
graphy, Chicago
· AutoWerke, European and American
Photography,
Deichtorhallen Hamburg, Hamburg

2001 · AutoWerke, Hedengaagse Europese
en Amerikaanse fotografie,
Frans Hals Museum, Haarlem
· Depicting Absence/Implying Presence,
San Jose Institute of Contemporary
Art, San Jose
· In Between: Art and Architecture,
MAK Österreichisches Museum für
angewandte Kunst/Gegenwartskunst,
Wien
· minimalismos, un signos de los
tiempos, Museo Nacional Centro de
Arte Reina Sofia, Madrid
· Museum as Subjects,
The National Museum of Art, Osaka
· Show Time,
Rena Bransten Gallery, San Francisco

2002 · Today til now: Contemporary
Photography from Düsseldorf, Part I,
Museum Kunst Palast, Düsseldorf
· Zwischen Schönheit und Sachlichkeit,
Kunsthalle in Emden, Emden
· Startkapital,
K21 Kunstsammlung im Ständehaus,
Düsseldorf

2003	· Scenery, Rena Bransten Gallery, San Francisco	**Bibliografie (Auswahl) /** *Bibliography (Selection)*

2003 · Scenery, Rena Bransten Gallery,
 San Francisco
 · The Becher School,
 Galerie van Leeuwen, Amsterdam
 · Wonderlands – Perspektiven
 aktueller Fotografie,
 Museum Küppersmühle, Duisburg

2004 · Architecture,
 Rena Bransten Gallery, San Francisco
 · Immersion,
 The Art Institute of Boston, Boston
 · Europe in Art,
 Kunsthaus Hamburg, Hamburg
 · Artéfacts. La vie secrete des choses,
 Fondation d'art contemporain,
 Daniel et Florence Guerlain,
 Les Mesnuls
 · Biennale, Museum of New Art, Pontiac
 · Von Körpern und anderen Dingen.
 Deutsche Fotografie im 20. Jahr-
 hundert, Museum Bochum, Bochum /
 Moscow House of Photography,
 Moskau
 · /hier groeien boeken uit de grond,/
 books grow out of the ground here,
 Dutch Libraries, Huis Marseille,
 Amsterdam

2005 · Friedrich Christian Flick Collection,
 Hamburger Bahnhof – Museum für
 Gegenwart, Berlin
 · Les Grands Spectacles,
 Museum der Moderne Salzburg,
 Salzburg
 · Contemporary Visions,
 Oulun City Art Museum,
 Oulun/Finnland
 · Schrift – Bilder – Denken.
 Walter Benjamin und die Kunst der
 Gegenwart, Haus am Waldsee, Berlin

Bibliografie (Auswahl) / *Bibliography (Selection)*

Animaux et animaux. Zeitgenössische Kunst und
Zoologie, hrsg. von M. Stegmann, Kunstverein
Schaffhausen 1997

Candida Höfer, Orte Jahre. Photographien
1968–1999, Ausst.-Kat. Kunsthalle Nürnberg 1999

AutoWerke II, hrsg. von Jone Elissa Scherf,
Ostfildern 2000

Candida Höfer, hrsg. von W. Holler, Ausst.-Kat.
Kupferstich-Kabinett, Dresden 2002

Candida Höfer, Monographie,
London / München 2003

Eingelagerte Welten – Candida Höfer in
ethnographischen Sammlungen, Ausst.-Kat.
Völkerkundemuseum der Universität Zürich,
Köln 2004

1965	geboren / *born* in Bournemouth/ Großbritannien / *Great Britain,* lebt / *lives* in London
1994	London College of Printing, London, B.A. (First Class Honors)
1994–1997	Royal College of Art, London, M.A.

Einzelausstellungen (Auswahl) / *Solo Exhibitions (Selection)*

1996 · Portrait of Hackney, Cafe Alba Gallery, London

1997 · Retrospective, Photofusion Gallery, London
· Persons Unknown and Travellers, Cafe Alba Gallery, London
· Persons Unknown, Holly Street Public Arts Trust Gallery, London
· Travellers, The Bell Street Gallery, Wiltshire

2000 · Life And Death In Hackney, White Cube, London

2002 · CAC Contemporary Art Centre, Vilnius
· Thoughts of Life and Death, Manchester Art Gallery, Manchester

2003 · Life And Death In Hackney, Yancey Richardson Gallery, New York

2004 · 1997–2004, CASA Centro de Arte de Salamanca, Salamanca

2005 · The Traveller Series, Galería VISOR, Valencia

Gruppenausstellungen (Auswahl) / *Group Exhibitions (Selection)*

1994 · Top Marks, The London Institute, London
· Degree Show, London College of Printing, London

1995 · Interim Show, Royal College of Art, London

1996 · Progress, Royal College of Art, London

1997 · Modern Narrative – The Domestic and the Social, ArtSway – Contemporary Visual Arts in the New Forest, Sway/Großbritannien
· Best of Royal College of Art, Summer Show, Villa Restaurant, London

1998 · Persons Unknown, M.A.C. Gallery, Birmingham
· Summer Show, The Paton Gallery, London
· Campaign Against Living Miserably, Royal College of Art, London
· Shoreditch Biennale, London
· Whitechapel Open, The Tannery, London

1999 · Neurotic Realism (Teil 2), The Saatchi Gallery, London / The Travelling Gallery, Edinburgh
· Housing and Homeless, The Candid Gallery, London

2000 · Parallax, Sandroni Rey Gallery, Venice/USA

2001 · AutoWerke, Hedengaagse Europese en Amerikaanse fotografie, Frans Hals Museum, Haarlem
· Residual Property. Portfolio Gallery, Edinburgh
· Tracking, Kent & Vicki Logan Galleries at California College of Arts and Crafts, Oakland/USA
· Creative Quarters, Museum of London / London Look Out / Pitshanger Manor Gallery, London
· go Europe: the kaleidoscope eye, Kunsthalle im ARTmax, Braunschweig

2002 · St James Ltd Photography Prize, Flowers East, London
· De Hallen, Haarlem

2003 · True Fictions. Inszenierte Fotokunst der 90er-Jahre, Stadtgalerie Saarbrücken, Saarbrücken
· In Natura – X Biennale Internazionale di Fotografia, Fondazione Italiana per la Fotografia, Turin

2004 · Art History: Photography References Painting, Yancey Richardson Gallery, New York
· Wirklich wahr! Realitätsversprechen von Fotografien, Ruhrlandmuseum Essen, Essen
· September, Green on Red Gallery, Dublin
· Identity II, Nichido Contemporary Art, Tokio

2005 · Foreign Affair, Center for Photography at Woodstock, Woodstock

Bibliografie (Auswahl) / *Bibliography (Selection)*

Hunter Catches Prize, in: British Journal of Photography, 29.05.1996

Tom Hunter, Tower Block Series, in: Siski 10/1998

Hackney Empire, in: The Face 5/1998

Making your dreams come true, hrsg. von Jone Elissa Scherf, George St. Andrews, Ostfildern 2001

Tom Hunter, Ostfildern 2003

1959	geboren / *born* in London, lebt / *lives* in London
1978–1981	Goldsmiths College, London, B.A. (Honors)
1994–1996	Goldsmiths College, London, M.A.

Einzelausstellungen (Auswahl) /
Solo Exhibitions (Selection)

1987	· F-stop Gallery, Bath
1988	· Watershed Arts Centre, Bristol
1993	· Haies Gallery, London
1995	· Consulting Room, Galerie du Dourven, Tredrez-Locquemeau · Consulting Room (Couch), Camerawork Gallery, London
1997	· Le Consortium, Dijon · Maureen Paley Interim Art, London
1998	· Galerie Anne de Villepoix, Paris · Ecole superieure des Beaux-Arts, Tours · Sabine Knust Galerie, München
1999	· Museum Folkwang Essen, Essen · Anton Kern Gallery, New York · Centre for Photography, Universidad de Salamanca, Salamanca · Museo Nacional Centro de Arte Reina Sofia, Madrid · Maureen Paley Interim Art, London · Jerwood Space, London
2000	· Le Consortium, Dijon / Marseille / Amsterdam
2002	· Third exhibition of new photographic work, Maureen Paley Interim Art , London

Gruppenausstellungen (Auswahl) /
Group Exhibitions (Selection)

1988	· Untitled Gallery, Sheffield · The Photographers' Gallery, London
1989	· Constructed Imagery, Plovdiv Gallery, Plovdiv/Bulgarien
1990	· Next Phase, Tobacco Dock, London
1991	· Slow Horses, St. James, London
1995	· Sick, 152c Brick Lane, London Nobby Stiles, Vandy Street, London
1996	· A.C.E.I., Arts Council Collection, Hatton Gallery, Newcastle · New Contemporaries, Tate Liverpool, Liverpool / Camden Arts Centre, London
1997	· Portrait, Maureen Paley Interim Art, London · Dramatically Different, Galeries du Magasin – Centre national d'art contemporain de Grenoble, Grenoble

· Strange Days,
Gian Ferrari Arte Contemporanea,
Mailand
· On the Bright Side of Life, Zeit-
genössische britische Fotografie,
Neue Gesellschaft für bildende Kunst,
Berlin
· Galerie Gebauer, Berlin
· Galerie Anne de Villepoix, Paris
· Moulin Saint-James,
Printemps de Cahors, Cahors

1998 · Le Consortium Dijon,
Musée national d'art moderne, Paris
· Shot Without Reason,
Bloom Gallery, Amsterdam /
Ikon Gallery, Birmingham
· Made in London,
Museu de Electricidade, Lissabon
· The Erotic Sublime (Slave to
the Rhythm),
Galerie Thaddaeus Ropac, Salzburg
· Family Credit,
Collective Gallery, Edinburgh

1999 · Another Girl Another Planet,
Lawrence Rubin Greenberg Van Doren
Fine Art, New York
· 3rd International Tokyo Photo Biennial,
Metropolitan Museum of Photography,
Tokio
· Dreamlands, Portfolio Gallery,
Edinburgh

2000 · Les Trahisons du modele,
Galerie Nei Lücht, Luxemburg
· Intersection I: Intimate/Anonymous,
Espace d'art Contemporain HEC,
Jouy-en-Josas
· docudrama,
Bury St. Edmunds Art Gallery,
Bury St. Edmund
· Pause/Pose,
Galerie Anne de Villepoix, Paris
· Wooden Heart, AVCO, London
· Quotidiana, Castello di Rivoli, Turin

2001 · AutoWerke, Hedengaase Europese
en Amerikaanese fotografie,
Frans Hals Museum, Haarlem
· The Beauty of Intimicy, Lens and paper,
Kunstraum Innsbruck, Innsbruck /
Staatliche Kunsthalle Baden-Baden,
Baden-Baden

2002 · Die Wohltat der Kunst,
Staatliche Kunsthalle Baden-Baden,
Baden-Baden

2003 · Die Wohltat der Kunst, Postfeministi-
sche Positionen der 90er-Jahre,
Sammlung Goetz, München
· Child in Time: Views of contemporary
artists on youth and adolescence,
Gemeentemuseum Helmond, Helmond
· Photography,
Eleni Koroneou Gallery, Athen

2004 · Girls' Night Out, Orange County
Museum of Art, Newport Beach
· A Period Eye: Photography Then and
Now, Norwich Castle Museum & Art
Gallery, Norwich
· Just love me,
Fries Museum, Leeuwarden
· Biennale, Museum of New Art, Pontiac
· Art of the Garden, Tate Britain, London
· Take Five! Huis Marseille turns five,
Huis Marseille, Amsterdam
· Stranger Than Fiction, Abersytwyth
Arts Centre, The University of Wales,
Aberystwyth

2004 · Focus on: New Photography,
Norton Museum of Art,
West Palm Beach
· Art of the Garden,
Manchester Art Gallery, Manchester
· Attentes, Casino Luxembourg –
Forum d'art contemporain, Luxemburg

2005 · Girls' Night Out,
Orange County Museum, Newport
Beach / Aspen Art Museum, St. Louis

Bibliografie (Auswahl) / *Bibliography (Selection)*

On the Bright Side of Life, Zeitgenössische britische
Fotografie, Ausst.-Kat. Neue Gesellschaft für
bildende Kunst, Berlin 1997

Sarah Jones, in: Artforum 36/1998

Reinhart Kriechbaum, Stilleben und erotisch
Sublimes, Galerien, Salzburg, in: Handelsblatt,
14.08.1998

Michel Guerrin, Les jeunes Filles en fleurs
photographiees par Sarah Jones, in: Le Monde,
14.02.1998

Florence Maillet, Sarah Jones. Cherchez le Garçon,
in: Beaux-Arts Magazine 165/1998

Chris Townsend, Vite Bodies: Photography and the
Crisis of Looking, München 1998

John Slyce, Sarah Jones, Spatial Alienations, in:
Flash Art 32/1999

Reinhart Kriechbaum, Konzertierte Rückkehr der
Transavantgarde. Salzburger Galerienrundgang,
in: Handelsblatt, 09.04.1999

Magdalena Kröner, Sarah Jones, in: Camera Austria
International 70/2000

Making your dreams come true, hrsg. von Jone
Elissa Scherf, George St. Andrews, Ostfildern 2001

INEZ VAN LAMSWEERDE &
VINOODH MATADIN

INEZ VAN LAMSWEERDE

1963	geboren / *born* in Amsterdam, lebt / *lives* in Amsterdam, Kopenhagen, New York
1983–1985	Vogue Academy of Fashion
1985–1990	Gerrit Rietveld Akademie, Amsterdam
1992–1993	Stipendium am / *Grant at* P.S. 1 Contemporary Art Center, New York

VINOODH MATADIN

| 1961 | geboren / *born* in Amsterdam, lebt / *lives* in Amsterdam, Kopenhagen, New York |
| | Studium an der / *Studies at the* Fashion Academy, Amsterdam |

Einzelausstellungen (Auswahl) / *Solo Exhibitions (Selection)*

1992	· Vital Statistics, Center for Art and Architecture, Groningen
1993	· Heaven, Centraal Museum, Utrecht
1994	· Ottobre degli Olandesi, Studio Bocchi, Rom
1995	· The Forest, Galerie Johnen & Schöttle, Köln / Grazer Kunstverein, Graz / Torch Gallery, Amsterdam / Ars Futura Galerie, Zürich
1996	· Kunsthaus Zürich, Zürich
1997	· The Widow, Matthew Marks Gallery, New York / Galerie Johnen & Schöttle, Köln / Torch Gallery, Amsterdam / Victoria Miro Gallery, London
1998	· Me, Matthew Marks Gallery, New York
1999	· Photographs, Deichtorhallen Hamburg, Hamburg · Me, Galerie Rüdiger Schöttle, München / Doug Lawing Gallery, Houston/Texas, Air de Paris, Paris / National Gallery of Iceland, Reykjavik
2000	· Romance, White Cube, London
2004	· cenai – centre national de l'estampe et de l'art imprimé, Chatou
2005	· Simulacra and Pseudo-Likeness, National Fund of the Contemporary Art, FNAC, Paris · Going dutch: new photography from the Netherlands, Museum of Art, Pontiac

Gruppenausstellungen (Auswahl) / *Group Exhibitions (Selection)*

1992	· Double Dutch – Dutch Realism Today, Sala 1, Rom · Fotowerk, Beurs van Berlage, Amsterdam
1993	· Unfair Cologne, Gallery Snoei, Rotterdam · Art Cologne, Torch Gallery, Amsterdam · We're two inflatable dolls in a hooker's bad dream, Stedelijk Museum Bureau, Amsterdam · High Heeled Art, Charles Cowles Gallery, New York · Naardenfotofestival, Naarden Vesting · In their own Image, P.S. 1 Contemporary Art Center, New York
1994	· Spellbound, Centro Cultural de Belem, Lissabon / Asociación Cultural Cruce, Madrid / P.S. 1 Contemporary Art Center, New York · Das Archiv, Forum Stadtpark/Camera Austria, Graz · Galerie Rüdiger Schöttle, München · Stelling Gallery, Leiden · Oh Boy, It's a Girl!, Kunstverein München, München · Ik en der Ander, Dignity for All, Reflections on Humanity, Beurs van Berlage, Amsterdam · Future, Salzburger Kunstverein, Salzburg · L'Hiver de L'Amour, Musée de l'Art Moderne de la Ville de Paris, Paris · Jetlag, Martina Detterer Galerie, Frankfurt/Main · NY NL-XX, Gemeentemuseum, Helmond
1995	· Alterità e identità, Biennale di Venezia, Venedig · A Glimpse of the Norton Family Collection as revealed, Santa Monica Museum of Art, Santa Monica · Somatogenics, Artist's Selections Part 1, Artists Space, New York · Album, Museum Boymans Van Beuningen, Rotterdam · Die Muse, Gallery Thaddaeus Ropac, Salzburg · Purple Prose 8112, Gallery Jousse Sequin, Paris · Kunst-Werke Berlin, Berlin · Peiling 4, Hollandse Nieuwe, Groninger Museum, Groningen

1996 · Aldrift: Scenes from the Penetrable
Culture, Center for Curatorial Studies,
Bard College, Annandale-on-Hudson,
New York
· Printemps Ete 1996,
Groninger Museum, Groningen
· Fotografie nach der Fotografie,
Siemens Artsprogramm, München
· Het oog als lasappararaat,
Stedelijk Museum, Amsterdam
· Schiedam Images of masculinity,
Victoria Miro Gallery, London
· Non! pas comme ça!,
Centre d'art Neuchâtel, Neuchâtel

1997 · A Rose is a Rose is a Rose, Gender
Performance in Photography,
Andy Warhol Museum, Pittsburgh /
Solomon R. Guggenheim Museum,
New York
· Fracturing the Gaze,
Doug Lawing Gallery, Houston
· Inbetweener,
Center for Contemporary Arts,
Glasgow
· My Little pretty,
Museum of Contemporary Art, Chicago
· A Succession of Collections 2,
Surrealism,
Wexner Center for the Arts, Columbus
· OH Invisible Light,
Museum of Modern Art, Oxford
· Discomfort, Santa Barbara Museum
of Contemporary Arts, Santa Barbara
· Taxonomy,
Museum of Modern Art, Oxford
· Transit, 60 artistes nés 60,
ENSBA, Paris
· Sous le Manteau, Ropac Gallery, Paris
· Engel Engel, Kunsthalle Wien, Wien

1998 · California Presumed innocence,
Institute for Contemporary Art,
Amsterdam

1999 · Zeitwenden, Kunst Museum Bonn, Bonn
· I know what you did last summer,
Air de Paris, Paris
· Ghost in the shell: Photography
and the Human Soul 1850–2000,
Los Angeles County Museum of Art,
Los Angeles

2000 · AutoWerke, European and American
Photography,
Deichtorhallen Hamburg, Hamburg

2001 · AutoWerke, Hedengaagse Europese
en Amerikaanse fotografie,
Frans Hals Museum, Haarlem

2002 · Transformer II, Air de Paris, Paris
· Yohji Yamamoto: May I help You?,
MEP – Maison Européenne de la
Photographie, Paris
· Archeology of Elegance,
Deichtorhallen Hamburg, Hamburg

2003 · Yohji Yamamoto: May I help You?,
Hara Museum of Contemporary Art,
Tokio

2004 · Angelblood,
Kenny Schachter Contemporary,
New York
· About Face portrait – Photography and
the Death of the Portrait,
Hayward Gallery, London
· Making Faces: The Death of the
Portrait – Je t'envisage: La disparition
du portrait, Musée de l'Elysée,
Lausanne
· The Now People, Part One: Paradise,
Matthew Marks Gallery, New York

2005 · Fashination, Moderna Museet,
Stockholm

Bibliografie (Auswahl) / *Bibliography (Selection)*

AutoWerke, hrsg. von Christa Aboitiz u. a.,
Ostfildern 2000

Inez van Lamsweerde & Vinoodh Matadin:
Photographien, hrsg. von Francesco Bonami,
Köln 2001

Inez van Lamsweerde, Photographs, Ausst.-Kat.
Deichtorhallen Hamburg, München 2002

Verena Cuni, Mythische Körper II. Cyborg_Configu-
rationen als Formation der (Selbst-) Schöpfung im
Imaginationsraum technologischer Kreation (II):
Monströse Versprechen und posthumane Anthro-
pomorphismen, Essay im Internet:
www.medienkunstnetz.de

Yvonne Volkhart, Monströse Körper. Der verrückte
Geschlechtskörper als Schauplatz monströser
Suchtverhältnisse, Essay im Internet:
www.medienkunstnetz.de

Sigrid Schade, Die Medien/Spiele der Puppe – vom
Mannequin zum Cyborg. Das Interesse aktueller
Künstlerinnen und Künstler am Surrealismus, Essay
im Internet: www.medienkunstnetz.de

Susanne Holschbach, Kontinuitäten und
Differenzen zwischen fotografischer und post-
fotografischer Medialität, Essay im Internet:
www.medienkunstnetz.de

1960	geboren / *born* in Bronx/New York, lebt / *lives* in New York	

1980–1982 The Rhode Island School of Design, Providence

1985 Whitney Museum Independent Study Program, New York

1989 Wesleyan University, Middeltown / Connecticut

Einzelausstellungen (Auswahl) /
Solo Exhibitions (Selection)

1992
· Max Protetch Gallery, New York
· Matrix 120,
 Wadsworth Atheneum, Hartford
· CT 1991, White Columns, New York
· Project Room,
 Jack Tilton Gallery, New York

1993
· White,
 Max Protetch Gallery, New York
· To Disembark, Hirshhorn Museum and Scupture Garden, Washington D.C.

1994
· Project Room, Ruth Bloom Gallery, Santa Monica

1995
· Photos and Notes, Max Protetch Gallery, New York
· Skin Tight, MIT List Visual Arts Center, Cambridge/USA
· Des Moines Art Center, Des Moines

1996
· The Evidence of Things Not Seen: Brooklyn Museum of Art, Brooklyn/New York
· New Work,
 San Francisco Museum of Modern Art, San Francisco

1997
· Day of Absence,
 Ezra and Cecile Zilkha Gallery,
 Center for the Arts, Wesleyan University, Middletown

1998
· Unbecoming,
 Institute of Contemporary Art, Philadelphia

2000
· Coloring,
 Walker Art Center, Minneapolis

2001
· Portraits and Non-Portraits, Kunstverein München, München
· Stranger,
 The Studio Museum in Haarlem, New York
· Coloured, D'Amelio Terras, New York

2002
· Anthony Meier Fine Art, San Francisco

2003
· Going There, D'AmelioTerras, New York
· Annotations,
 Dia Center for the Arts, New York

2004
· Regen Projects, Los Angeles

2005
· Some changes,
 The Power Plant Contemporary Art Center, Toronto

Gruppenausstellungen (Auswahl) /
Group Exhibitions (Selection)

1991
· Biennial,
 Whitney Museum of American Art, New York

1992
· Good Mirrors Are Not Cheap, Whitney Museum of American Art at Philip Morris, New York / Museum of Fine Arts, Boston

1994
· Duchamp's Leg,
 Walker Art Center, Minneapolis

1995
· Skin Type,
 MIT List Visual Arts Center, Cambridge/USA

1996
· Inclusion I Exclusion: Art in the Age of Post-Colonialism and Global Migration, Steirischer Herbst 96, Graz
· 10th Biennale of Sydney, Sydney
· Jurassic Technologies Reverant, Art Gallery of New South Wales, Sydney

1997
· Coming Age,
 White Columbus New York, New York

1998
· Rhapsodies in Black,
 Hayward Gallery, London

1999
· The American Century: Art and Culture 1900–2000,
 Whitney Museum of American Art, New York
· Other Narratives: Fifteen Years, Contemporary Arts Museum, Houston

2000
· AutoWerke, European and American Photography,
 Deichtorhallen Hamburg, Hamburg
· Coloring: New York,
 Walker Art Center, Minneapolis
· Good Business is the Best Art, The Bronx Museum of New York, New York

2001
· AutoWerke, Hedengaagse Europese en Amerikaanse fotografie, Frans Hals Museum, Haarlem

2002
· Documenta XI, Kassel

2003
· Annotations,
 Dia Center for the Arts, New York
· Fast Forward: Twenty Years of White Room, White Columns, New York
· Drawings of Choice from a New York Collection, Krannert Art Museum University of Illinois at Urbana-Champaign, Champaign / Arkansas Arts Center, Little Rock / Georgia Museum of Art, Athens / Bowdoin College Museum of Art, Brunswick / Cincinnati Art Museum, Cincinnati

Life Death Love Hate Pleasure
Pain: Selected works from the MCA
Permanent Collection,
Museum of Contemporary Art, Chicago

2003 · Annotations,
Dia Center for the Arts, New York
· Fast Forward: Twenty Years of White
Rooms, White Columns, New York
· Stranger in the Village,
Guild Hall, East Hampton, New York
· Influence, Anxiety, and Gratitude,
Toward an understanding of trans-
generational dialogue as a gift
economy,
MIT List Visual Arts Center,
Cambridge/USA
· Only Skin Deep: Changing Visions of
the American Self, International Center
of Photography, New York / Seattle Art
Museum, Seattle
· Supernova, San Francisco Museum
of Modern Art, San Francisco

2004 · Open House, Brooklyn Museum of Art,
Brooklyn/New York
· Singular Forms, Solomon R.
Guggenheim Museum, New York
· Surfing the Century: Twentieth-
Century Art, University of Michigan
Museum of Art, Ann Arbor / Michigan

2005 · The Shape of Time,
Walker Art Center, Minneapolis

Bibliografie (Auswahl) / *Bibliography (Selection)*

Glenn Ligon: To Disembark, Ausst.-Kat. Hirshhorn
Museum and Sculpture Garden / Smithsonian
Institution / Museum of Modern and Contemporary
Art, Washington 1993

Roberta Smith, Glenn Ligon, in: The New York
Times, 03.11.1995

Richard Meyer, Glenn Ligon: The Limits of Visibility,
in: Art + Text, August-Oktober/1997

Holland Cotter, Stories about Race, in: The New
York Times, 02.12.1998

Glenn Ligon 98.1 (new works), International Artist-in
Residence-Programme, San Antonio/Texas 1998

T. Golden, Unbecoming, Institute of Contemporary
Art, Philadelphia 1998

Wayne Koestenbaum, Best of 1998, in: Artforum,
Dezember/1998

Paulo Herkenhoff, African Diasporas: Glenn Ligon
and Fortunato Lopes da Silva, in: XI Mostra da
Gravura Cidade de Curitiba, Brazil o.J.

AutoWerke, hrsg. von Christa Aboitiz u.a.,
Ostfildern 2000

Glenn Ligon stranger, Studio Museum Harlem,
New York 2001

Coloring: New Works by Glenn Ligon, Ausst.-Kat.
Walker Art Center, Minneapolis 2001

Glenn Ligon. Portraits and Non-Portraits, Ausst.-
Kat. Kunstverein München, München 2002

Barbara Pollack, Glenn Ligon at D'Amelio Terras, in:
Art in America, Mai/2004

1964	geboren / *born* in Norwood/Massachusetts, lebt / *lives* in Los Angeles
1991	Studienende am / *Finished studies at* San Francisco Art Institute, San Francisco, B.F.A.
1993	Art Center College of Design, Pasadena, M.F.A.

Einzelausstellungen (Auswahl) /
Solo Exhibitions (Selection)

1993	· Shaun, Art Center College of Design, Pasadena
1994	· Friedrich Petzel Gallery, New York · Auditions, Galerie neugerriemschneider, Berlin
1995	· Künstlerhaus Stuttgart, Stuttgart
1996	· Blum & Poe, Santa Monica / Friedrich Petzel Gallery, New York · Galerie neugerriemschneider, Berlin
1997	· S.L. Simpson Gallery, Toronto
1998	· Kemper Museum of Contemporary Art, Kansas City · Galerie Yvon Lambert, Paris · Goshogoaka, Blum & Poe, Santa Monica · Goshogoaka, Wako Works of Art, Tokio · Goshogoaka, Friedrich Petzel Gallery, New York
1999	· Museum Boijmans Van Beuningen, Rotterdam · Galerie Mot & Van den Boogaard, Brüssel · Galerie neugerriemschneider, Berlin
2000	· Barbara Gladstone Gallery, New York · Wako Works of Art, Tokio · Kunsthalle Zürich, Zürich / Kunstmuseum Wolfsburg, Wolfsburg
2001	· Museum of Contemporary Art, Chicago / Museum of Contemporary Art, San Diego
2003	· Barbara Gladstone Gallery, New York · Interview Locations / Family Photographs, Blum & Poe, Los Angeles
2004	· Galerie neugerriemschneider, Berlin · Tomio Koyama Gallery, Tokio

Gruppenausstellungen (Auswahl) /
Group Exhibitions (Selection)

1995	· La Belle et Le Bête, Musée d'Art Moderne de la Ville de Paris, Paris / Museum Boijmans Van Beuningen, Rotterdam · Campo '95, Venedig / Fondazione Sandretto Re Rebaudengo, Turin · Galerie Paul Andriesse, Amsterdam
1996	· aldrift: Scenes from the Penetrable Culture, Center for Curatorial Studies Museum, Bard College, Annadale-on-Hudson, New York · Playpen & Corpus Delirium, Kunsthalle Zürich, Zürich

· Prospect 96: Photographie in der Gegenwartskunst, Frankfurter Kunstverein, Frankfurt/Main
· Hall of Mirrors: Art & Film since 1945, Museum of Contemporary Art, Los Angeles
· persona, Renaissance Society, Chicago / Kunsthalle Basel, Basel
· Still/A Novel, a documentary, Witte de With, Rotterdam

1997	· Biennial, Whitney Museum of American Art, New York
1998	· Choreography for the Camera, Walker Art Center, Minneapolis · L.A. Times: Art from Los Angeles, Fondazione Sandretto Re Rebaudengo, Turin · Tell Me a Story: Narration in Contemporary Painting and Photography, Le Magasin, Grenoble · Scratches on the Surface of Things, Museum Boymans Van Beuningen, Rotterdam · Stills: Emerging Photography in the 1990's, Walker Art Center, Minneapolis · Truce: Echoes of Art in an Age of Endless Conclusions, Site Santa Fe, Santa Fe · Scene of the Crime, UCLA Armand Hammer Museum of Art, Los Angeles · Contemporary Projects: Longing and Memory, Los Angeles County Museum of Art, Los Angeles
1999	· Moving Images: Film Reflexionen in der Kunst, Galerie für Zeitgenössische Kunst, Leipzig · Life Cycles, Galerie für Zeitgenössische Kunst, Leipzig · Shirley, Blum & Poe, Santa Monica · Friedrich Petzel Gallery, New York · China Art Objects Galleries, Los Angeles · COLA Exhibition, Los Angeles Municipal Art Gallery / Los Angeles · Proliferation / Museum of Contemporary Art, Los Angeles · Cinema Cinema: Contemporary Art and the Cinematic Experience, Van Abbe Museum, Eindhoven · Looking at Ourselves: Works by Women Artists from the Logan Collection, Museum of Modern Art, San Francisco · Fast Forward Archives, Kunstverein Hamburg, Hamburg · So Faraway, So Close, Museum of Modern Art, Oxford

· Spaced Out: Late 1990's Works from the Vicki and Kent Logan Collection, California College of Arts and Crafts Institute, Oakland / Les Rencontres Internationales de la Photographie, Arles

2000
· Beyond Boundaries: Contemporary Photography in California, California State University, Long Beach / Santa Barbara Contemporary Arts Forum, Santa Barbara
· Elysian Fields, Centre Georges Pompidou, Paris
· Age of Influence: Reflections in the Mirror of American Culture, Museum of Contemporary Art, Chicago
· San Francisco Art Institute, San Francisco
· 2000 Biennial Exhibition, Whitney Museum of American Art, New York
· AutoWerke, European and American Photography, Deichtorhallen Hamburg, Hamburg

2001
· AutoWerke, Hedengaase Europese en Amerikaanese fotografie, Frans Hals Museum, Haarlem
· Public Offerings, Museum of Contemporary Art, Los Angeles
· Beyond Boundaries: Contemporary Photography in California, Ansel Adams Center for Photography, San Francisco

2002
· Keine Kleinigkeit, Kunsthalle Basel, Basel

2003
· Photographier to photograph, Collection Lambert, Musée d'art contemporain, Avignon
· Cine casi Cine 2003, Museo Nacional Centro de Arte Reina Sofia, Madrid

2004
· Strange Days, Museum of Contemporary Art, Chicago
· Lei – Donne nelle collezioni Italiane, Fondazione Sandretto Re Rebaudengo, Turin
· Readings, Tina Kim Fine Art, New York
· Made in Mexico, ICA, Boston
· 2004 Whitney Biennial Exhibition, Whitney Museum of American Art, New York
· Videodreams, Kunsthaus Graz am Landesmuseum Joanneum, Graz
· Accrochage, Jan Mot, Brüssel
· Made in Mexico, UCLA Armand Hammer Museum of Art, Los Angeles
· Uses of the Image: Photography, Film and Video in the Jumex Collection, Malba – Coleccion Costantini, Buenos Aires

2005
· In Focus: Themes in Photography, Albright-Knox Art Gallery, Buffalo
· Eye Spy: Photography form the permanent collection, MCASD La Jolla, San Diego
· At years end, rethinking The Family of Man, De Appel Foundation, Amsterdam
· An Aside, Camden Arts Centre, London / The Fruitmarket Gallery, Edinburgh / Glynn Vivian Art Gallery, Swansea

Bibliografie (Auswahl) / *Bibliography (Selection)*

Susan Kandel, Land Ahoi, in: Los Angeles Times, 17. 11. 1994

Lane Relyea, Openings, Sharon Lockhart, in: Artforum, November/1994

David A. Greene, Land Escape: A Photographic Field Trip Through the Conceptual Plane, in: Los Angeles Reader, November/1994

Eva Meier, Sharon Lockhart, in: PAKT, September/ Oktober/1994

Ronald Berg, Küssen als Kunst, in: Der Tages- spiegel, 16.08.1994

Brigitte Werneburg, Truffautsche Obsessionen, in: die tageszeitung, 13.08.1994

Diederich Diederichsen, Oostende, in: Texte zur Kunst, 15, Juni/1994, S. 214-217

Anastasia Aukeman, Sharon Lockhart, in: Art in America, April/1995, S. 112

Claudia Wahjude, Sightings: New Photographic Art, in: Kunstforum International 141/1998

Russel Ferguson, Unfinished Stories, Unbroken Contemplation, in: Cinéma Cinéma: Contemporary Art and Cinematic Experience, Ausst.-Kat. Van Abbe Museum Eindhoven 1999

Sharon Lockhart, Teatro Amazonas, Ausst.-Kat. Museum Boijmans Van Beuningen, Rotterdam 1999

AutoWerke, hrsg. von Christa Aboitiz u. a., Ostfildern 2000

Sharon Lockhart, Ausst.-Kat. Museum of Contempoary Art, Chicago / Museum of Contemporary Art, San Diego 2001

1938	geboren / *born* in Charkow/Ukraine, lebt / *lives* in Charkow, Berlin

Einzelausstellungen (Auswahl ab 1989) /
Solo Exhibitions (Selection since 1989)

1989
· Museum of Contemporary Art,
Tampere

1990
· Museum of Contemporary Art, Tel Aviv
· The Missing Picture, Alternative
Contemporary Photography from the
Soviet Union,
MIT List Visual Arts Center,
Cambridge/USA
· National Bank Gallery, Helsinki

1993
· Galerie Wohnmaschine, Berlin

1994
· Hotel Europa, Foto Festival, Rotterdam
· Perspectief,
Photographic Center, Rotterdam

1995
· The Institute of Contemporary Art,
Philadelphia
· Portikus, Frankfurt/Main
· Galerie Ulrike Barthel, Bremen
· Staircase, Galerie für Zeitgenössische
Kunst, Leipzig
· Kunstverein Göttingen, Göttingen

1996
· Kunsthalle Zürich, Zürich
· SCCA Soros Centre Contemporary Art,
Kiew
· Galerie Poller, Frankfurt/Main
· Die fünfte Kolonne, Körper und Betrug,
Galerie Wohnmaschine, Berlin

1997
· DAAD Galerie, Berlin

1998
· Stedelijk Museum, Amsterdam
· Les Misérables, Über die Welt –
About the world,
Sprengel Museum Hannover, Hannover
· Leben & Arbeit,
Galerie Wohnmaschine, Berlin

1999
· Centre National de la Photographie,
Paris
· Ueneziafiere,
Museum Querini Stampalia, Venedig
· DAAD Galerie, Berlin
· Galerie Scalo, Zürich

2000
· Galerie Barbara Gross, München
· Dvir Gallery, Tel Aviv
· The Photographers' Gallery, London
· Projekte mit Fotografie – Berlin,
Stadt im Wandel,
Kunststiftung Poll, Berlin

2001
· The Saatchi Gallery, London

2003
· Galerie Barbara Gross, München

2004
· A Retrospective, ICA, Boston
· A Testimony of the negative photo-
graphy, The Centre of Contemporary
Art, Warschau
· Kunstverein Arnsberg, Arnsberg

Gruppenausstellungen (Auswahl ab 1990) /
Group Exhibitions (Selection since 1990)

1990
· International Biennial of Photography,
Turin
· Erosion,
Amos Anderson Art Museum, Helsinki

1991
· Carnegie International,
The Carnegie Museum, Pittsburgh
· Photo Manifesto,
Museum of Contemporary Arts,
Baltimore

1992
· Herbarium, The Photographic Expe-
rience in Contemporary Russian Art,
Fotogalerie Wien, Wien /
Kunsthalle Wien, Wien
· Jahreslabor, Photographie-
stipendiaten,
Berlinische Galerie, Berlin

1993
· New Photography 9,
Museum of Modern Art, New York

1994
· Photo-reclamation, New Art from
Moscow and Saint Petersburg,
The Photographers' Gallery, London /
John Hansard Gallery University of
Southampton, Southampton

1995
· Currents '95: Familiar Places, ICA,
Boston
· Contemporary Russian Photography,
Akademie der Künste,
Galerie im Marstall, Berlin

1996
· Russian Jewish Artists 1890–1990,
The Jewish Museum, New York
· Fotofiction,
Kasseler Kunstverein, Kassel

1997
· Lust und Last, Leipziger Kunst seit
1945, Germanisches Nationalmuseum,
Nürnberg /
Museum der bildenden Künste, Leipzig
· Bohème und Diktatur,
Deutsches Historisches Museum,
Berlin

1998
· Contemporain centre regional Cart,
Sète
· Satani Gallery, Tokio
· Galerie Barbara Gross, München
· Collection 98,
Galerie für Zeitgenössische Kunst,
Leipzig

1999
· Global Conceptualism,
Queens Museum of Art, New York
· Ich und die Anderen, Fotografien und
Videoarbeiten, Ursula Blickle-Stiftung,
Kraichtal / Fotomuseum im Münchner
Stadtmuseum, München
· After the Wall,
Moderna Museet, Stockholm
· Future is now, Ucrainian Art in
the Nineties,
Museum of Contemporary Art, Zagreb
· Underlexpo, Metro, Stockholm

2000 · How you look at it, Fotografien des
20. Jahrhunderts,
Sprengel Museum Hannover,
Hannover / Städelsches Kunstinstitut,
Frankfurt/Main
· Positions, attitudes, actions,
social and political commitment in
photography,
Foto Biennale Rotterdam, Rotterdam
· Das Versprechen der Fotografie,
Akademie der Künste, Berlin /
Schirn Kunsthalle, Frankfurt/Main
· AutoWerke, European and American
Photography,
Deichtorhallen Hamburg, Hamburg

2001 · Remake Berlin,
Neuer Berliner Kunstverein, Berlin
· AutoWerke, Hedengaagse Europese
en Amerikaanse fotografie,
Frans Hals Museum, Haarlem

2002 · Stories – Erzählstrukturen in der
zeitgenössischen Kunst,
Haus der Kunst, München

2003 · Berlin–Moskau / Moskau–Berlin 1950–
2000, Martin-Gropius-Bau, Berlin
· Cruel and tender: the real in the
20th century photography,
Tate Modern, London
· Man in the Middle, Menschenbilder,
Sammlung Deutsche Bank,
Kunsthalle Tübingen, Tübingen

2004 · Soziale Kreaturen. Wie Körper
Kunst wird,
Sprengel Museum Hannover, Hannover
· IDFA: Paradocs,
Stedelijk Museum, Amsterdam
· Privatisierungen. Zeitgenössische
Kunst aus Osteuropa,
Kunst-Werke Berlin, Berlin
· HA KYPOPT! Russische Kunst heute,
Staatliche Kunsthalle Baden-Baden,
Baden-Baden
· Beauty of Darkness,
Reflex Modern Art Gallery, Amsterdam
· Conditional being. New acquisitions
in the Rafael Zous Collection
of Contemporary Photography,
Metrònom, Barcelona
· Dorf in der Metropole – Rohkunstbau in
Berlin, Künstlerhaus Bethanien, Berlin
· Channel Zero,
Netherlands Media Art Institute
Montevideo, Amsterdam
· Blow up. Zeitgenössische Künstler-
Fotografie, Ulmer Museum, Ulm
· Wirklich wahr! Realitätsversprechen
von Fotografien,
Ruhrlandmuseum Essen, Essen

2005 · Über Schönheit,
Haus der Kulturen der Welt, Berlin
· Western Biennale of Art: Art Tomorrow,
John Natsoulas Center for the Arts,
Davis/Kalifornien
· Citizens,
PM Gallery and Home, London
· The Seven Sins. Lublijana – Moscow,
Moderna Galerija Tomsiceva, Lublijana
· Architektur der Obdachlosigkeit,
Berlinische Galerie, Berlin
· Die zehn Gebote,
Deutsches Hygiene-Museum, Dresden

Bibliografie (Auswahl) / *Bibliography (Selection)*

Boris Michailov, Ausst.-Kat. Frankfurter Portikus /
Kunsthalle Zürich, Stuttgart 1995

Boris Michailov, Die Dämmerung, At Dusk,
Köln 1996

Boris Michailov, Am Boden, By the Ground,
Köln 1996

Boris Michailov – Les Misérables, Über die Welt,
Ausst.-Kat. Sprengel Museum Hannover 1998

Boris Michailov, Unfinished Dissertation,
Unvollendete Dissertation, New York / Zürich /
Berlin 1998

Boris Michailov, The Photography Book,
London 1998

Boris Michailov, Case History, New York / Zürich /
Berlin 1999

Ich und die Anderen, Ausst.-Kat. Fotomuseum im
Münchner Stadtmuseum, München 1999

Boris Michailov, Drucksache NF 4,
Düsseldorf 2000

AutoWerke II, hrsg. von Jone Elissa Scherf,
Ostfildern 2000

Gilda Williams, Boris Michailov, Berlin 2001

Boris Michailov, Salt Lake, Göttingen 2002

Boris Mikhailov. Eine Retrospektive, hrsg. von
Urs Stahel, Amsterdam 2003

1955 geboren / *born* in München / *Munich,*
lebt / *lives* in München / *Munich,*
Prien am Chiemsee

1977–1982 Akademie der Bildenden Künste
München, München / *Munich*

1999–2000 Gastprofessur für Fotografie an der /
Guest professor for photography at the
Universität Paderborn, Paderborn

Einzelausstellungen (Auswahl) / *Solo Exhibitions (Selection)*

1985 · Kunstforum,
Städtische Galerie im Lenbachhaus,
München

1988 · Der Geister Bahnen,
Galerie Mosel & Tschechow /
Galerie Conrads, Düsseldorf
· Exemples de l'amor galant i de l'amor
espiritual, Tinglado, Moll de Costa,
Tarragona / Canal de Isabel II, Madrid
· Liebe der ersten Menschen –
Souvenirs vom Paradies,
Badischer Kunstverein Karlsruhe,
Karlsruhe

1993 · Der Liebe Pilgerfahrt,
Münchner Stadtmuseum, München

1994 · Bilder für ein Raumschiff,
Landesmuseum Karlsruhe, Karlsruhe /
Galerie Mosel & Tschechov, München

1996 · Romantik der Zukunft,
Museum Moderner Kunst,
Palais Lichtenstein, Wien

1998 · Das Leben der Dinge, Städtische
Galerie im Lenbachhaus, München
· Adriapolis,
Galerie Wohnmaschine, Berlin
· Werbung ohne Produkte und Bilder
aus Adriapolis,
Galerie Mosel & Tschechov, München

2003 · Der Text ist eine Lüge,
Dany Keller Galerie, München

2004 · Poesie, Galerie Mosel & Tschechow,
München

Gruppenausstellungen (Auswahl) / *Group Exhibitions (Selection)*

1985 · Alles und noch viel mehr,
Kunsthalle Bern, Bern

1986 · Luftschlösser, Künstlerwerkstatt
Lothringer Straße, München

1987 · Fokus, Kunsthalle der Hypo-
Kulturstiftung, München

1989 · Die Gegenwart der Vergangenheit,
Bonner Kunstverein, Bonn

1990 · Buchstäblich,
Von der Heydt-Museum, Wuppertal

1991 · Magia naturalis,
Kommunales Museum, Prag

1992 · Gegenbilder,
Westfälisches Landesmuseum für
Kunst und Kulturgeschichte Münster,
Münster

1994 · Kunst der Gegenwart,
Ludwig Forum für Internationale Kunst,
Aachen

1995 · Gut gewachsen, Haus der Kunst,
München

1996 · Realität – Anspruch – Medien,
Kunsthalle Bremen, Bremen /
Museum Wiesbaden, Wiesbaden

1997 · Der Einwohner, Galerie 5020, Salzburg

2000 · Ein Jahrhundert Kunst in Deutschland,
Nationalgalerie, Berlin

2000 · AutoWerke, European and American
Photography,
Deichtorhallen Hamburg, Hamburg

2001 · AutoWerke, Hedengaagse Europese
en Amerikaanse fotografie,
Frans Hals Museum, Haarlem

2004 · True Fiction. Inszenierte Fotokunst
der 90er-Jahre, Stadtgalerie
Saarbrücken, Saarbrücken

Publikationen / *Publications*

Normal und sterblich. Zwei komische Tragödien,
Hamburg 1984

Magie oder Maggi? Hamburg 1987

Hin und zurück, Hamburg 1988

Liebe und Schulden, Hamburg 1989

Der Mann, der nicht nach Hause wollte,
Hamburg 1994

Wie man sich glücklich verirrt, Hamburg 1995

Regen und andere Niederschläge oder die
falsche Inderin, Bonn 2001

Idiotenhügel, Bonn 2004

Bibliografie (Auswahl) / *Bibliography (Selection)*

Der Geister Bahnen, München 1988

Der Liebe Pilgerfahrt, Ausst.-Kat. Münchner
Stadtmuseum, München 1992

Romantik der Zukunft, Ausst.-Kat. Museum
Moderner Kunst, Palais Lichtenstein, Wien /
Klagenfurt 1996

Das Leben der Dinge, Ausst.-Kat. Städtische
Galerie im Lenbachhaus, München 1998

AutoWerke II, hrsg. von Jone Elissa Scherf,
Ostfildern 2000

1961	geboren / *born* in Sandusky/Ohio, lebt / *lives* in Los Angeles, New York
1982–1985	San Francisco Art Institute, San Fransisco
1985–1988	California Institute of Arts, Valencia/Kalifornien
2000	Professor für Kunst / *Professor of Fine Art,* Yale University, New Haven
2001	Professor für Kunst / *Professor of Fine Art,* University of California, Los Angeles

Einzelausstellungen (Auswahl) /
Solo Exhibitions (Selection)

1994
· Portraits, Regen Projects, Los Angeles

1995
· Portraits, Gavin Brownlenterprise, New York
· Houses and Landscapes, Regen Projects, Los Angeles
· Houses and Freeways, Jay Gorney Modern Art, New York

1997
· Museum of Contemporary Art, Los Angeles

1998
· Mini-Malls, Jay Gorney Modern Art, New York

1999
· Regen Projects, Los Angeles

2000
· The Photographers' Gallery, London

2002
· Ice Houses, Regen Projects, Los Angeles
· Skyways & Icehouses, Walker Art Center, Minneapolis
· Surfers, Stephen Friedman Gallery, London / Regen Projects, Los Angeles

Gruppenausstellungen (Auswahl) /
Group Exhibitions (Selection)

1992
· Wasteland, Fotografie Biennale Rotterdam III, Rotterdam

1993
· Dress Codes, ICA, Boston

1994
· Persona Cognita, Museum of Modern Art at Heide, Melbourne
· Oh boy, it's a girl, Kunstverein München, München

1995
· feminimasculin: Le sexe de l'art, Musée National d'Art Moderne, Paris
· P.L.A.N.: Photography Los Angeles Now, Los Angeles County Museum of Art, Los Angeles
· 1995 Whitney Biennial, Whitney Museum of American Art, New York

1996
· a/drift: Scenes From the Penetrable Culture, Center for Curatorial Studies Museum, Bard College, Annandale-on-Hudson, New York
· Art at the End of the 20th Century: Selections from the Whitney Museum of American Art, National Gallery, Athen / Museu d'Art Contemporani de Barcelona, Barcelona / Kunstmuseum Bonn, Bonn
· Sexual Politics: Judy Chicago's Dinner Party in Feminist Art History, UCLA Armand Hammer Museum of Art, Los Angeles
· Persona, The Renaissance Society at the University of Chicago, Chicago / Kunsthalle Basel, Basel
· Black and Blue, Groninger Museum, Groningen

1997
· American Art 1975–1995 from the Whitney Museum: Multiple Identity, Castello di Rivoli, Museo d'Arte Contemporanea, Rivoli
· Sunshine & Noir: Art in L.A. 1960–1997, Crenzien, Louisiana Museum of Modern Art, Humlebæk/ Dänemark / Kunstmuseum Wolfsburg, Wolfsburg
· Spheres of Influence, Museum of Contemporary Art, Los Angeles
· Rose is a Rose is a Rose: Gender Performance in Photography, Solomon R. Guggenheim Museum, New York / Andy Warhol Museum, Pittsburgh

1998
· Love's Body, Rethinking Naked and Nude in Photography, Tokyo Metropolitan Museum of Photography, Tokio
· From the Corner of the Eye, Stedelijk Museum, Amsterdam
· Where: Allegories of Site in Contemporary Art, Whitney Museum of American Art at Champion, Stanford

2000
· AutoWerke, European and American Photography, Deichtorhallen Hamburg, Hamburg

2001
· AutoWerke, Hedengaagse Europese en Amerikaanse fotografie, Frans Hals Museum, Haarlem

2002
· Die Wohltat der Kunst, Staatliche Kunsthalle Baden-Baden, Baden-Baden

2003
· Die Wohltat der Kunst, Sammlung Goetz, München
· Elegy: Contemporary Ruins, Museum of Contemporary Art Denver, Denver
· Phantom der Lust. Visionen des Masochismus in der Kunst, Neue Galerie Graz am Landesmuseum Joanneum, Graz

2004
- Imágenes en movimiento //
 Moving Pictures,
 Guggenheim Museum Bilbao, Bilbao
- Only Skin Deep: Changing Visions of
 the American Self,
 International Center of Photography,
 New York
- Likeness – Portraits of artists by other
 artists, Wattis Institute for
 Contemporary Art, San Francisco
- 2004 Whitney Biennial Exhibition,
 Whitney Museum of American Art,
 New York
- Likeness: Portraits of Artists by Other
 Artists, ICA, Boston
- 26th Bienal Internacional de São
 Paulo, Fundação Bienal de São Paulo,
 São Paulo

2005
- In Focus: Themes in Photography,
 Albright-Knox Art Gallery, Buffalo
- 100 Artists see God, ICA, London
- Walk to Remember,
 Los Angeles Contemporary Exhibitions,
 Los Angeles
- Ten Year Anniversary Exhibition,
 Stephen Friedman Gallery, London
- Getting Emotional, ICA, Boston
- Boost In The Shell, De Bond, Brügge
- Wunschwelten. Neue Romantik
 in der Kunst der Gegenwart,
 Schirn Kunsthalle, Frankfurt/Main

Bibliografie (Auswahl) / *Bibliography (Selection)*

A Different Light: Visual Culture, Sexual Identity,
Queer Practice, hrsg. von Blake Nayland, Lawrence
Rinder, Amy Scholder, San Francisco 1995

Nothing But the Girl: The Blatant Lesbian Image,
hrsg. von Susie Bright, Jill Posener, London /
New York 1996

Sexual Politics: Judy Chicago's Dinner Party
in Feminist Art History, hrsg. von Amilia Jones,
Berkeley 1996

Cherry Smyth, Damn. Fine Art by New Lesbian
Artists, New York / London 1996

Reframings: New American Feminist
Photographies, hrsg. von Diane Neumaier, Philadel-
phia 1995

feminimasculin: Le sexe de l'art, Ausst.-Kat.
Musée National d'Art Moderne, Paris 1995

Constructing Masculinity, hrsg. von Maurice Berger,
Brian Wallis, Simon Watson, New York 1996

Defining the Nineties: Consensus-making in
New York, Miami and Los Angeles, hrsg. von
Bonnie Clearwater, Ausst.-Kat. Museum of
Contemporary Art, Miami 1996

Identity Crisis: Self-Portraiture at the End of the
Century, Ausst.-Kat. Milwaukee Art Museum,
Milwaukee 1997

Lost Paradise: Catherine Opie, Joachim Koester,
Ellen Cantor, Ausst.-Kat. Presenca Galeria,
Porto 1998

The Art of the X Files, hrsg. von Marvin Heiferman,
Carole Kismaric, New York 1998

Frances Borzello, Seeing Ourselves: Women's Self-
Portraits, London 1998

Kathy O'Dell, Contract with the Skin: Masochism
Performance Art and the 1970s, Minneapolis 1998

AutoWerke, hrsg. von Christa Aboitiz u. a.,
Ostfildern 2000

Catherine Opie: Skywalks & Icehouses, Ausst.-Kat.
The Walker Art Center, Minnesota 2001

1970 geboren / *born* in London,
 lebt / *lives* in London

1990–1993 London College of Printing, London,
 B.A. Photography

1997–1999 Royal College of Art, London,
 M.A. Fine Art Photography

Einzelausstellungen (Auswahl) / *Solo Exhibitions (Selection)*

1999 · Emily Tsingou Gallery, London

2001 · Emily Tsingou Gallery, London
 · DCA – Dundee Contemporary Arts,
 Dundee

2003 · Emily Tsingou Gallery, London
 · Centre pour l'image contemporaine,
 Genf
 · Nichido Contemporary Art, Tokio
 · The British School at Rome, Rom

2004 · Twelve Trees,
 Alberto Peola Arte Contemporanea,
 Turin

2005 · New Photographs and Film,
 Emily Tsingou Gallery, London

Gruppenausstellungen (Auswahl) / *Group Exhibitions (Selection)*

1995 · Stream, Plummet, London

1996 · Spatial Penetration (artists'
 collaboration), Galatasaray, Berlin
 · Stadtluft, Architektenkammer, Berlin
 · Flag, Clink Street Wharf, London
 Euthanasia, Plummet, London

1997 · On the Bright Side of Life: Zeit-
 genössische britische Fotografie,
 Neue Gesellschaft für Bildende Kunst,
 Berlin
 · Public Relations: New British Photo-
 graphy, Stadthaus Ulm, Ulm
 · Remix: Images photographiques,
 Musée des Beaux-Arts, Nantes
 · New Contemporaries,
 Tea Factory, Liverpool
 · Critical Distance,
 Andrew Mummery Gallery, London
 · Plastic Metropolis and Inventories,
 Shoreditch Biennale, London
 · Host, Tramway, Glasgow

1999 · Common People: British Art from
 Phenomenon to Reality,
 Palazzo Re Rebaudengo,
 Guarene d'Alba
 · Near and Elsewhere, The Photo-
 graphers' Gallery, London
 · Evidence of Existence,
 Kunstraum Siegert, Basel
 · The Garden of Eros,
 Palau de la Verreina, Barcelona
 · Group Show,
 Galerie Rudolphe Janssen, Brüssel
 · Tendance, Abbaye Saint-Andre Centre
 d'Art Contemporain, Meymac
 · River Deep, Mountain High,
 Gallery Westland Place, London

2001 · Edinburgh Where Are We?,
 Victoria and Albert Museum, London
 · Night on Earth,
 Städtische Ausstellungshalle Münster,
 Münster
 · The Fantastic Recurrence of Certain
 Situations: Recent British Art and
 Photography,
 Sala de Exposiciones del Canal de
 Isabel II, Madrid
 · AutoWerke, Hedengaagse Europese
 en Amerikaanse fotografie,
 Frans Hals Museum, Haarlem

2003 · Identity, Nichido Contemporary Art,
 Tokio

2004 · Ordnung und Chaos, Fotomuseum
 Winterthur, Winterthur
 · Identity II, Nichido Contemporary Art,
 Tokio

Bibliografie (Auswahl) / *Bibliography (Selection)*

On the Bright Side of Life: Zeitgenössische britische Fotografie, Ausst.-Kat. Neue Gesellschaft für Bildende Kunst, Berlin 1997

Public Relations. New British Photography, Ausst.-Kat. Stadthaus Ulm 1997

New Contemporaries, Ausst.-Kat. Tea Factory, Liverpool 1998

Remix: Images photographiques, Ausst.-Kat. Musée des Beaux-Arts, Nantes 1998

Chris Townsend, Sophy Rickett, in: Hotshoe International, März/April 2000

Izi Glover, Sophy Rickett, in: Frieze, Juli/2001

Rob Tufnell, Sophy Rickett, in: Portfolio, Juni/2001

The Fantastic Recurrence of Certain Situations: Recent British Art and Photography, Ausst.-Kat. Sala de Exposiciones del Canal de Isabel II, Madrid 2001

Making your dreams come true, hrsg. von Jone Elissa Scherf, George St. Andrews, Ostfildern 2001

Nothing, Ausst.-Kat. Northern Gallery for Contemporary Art, Sunderland 2001

Night on Earth, hrsg. von Ralf Christofori, Ausst.-Kat. Städtische Ausstellungshalle Münster, Köln 2001

1965	geboren / *born* in Buchloe/Ostallgäu, lebt / *lives* in Berlin
1986–1989	Kunstakademie Stuttgart, Stuttgart
1990–1992	Hochschule der Künste Berlin, Berlin
1992–1994	Akademie der bildenden Künste München, München / *Munich*
1996–1997	Goldsmiths College, London, M.A. Fine Arts

Einzelausstellungen (Auswahl) /
Solo Exhibitions (Selection)

1996
- Collection (Quote – Unquote), Akademiegalerie, München

1998
- Will You Please Be Quiet, Please (Der TV Effekt), Kunstverein München, München

1999
- Whatizzit Wagon, Galerie Michael Janssen, Köln
- Förderkoje ART Cologne, Galerie Michael Janssen, Köln
- Surprise Chefs, Galerie Andreas Binder, München / Portfolio Kunst AG, Wien

2001
- Reanimation, Westfälischer Kunstverein Münster, Münster
- Dorothy Vallens: Atelier Rheingold, Atelier Rheingold, Berlin

2002
- Dorothy Vallens: Drei Tage Madeleine, Plattform Berlin, Berlin
- Casino, nachmachen – vormachen, Re-animation, Galerie Andreas Binder, München
- Galerie Andreas Binder, München

Gruppenausstellungen (Auswahl) /
Group Exhibitions (Selection)

1994
- Der Küchentisch, Kunstverein München, München

1995
- … does the mind rule the body or does the body rule the mind, Ausstellungsraum Balanstraße, München
- Der zweite Blick, Haus der Kunst, München
- Nahverkehr, Großweidenmühlstraße, Nürnberg

1996
- Collection 2, Studiowelten, Galerie Bartsch & Chariau, München

1997
- Funfair, Galerie Andreas Binder, München
- Collection 3, Gallery Funaki, Melbourne
- Home Exit, Goethe Institut, London
- Der Attraktor, Künstlerwerkstatt Lothringer Straße, München

1998
- Utopie Alltag Ferien, Künstlerwerkstatt Lothringer Straße, München
- Photographie als Handlung / Photography as Concept, 4. Internationale Fototriennale Esslingen, Esslingen

1999	· Ich und die Anderen, Ursula Blickle Stiftung, Kraichtal / Fotomuseum im Stadtmuseum München, München
2000	· Dorothea von Stetten Kunstpreis, Kunstmuseum Bonn, Bonn · AutoWerke, European and American Photography, Deichtorhallen Hamburg, Hamburg
2001	· AutoWerke, Hedengaagse Europese en Amerikaanse fotografie, Frans Hals Museum, Haarlem · Space, Witte de With, Center for Contemporary Art, Rotterdam · (Tele)Visionen, Kunsthalle Wien, Wien · Kommunikationsbeispiele, Fotografie Wien, Wien · ÜberSicht, Galerie Luciano Fasciati, Chur
2002	· ten years phase #2, Galerie Andreas Binder, München · confiture demain et confi..., Centre d'Art Contemporain, Sète
2005	· Positionen der Photographie – Selected View, Galerie Andreas Binder, München · Born in the 60ies. Positionen zeitgenössischer Fotografie, The Cultural Forum for Photography, Berlin

Bibliografie (Auswahl) / *Bibliography (Selection)*

Der Attraktor, Ausst.-Kat. Künstlerwerkstatt Lothringer Straße, München 1997

Will you please be quiet, Please (Der TV-Effekt), Ausst.-Kat. Kunstverein München 1998

Fotografie als Handlung/Photography as Concept, Ausst.-Kat. Villa Merkel und Bahnwärterhaus, Esslingen 1998

Ursula Rogg im Kunstverein München, in: Kunst-Bulletin 5/1998, S. 42

Space, Ausst.-Kat. Center for Contemporary Art, Rotterdam 1999

"What can Photography tell about...", in: Creative Camera, Dezember 1998/Januar 1999

AutoWerke II, hrsg. von Jone Elissa Scherf, Ostfildern 2000

Ich und die Anderen, Ausst.-Kat. Ursula Blickle Stiftung, Kraichtal / Fotomuseum im Stadtmuseum München, München 1999

Ursula Rogg. Reanimation, Ausst.-Kat. Westfälischer Kunstverein Münster, Münster 2001

1965	geboren / *born* in Belfast, lebt / *lives* in Newport/Wales
	Studium an der / *studies at the* University of Ulster and West Surrey College of Art and Design, Belfast
seit / *since* 1994	Direktor des / *Director of the* Photographic Research Centre, University of Newport/ Wales

Einzelausstellungen (Auswahl) /
Solo Exhibitions (Selection)

1989	· Gallery Vapauden Aukion, Helsinki · Mikkelin Valokuvakeskus, Mikkeli/Finnland
1991	· The Orange Order, The Photographers' Gallery, London
1992	· The International Center of Photography, New York · The Orange Order, Impressions Gallery, York · The Gallery of Photography, Dublin
1993	· Blue Sky Gallery, Portland/Oregon · The Orange Order, Arts Council Gallery, Belfast · The United Nations General Assembly Building, New York · The Old Museum, Belfast
1994	· Cornerhouse, Manchester
1995	· Police Force, The Photographers' Gallery, London
1996	· Fotogallery, Cardiff
1997	· Blue Sky Gallery, Portland/Oregon · Françoise Knabe Galerie, Frankfurt/Main
1998	· Angles Gallery, Los Angeles · Rhona Hoffman Gallery, Chicago · Rena Bransten Gallery, San Francisco · Galerie du Jour, Agnès B, Paris
1999	· Kerlin Gallery, Dublin
2000	· Museum of Contemporary Art, Zagreb · Rena Bransten Gallery, San Francisco · Rhona Hoffman Gallery, Chicago · Center of Photography, University of Salamanca, Salamanca · Bonakdar Jancou Gallery, New York · Photo.doc, Form box, Helsinki · Maureen Paley Interim Art, London
2001	· Galerie du Jour, Agnès B, Paris · Hasselblad Centre, Kunst Museum Gothenberg, Gothenberg · LA International Biennale, Angeles Gallery, Los Angeles
2002	· Inside Out, Foundation Marangoni, Florenz
2003	· Hidden, Imperial War Museum, London / Irish Museum of Modern Art, Dublin · Scenery, Rena Bransten Gallery, San Francisco
2004	· Wales at the 50th Venice Biennale, The National Museum & Gallery Cardiff, Cardiff
2005	· Museeum foor Fotografie, Antwerpen

Gruppenausstellungen (Auswahl) /
Group Exhibitions (Selection)

1988	· Death, Cambridge Darkroom Gallery, Cambridge
1996	· Galerie du Jour, Agnés B, Paris
1997	· The Missing, Netherlands Foto Institut, Rotterdam · On the Bride Side of Life, Zeitgenössische britische Fotografie, Neue Gesellschaft für bildende Kunst, Berlin
1999	· Engaging Tradition, Hotbath Gallery, Bath · 0044, P.S. 1 Contemporary Art Center, New York / Albright-Knox Art Gallery, Buffalo · Tokyo Photo Biennale, Tokio Metropolitan Museum of Photography, Tokio · Contemporary Art, Ormeau Baths Gallery, Belfast · Silent Presence, Staatliche Kunsthalle Baden-Baden, Baden-Baden · Under Exposed, Public Art Project, Stockholm · Declinations of Boundaries, Galerie Lichtblick, Köln · Revealing Views: Images from Ireland – Ballroom, Royal Festival Hall, London
2000	· British Art Show 5, Scottish National Gallery of Modern Art, Edinburgh / Southampton City Art Gallery, Southampton / National Museum of Wales, Cardiff / Birmingham Museum and Art Gallery, Ikon Gallery, Birmingham · Lautlose Gegenwart. Das Stilleben in der zeitgenössischen Fotografie, Bielefelder Kunstverein, Bielefeld · 0044, Ormeau Baths Gallery, Belfast · Crawford, Municipal Art Gallery, Cork · Irish Art Now, From the Poetic to the Political, McMullen Museum of Art, Boston · AutoWerke, European and American Photography, Deichtorhallen Hamburg, Hamburg
2001	· AutoWerke, Hedengaagse Europese en Amerikaanse fotografie, Frans Hals Museum, Haarlem · New Directions, Winston Wachter Fine Art, Seattle · Depicting Absence/Implying Presence, San Jose Institute of Contemporary Art, San Jose
2002	· The Unblinking Eye, Irish Museum of Modern Art, Dublin · Gewaltbilder, Museum Bellerive, Zürich · The Gap Show. Critical Art from Great Britain, Museum am Ostwall, Dortmund

2003 · Installation – Disaster Area,
 The Glashouse, Amsterdam
 · La Biennale di Venezia, Venedig
 · M_ARS – Kunst und Krieg,
 Neue Galerie Graz am Landesmuseum
 Joanneum, Graz

2004 · Collection Agnès B, Les Abattoirs,
 Frac Midi-Pyrénées, Toulouse

Bibliografie (Auswahl) / *Bibliography (Selection)*

Paul Seawright, hrsg. von Declan McGongale,
Salamanca 2000

AutoWerke, hrsg. von Christa Aboitiz u. a.,
Ostfildern 2000

The Forest: Paul Seawright, hrsg. von
V. Williams u. a., o. O. 2001

Wales at the Venice Biennale 2003, hrsg. von
Cerith Wyn Evans u. a., Köln 2003

Hidden, Ausst.-Kat. Imperial War Museum,
London 2004

1968	geboren / *born* in Macclesfield / Großbritannien / *Great Britain,* lebt / *lives* in Glasgow
1988–1991	Glasgow School of Art, Glasgow, B.A. Fine Art

Einzelausstellungen (Auswahl) /
Solo Exhibitions (Selection)

1995	· Map of the Sewer, Transmission Gallery, Glasgow
1996	· Catalyst Arts, Belfast · The Contents of the Gap, Luxus Cont., Glasgow
1997	· Centre for Contemporary Art, Glasgow · Stephen Friedman Gallery, London · Hermetic Gallery, Millwaukee · Francesca Piar, Bern · Galleri Nicolai Wallner, Kopenhagen · The Photographers' Gallery, London
1998	· Galleri Nicolai Wallner, Kopenhagen · Bloom Gallery, Amsterdam
1999	· Stephen Friedman Gallery, London · Yvon Lambert, Paris
2000	· Galleri Nicolai Wallner, Kopenhagen
2001	· Stephen Friedman Gallery, London · Bard College, New York
2003	· Galleri Nicolai Wallner, Kopenhagen
2005	· Pavel Braila, Galerie Yvon Lambert, Paris · Anton Kern Gallery, New York · Drawings Sculptures Photography, Galleri Nicolai Wallner, Kopenhagen

Gruppenausstellungen (Auswahl) /
Group Exhibitions (Selection)

1992	· In Here, Transmission Gallery, Glasgow
1994	· Some of My Friends, Galleri Campbells Occasionally, Kopenhagen · New Art in Scotland, Centre for Contemporary Art, Glasgow
1995	· Scottish Autumn, Bartok 23 Galeria, Budapest
1996	· Sarah Staton Superstore, Up & Co, New York · Absolute Blue and White, Inverleith House, Edinburgh · The Unbelievable Truth, Stedelijk Museum Bureau Amsterdam, Amsterdam / Tramway, Glasgow · Fucking Biscuits and Other Drawings, Bloom Gallery, Amsterdam · Big Girl/Little Girl, Collective Gallery, Edinburgh · White Hysteria, Contemporary Art Centre of South Australia, Adelaide/Australien · Toons, Galleri Campbells Occasionally, Kopenhagen · Upset, James Colman Fine Art, London

1997	· Blueprint, de Appel Foundation, Amsterdam · Tales of The City, Stills Gallery, Edinburgh · Public Relations, New British Photography, Stadthaus Ulm, Ulm · Caldas Biennale, Caldas da Rainha/Portugal · About Life in the Periphery, Wacker Kunst, Darmstadt · Appetizer, Free Parking, Toronto · Slight, Norwich Gallery, Norwich · Biscuit Barrel, Margaret Harvey Gallery, St. Albans
1998	· Surfacing – Contemporary Drawing, ICA, London · Real Life, Galleria S.A.L.E.S., Rom · Young Scene, Wiener Secession, Wien · Habitat, Centre for Contemporary Photography, Melbourne
1999	· Information, Kommunikation und Didaktik in der zeitgenössischen bildenden Kunst, Grazer Kunstverein, Graz · Getting the Corners, Or Gallery, Vancouver · Plug In, Salon 3, London · Word Enough to Save a Life, Word Enough to Take a Life, Clare College Mission Church, London · Common People – British Art between Phenomenon and Reality, Palazzo Re Rebaudengo, Guarene d'Alba · Waste Management, Art Gallery of Ontario, Ontario · Free Coke, Greene Naftali Gallery, New York · Ainsi de suite 3 (deuxieme partie), Sète
2000	· The British Art Show 5, National Touring Exhibition, Edinburgh · Personal History, The Fruitmarket Gallery, Edinburgh Diary, Cornerhouse, Manchester
2001	· AutoWerke, Hedengaagse Europese en Amerikaanse fotografie, Frans Hals Museum, Haarlem · Open Country. Contemporary Scottish Artists, Le Musée cantonal des Beaux-Arts de Lausanne, Lausanne · The Fantastic Recurrence of Certain Situations, Recent British Art and Photography, Consejeria de Cultura, Madrid
2002	· Reality Check, The Photographers' Gallery, London
2003	· Ten Years anniversary exhibition, Galleri Nicolai Wallner, Kopenhagen

2004　　　· State of play,
　　　　　　Serpentine Gallery, London
　　　　　· About Corporeality in editions:
　　　　　　Artist books, prints, photography,
　　　　　　Galerie Lelon, Zürich
　　　　　· Britannia works,
　　　　　　The British Council, Athen
　　　　　· Biennale, Museum of Art, Pontiac
　　　　　· Piss off, Museum of Art, Pontiac
　　　　　· Down here, Bergen Kunsthall, Bergen

Bibliografie (Auswahl) / *Bibliography (Selection)*

Judith Findlay, David Shrigley: Map of the Sewer –
Transmission Gallery, in: Zing Magazine,
Winter/1995

Lars Bang Larsen, Toons: Campbells
Occasionally, Copenhagen, in: Flash Art,
November/December 1996

Mike Wilson, David Shrigley: Catalyst Arts,
Belfast 1996

Judith Findlay, David Shrigley: Artist, in: Flash Art,
Mai/Juni/1996, S. 64

Judith Findlay, David Shrigley: Transmission, in:
Flash Art, Januar/Februar/1996, S. 106

Public Relations: New British Photography,
Ausst.-Kat. Stadthaus Ulm 1997

David Beech, David Shrigley: The Photographers'
Gallery, in: Art Monthly, Nr. 204, März/1997,
S. 29–30

Insert: David Shrigley, in: Parkett 53/1998,
S. 153–168

Why we Got the Sack from the Museum,
London 1998

Blank Page and Other Pages, hrsg. von
The Modern Institute, Glasgow 1998

Making your dreams come true, hrsg. von
Jone Elissa Scherf, George St. Andrews,
Ostfildern 2001

Kill your pets, Frankfurt/Main 2004

1966	geboren / *born* in Leigh-on-Sea / Großbritannien / *Great Britain,* lebt / *lives* in London
1984–1985	Central School of Art and Design, London
1985–1988	Goldsmiths College, London, B.A. (Honors)
1993–1995	Goldsmiths College, London, M.A. Fine Art

Einzelausstellungen (Auswahl) /
Solo Exhibitions (Selection)

1995	· Entwistle Gallery, London
1996	· All or Nothing, Studio Gallery, Budapest
1997	· Frith Street Gallery, London
1998	· Galerie Barbara Thumm, Berlin
1999	· British Council Window Gallery, Prag · Fotogalleriet, Oslo
2000	· Frith Street Gallery, London · Galerie Barbara Thumm, Berlin · Because a fire was in my head, South London Gallery, London
2001	· Gallery Side 2, Tokio
2002	· Imago 02, Centro de Arte de Salamanca, Salamanca
2003	· Glamour Studios, Galerie Barbara Thumm, Berlin
2005	· Solo Exhibition, Frith Street Gallery, London

Gruppenausstellungen (Auswahl) /
Group Exhibitions (Selection)

1986	· New Contemporaries, ICA, London
1989	· West Norwood Railway Arches, London · Current, Swansea Arts Centre, Swansea
1990	· Third Eye Centre, Centre for Contemporary Art, Glasgow
1991	· Clove Gallery, London
1992	· Love at First Sight, Showroom Gallery, London
1993	· Wonderful Life, Lisson Gallery, London
1994	· !GOL!, Mark Boote Gallery, New York · The Event, 152c Brick Lane, London · Close Encounters, Ikon Gallery, Birmingham · Institute of Cultural Anxiety: Works from the Collection, ICA, London · Räume für neue Kunst – Rolf Hengesbach, Wuppertal · Having IV, Spital Studio, London
1995	· MA Exhibition, Goldsmiths College, London · Frith Street Gallery, London

1996	· Try, Royal College of Art / London Ace / Hayward Gallery, London
1997	· The Oscars, La Nuova Pesa, Rom · Public Relations: New British Photography, Stadthaus Ulm, Ulm · Within These Walls, Kettles Yard, Cambridge · History. Works from the MAG Collection, Ferens Art Gallery, Hull · Whisper & Streak, Galerie Barbara Thumm, Berlin · World af Interiors, Binz 39, Zürich · Alpenblick: Die zeitgenössische Kunst und das Alpine, Kunsthalle Wien, Wien
1998	· Inbreeder: Some English Aristocracies, Collective Gallery, Edinburgh · Your Place or Mine, Elga Wimmer Gallery, New York · New British Photography, Real Gallery, New York · Made in London (Simmons & Simmons Collection), Museu de Electricidade, Lissabon · Group Show, Frith Street Gallery, London · The Tarantino Syndrome, Künstlerhaus Bethanien, Berlin
1999	· Vertigo: The Future of the City, The Old Fruitmarket, Glasgow · 0 to 60 in 10 Years, Frith Street Gallery, London · Blue Suburban Skies, The Photographers' Gallery, London · Natural Dependency, Jerwood Space, London
2001	· Autowerke, Hedendaagse Europese en Amerikaanse Fotografie, Frans Hals Museum, Haarlem · Arco Artfair, Madrid · ExtraOrdinary: American Places in Recent Photography, Madison Art Center, Madison · Because a Fire Was in My Head, South London Gallery, London · Real Places?, Westfälischer Kunstverein Münster, Münster · Give and Take, Jerwood Space, London · Magic Hour, Künstlerhaus, Graz
2002	· ExtraOrdinary: American Places in recent Photography, Madison Art Center, Madison / Cube Gallery, Manchester / RIBA Architecture Gallery, London
2003	· Sodium Dreams, CCS Museum, Bard College, New York

2004	· gifted, The Arts Gallery, London
	· Other Times, Contemporary British Art, City Art Gallery, Prag
2005	· Eccentric Spaces, Frith Street Gallery, London
	· Our Surroundings, Dundee Contemporary Arts, Dundee

Bibliografie (Auswahl) / *Bibliography (Selection)*

Laura Cottingham, Wonderful Life, in: Frieze, September/Oktober 1993

Mark Durden, Close Encounters, Ikon Gallery, in: Creative Camera, Dezember 1993/January 1994

Martin Maloney, Glitz and Thrift, in: Blueprint, Dezember/1995

Martin Maloney, Ouverture, in: Flash Art 183/1995

Ian Hunt, Entwistle, in: Frieze, Mai/1995, S.59–60

Zürich – Janette Parris, Andreas Rüthi und Bridget Smith in der Stiftung Binz, in: Kunstbulletin 11/1997

Hollow Illusions. The Work of Bridget Smith, in: Portfolio 26/1997

Public Relations: New British Photography, Ausst.-Kat. Stadthaus Ulm 1997

On the Bride Side of Life, Zeitgenössische britische Fotografie, Ausst.-Kat. Neue Gesellschaft für bildende Kunst, Berlin 1997

Within These Walls, Ausst.-Kat. Kettles Yard, Cambridge 1997

The Campaign Against Living Miserably, Ausst.-Kat. Royal College of Art Galleries, London 1998

Making your dreams come true, hrsg. von Jone Elissa Scherf, George St. Andrews, Ostfildern 2001

Bridget Smith, Ausst.-Kat. Centro de Arte de Salamanca 2002

1971	geboren / *born* in Belfast, lebt / *lives* in London
1992–1995	Napier University, Edinburgh, B.A. (Honors) Photography and Film
1996–1997	College of Art, London, M.A. Photography

Einzelausstellungen (Auswahl) / *Solo Exhibitions (Selection)*

1995
- Scottish Homes, Stills Gallery, Edinburgh

1998
- Maureen Paley Interim Art, London

1999
- Nederlands Foto Instituut, Rotterdam
- Cornerhouse, Manchester
- Galleria Raucci/Santamaria, Neapel

2000
- Irish Museum of Modern Art, Dublin
- Maureen Paley Interim Art, London
- Progetto, Castello di Rivoli, Turin

2002
- Monica de Cardenas, Mailand
- Maureen Paley Interim Art, London

2003
- Fondazione Sandretto Re Rebaudengo, Turin

2005
- Lisboaphoto 2005: Museu da Cidale Plácio Pimenta, Lissabon

Gruppenausstellungen (Auswahl) / *Group Exhibitions (Selection)*

1997
- John Kobal Foundation, National Portrait Gallery, London

1998
- Silver & Syrup: A Selection from the History of Photography, Victoria and Albert Museum, London
- Remix: Images photographiques, Musée des Beaux-Arts, Nantes
- Look at me, The British Council Touring Exhibition, Kunsthal Rotterdam, Rotterdam
- Real Life, Galleria S.A.L.E.S., Rom
- Sightings – New Photographic Art, ICA, London
- Shine – Photo '98, National Museum of Film & Photography, Bradford
- Modern Narratives: The Domestic and the Social, Artsway, London

1999
- Galerie Rudolphe Janssen, Brüssel
- 3rd International Tokyo Photo Biennial, Tokyo Metropolitan Museum of Photography, Tokio

2000
- Suspendidos, Centro de Fotografia, Universidad de Salamanca, Salamanca
- Give and Take: The Contemporary Art Society at the Jerwood, Jerwood Space, London

2001
- AutoWerke, Hedengaagse Europese en Amerikaanse fotografie, Frans Hals Museum, Haarlem
- Extended Painting, Monica de Cardenas, Mailand
- Instant City, Museo Pecci, Prato
- Oostduitse meisjes en andere stukken, Gemeentemuseum Helmond, Helmond

2002
- Location: UK, Gimpel Fils, London
- Cowboys en kroegtijgers, Gemeentemuseum Helmond, Helmond
- The Unblining Eye, Irish Museum of Modern Art, Dublin

2003
- Landscape, The Saatchi Gallery, London
- Telling Tales: Narrative Impulses in Recent Art, Tate Liverpool, Liverpool
- Yet untitled. Collection Bernd F. Künne, Städtische Galerie Wolfsburg, Wolfsburg
- Einblicke in Privatsammlungen, Museum Folkwang Essen, Essen
- Sodium Dreams, Bard College, Annandale-on-Hudson

2004
- Take Five! Huis Marseille turns five, Huis Marseille Foundation for Photography, Amsterdam
- Yet untitled. Collection Bernd F. Künne, National Museum of Photography, Kopenhagen
- Colección Sandretto Re Rebaudengo, Institut d'Art Moderne de Castro, Valencia

2005
- Smile away the parties and champagne, Gemeentemuseum Helmond, Helmond

Bibliografie (Auswahl) / *Bibliography (Selection)*

Barry Schwabsy, Openings: Hannah Starkey, in: Artforum International 37/1998, S. 142–143

Claire Bishop, Hannah Starkey, Quitely Loaded Moments, in: Flash Art 32/1999, S. 124–125

A Project for the Castle, Hannah Starkey, hrsg. von Marcelle Beccaria, Ausst.-Kat. Castello di Rivoli, Turin 2000

Hannah Starkey: Moments in the Modern World, Photographic Works 1997–2000, Ausst.-Kat. Irish Museum of Modern Art, Dublin 2000

Hannah Starkey bei Interim Art, in: Kunst-Bulletin 5/2000, S. 38

Alex Farquharson, Girls Interrupted, in: frieze 11/2000, S. 88–89

Sarah Glennie, Hannah Starkey, in: Art News 9/2000, S. 188

Making your dreams come true, hrsg. von Jone Elissa Scherf, George St. Andrews, Ostfildern 2001

Fisum Güner, Hannah Starkey, in: Modern Painters, hrsg. von Maureen Paley Interim Art, London 2002

1957	geboren / *born* in Altdorf/Schweiz/ *Switzerland,* lebt */lives* in Zürich, Düsseldorf
1977–1978	Schule für Gestaltung, Zürich
1979–1981	Schule für Gestaltung, Basel
1982–1985	Hochschule der Künste Berlin, Berlin

Einzelausstellungen (Auswahl) /
Solo Exhibitions (Selection)

1990	· Helmhaus, Zürich
1992	· Galerie Anne de Villepoix, Paris · Galerie Conrads, Düsseldorf · Galerie Walcheturm, Zürich
1993	· Projektionen und Fotografien NYC 1991/1993, Kunstmuseum Luzern, Luzern
1994	· Allen Street, Kunsthalle St. Gallen, St. Gallen · Galerie Monica de Cardenas, Mailand
1995	· Les Ateliers d'Artistes de la Ville de Marseille, Marseille · Attitudes, Centre d'Art Contemporain, Genf · Allen Street, Le Consortium, Dijon · Galerie Daniel Buchholz, Köln · T in the Park, Kunstverein Elsterpark, Leipzig
1996	· Visitors, museum in progress, Wien · Janice Guy Gallery, New York · Retrats, Tinglado Dos, Tarragona · Portrait Tarragone, Kopenhagen 1996, Musée d'Art Moderne de la Ville de Paris, Paris
1997	· Oxford Street, Tate Gallery, London · Galerie Mikael Andersen, Kopenhagen
1998	· Placa dels Angels, Museu d'Art Contemporani, Barcelona · Galerie Anne de Villepoix, Paris · Galerie Hauser & Wirth, Zürich · Rencontres Internationales de la Photographie, Arles · Yamaguchi 10-4-98, Yamaguchi Prefecture Museum, Yamaguchi
1999	· Museum of Contemporary Art, Chicago · CITY, Kunsthalle Düsseldorf, Düsseldorf / Kunsthalle Zürich, Zürich · Bondi, Sprengel Museum Hannover, Hannover · Spiral Art Center, Tokio · Museum für Moderne Kunst, Frankfurt/Main · Galerie Christian Drantmann, Brüssel · Galerie Christian Meyer, Wien
2000	· Galleria civica d'Arte Moderna e Contemporanea, Turin · Museum of Contemporary Art, Chicago · Urban views, Stedelijk Museum, Amsterdam
2001	· Fotografien und Videos, Dogenhaus Galerie, Leipzig

2002	· Fenster-Installation, Palais de Tokyo, Paris · 19 Australian and International Photographers, Conny Dietzschold Gallery, Sydney
2003	· Murray Guy, New York
2004	· Roberts & Tilton, Los Angeles · Los Angeles Contemporary Exhibitions, Los Angeles · The Pallasades 05-01-01, Off-site Project, Ikon Gallery, Birmingham
2005	· Galerie Jablonka, Köln · Portraits, RWE-Turm, Essen

Gruppenausstellungen (Auswahl) /
Group Exhibitions (Selection)

1990	· Musée d'Art Moderne de la Ville de Paris, Paris
1991	· Fondation Cartier, Paris
1992	· P.S. 1 Contemporary Art Center, New York
1993	· Fondation pour l'Architecture, Brüssel · Andrea Rosen Gallery, New York
1994	· 3. Internationale Foto-Triennale, Galerie der Stadt Esslingen, Esslingen · Et passim, Kunsthalle Bern, Bern
1995	· Kwangju Biennale, Kwangju/Korea · Castello di Rivoli, Rivoli
1997	· Johannesburg Biennale, Johannesburg · Yokohama Museum of Art, Yokohama / Japan Henry Art Gallery, Seattle · Bard College, Annandale-on-Hudson, New York / Cityspace, Kopenhagen · Prospect, Frankfurter Kunstverein, Frankfurt/Main / The Photographers' Gallery, London / The Whitney Museum of American Art, New York
1998	· Everyday, Sydney Biennale, Sydney
1999	· Chicago, July 99, Museum of Contemporary Art, Chicago
2000	· Le Desert, Fondation Cartier, Paris · Szenenwechsel, Museum für Moderne Kunst, Frank- furt/Main · Gift of Hope, Museum of Contemporary Art, Tokio · Bleibe, Akademie der Künste, Berlin · Quotidiana, Castello di Rivoli, Turin · Moment, Dundee Contemporary Arts, Dundee · AutoWerke, European and American Photography, Deichtorhallen Hamburg, Hamburg

2001	· AutoWerke, Hedengaagse Europese en Amerikaanse fotografie, Frans Hals Museum, Haarlem
2002	· today till now – zeitgenössische Fotografie aus Düsseldorf, Museum Kunst Palast, Düsseldorf
2003	· Överblick konst från, Umeå/Schweden
	· Strangers: The First Triennial of Photography and Video, International Center of Photography, New York
	· Brighton Photo Biennial, Brighton
2004	· Outlook. International Art Exhibition Athens 2003, Arena – Society for the Advancement of Contemporary Art in Athens, Athen
	· Outcasts and Sunday's Children – Acquisitions in 2003, De Hallen, Haarlem
	· Yet untitled – Collection Bernd F. Künne, National Museum of Photography, Kopenhagen
	· Compostela / 10 artists on Compostela, CGAC Centro Galego de Arte Contemporánea, Santiago de Compostela
	· Collection Agnès B, Les Abattoirs – Frac Midi-Pyrénées, Toulouse
	· Relating to Photography, Fotografie Forum International, Frankfurt/Main
	· Take Five! Huis Marseille turns five, Huis Marseille, Amsterdam
	· Situations construites, attitudes – espace d'arts contemporains, Genf
	· Europe in Art, Kunsthaus Hamburg, Hamburg
2005	· … aus der Fotosammlung: Neuerwerbungen, Landesgalerie am Oberösterreichischen Landesmuseum, Linz
	· Sharjah International Biennial 7, Department of Culture and Information, Government of Sharjah, Sharjah/Vereinigte Arabische Emirate
	· Slow Down, Galería Pilar Parra, Madrid
	· Galerie der Stadt Tuttlingen, Tuttlingen

Bibliografie (Auswahl) / *Bibliography (Selection)*

Beat Streuli, Projektionen und Fotografien NYC 1991/93, Ausst.-Kat. Kunstmuseum Luzern 1993

Beat Streuli, USA 95, Ausst.-Kat. Württembergischer Kunstverein Stuttgart, Ostfildern 1995

Beat Streuli I projections, Ateliers d'Artistes, Marseille 1995

Portrait Tarragone, Copenhague 1996, Ausst.-Kat. Musée d'Art Moderne de la Ville de Paris 1996

Beat Streuli – Bondi Beach/Parramatta Road, Ausst.-Kat. Sprengel Museum Hannover 1999

City, hrsg. von Rupert Pfab, Boris Groys, Ausst.-Kat. Kunsthalle Düsseldorf / Kunsthalle Zürich, Ostfildern 1999

Marseilles, Actes Sud, Arles 1999

AutoWerke, hrsg. von Christa Aboitiz u. a., Ostfildern 2000

Beat Streuli. Urban Views in het Stedelijk Museum Amsterdam, Ausst.-Kat. Stedelijk Museum, Rotterdam 2000

Portaits 98–00, La bella estate, Ausst.-Kat. Galeria Civica d'Arte Moderna, Turin 2000

Beat Streuli, New York City, o. O., 2003

1954	geboren / *born* in Geldern/Niederrhein, lebt / *lives* in Düsseldorf
1973–1980	Kunstakademie Düsseldorf, Düsseldorf
1993–1996	Professur für Fotografie an der / *Professor for photography at the* Staatlichen Hochschule für Gestaltung, Karlsruhe

Einzelausstellungen (Auswahl) /
Solo Exhibitions (Selection)

1978	· Streets of New York City, P.S. 1 Contemporary Art Center, New York
1987	· Unconscious Places, The Fruitmarket Gallery, Edinburgh
1988	· Another Objectivity, ICA, London
1990	· The Renaissance Society, Chicago
1992	· Museum Haus Lange, Krefeld · Hirschhorn Museum and Sculpture Garden, Washington D.C.
1993	· Kunsthalle Hamburg, Hamburg
1994	· Strangers and Friends, ICA, London · ICA, Boston
1995	· Straßen: Photographie 1976–1995, Kunstmuseum Bonn, Bonn · Porträts, Sprengel Museum Hannover, Hannover · Face to Face, Fine Arts Foundation of Beijing Art Palace, Peking
1998	· Still, Stedelijk Museum, Amsterdam
1999	· Centre National de la Photographie, Paris
2000	· My Portrait, The National Museum of Modern Art, Tokio / The National Museum of Modern Art, Kyoto
2001	· Pictures from Dandelion Room, Schirmer-Mosel Showroom, München
2002	· New Pictures from Paradise, Centro de Fotografia, Universidad de Salamanca / Staatliche Kunstsammlungen, Dresden
	· Thomas Struth 1977–2002, Dallas Museum of Art, Dallas / Museum of Contemporary Art, Los Angeles
2004	· Portraits – Une Heure, Musée d'art contemporain, Bordeaux

Gruppenausstellungen (Auswahl) /
Group Exhibitions (Selection)

1990	· Aperto OE 90, Biennale di Venezia, Venedig
1991	· The Carnegie International 1991, Carnegie Museum of Modern Art, Pittsburgh · Documenta IX, Kassel
1992	· Aus der Distanz, Kunstsammlung Nordrhein-Westfalen, Düsseldorf
1994	· The Epic and the Everyday, Hayward Gallery, London
1995	· Contemporary Photography, Absolute Landscape – Between Illusion & Reality, Museum of Art, Yokohama
1996	· Kunsthalle Basel, Basel
1997	· Positionen künstlerischer Photographie in Deutschland nach 1945, Berlinische Galerie, Berlin · Museum Studies – Eleven Photographer's Views, High Museum of Art, Atlanta
1998	· Biennale of Sidney, Sidney
2000	· AutoWerke, European and American Photography, Deichtorhallen Hamburg, Hamburg
2001	· AutoWerke, Hedengaagse Europese en Amerikaanse fotografie, Frans Hals Museum, Haarlem · City, Museo Pecci, Prato · Museum für Gegenwartskunst, Siegen · En plein terre, Kunstsammlung Basel, Basel · Ex(o)dus, Haifa Museum of Art, Haifa · Museum of Desires, Museum Ludwig, Köln
2002	· Heute bis jetzt. Zeitgenössische Fotografie aus Düsseldorf, Museum Kunst Palast, Düsseldorf · Wallflower, Kunsthaus Zürich, Zürich · Open City: Aspects of Street Photography 1950–2000, Museo de Bellas Artes, Bilbao · Zwischen Schönheit und Sachlichkeit, Kunsthalle Emden, Emden · The viewer as participant, Astrup Fearnley Museum of Modern Art, Oslo

2003	· Jede Fotografie ist ein Bild: Siemens Fotosammlung, Pinakothek der Moderne, München · Cruel and Tender. Zärtlich und Grau- sam. Fotografie und das Wirkliche, Museum Ludwig, Köln / Tate Modern, London · Sandretto Re Rebaudengo Collection, Institut Valencià d'Art Modern, Valencia · actionbutton, Hamburger Bahnhof – Museum für Gegenwart, Berlin · Site Specific, Museum of Contemporary Art, Chicago · Photo-Kunst – 1852–2002, Staatsgalerie Stuttgart, Stuttgart · Interrogare il luogo, Studio La Città, Verona	**Bibliografie (Auswahl) /** *Bibliography (Selection)* Unbewußte Orte / Unconscious Places, hrsg. von Ulrich Loock, Ausst.-Kat. Kunsthalle Bern, Köln 1987 Thomas Struth. Photographs, hrsg. von Benjamin Buchloh, Ausst.-Kat. The Renaissance Society at the University of Chicago 1990 Thomas Struth. Portraits, Ausst.-Kat. Museum Haus Lange Krefeld 1992 Thomas Struth. Museum Photographs, Ausst.-Kat. Hamburger Kunsthalle, München 1993 Strangers and Friends. Photographs 1986–1992, Ausst.-Kat. The Institute of Contemporary Art Boston, Cambridge / München 1994
2004	· Colección Taschen, Museo Nacional Centro de Arte Reina Sofía, Madrid · Archiskulptur, Foundation Beyeler, Basel · 26° Bienal de São Paulo, São Paulo · Fotografía alemana contemporánea – Distancia y Proximidad, Museo de Arte Moderno de la Ciudad de Buenos Aires, Buenos Aires · Love / Hate. From Magritte to Cattelan, Villa Manin, Centro d'arte contemporanea, Passariano · Pinakothek der Moderne, München · Pergamon-Museum 1/2/3/4/5/6, Hamburger Bahnhof – Museum für Gegenwart, Berlin · 3. Berlin Biennale für Zeitgenössische Kunst, Berlin	Landschaften, Ausst.-Kat. Achenbach Kunsthandel, Düsseldorf 1994 Thomas Struth. Portraits, Ausst.-Kat. Sprengel Museum Hannover, München 1997 Still, Ausst.-Kat. Carré d'Art Nîmes, München 1998 Thomas Struth. Portraits, München 1998 Thomas Struth. Museum Photographs, München 1998 AutoWerke II, hrsg. von Jone Elissa Scherf, Ostfildern 2000 Thomas Struth, Photographien 1977–2002, München 2002
2005	· Blumenstück – Künstlers Glück, Museum Morsbroich, Leverkusen	Thomas Struth: Pergamon Museum 1–6, hrsg. von Ludger Derenthal, Ausst.-Kat. Museum für Foto- grafie im Hamburger Bahnhof – Museum für Gegen- wart, München 2004 Thomas Struth, New Pictures from Paradise, München 2002 Thomas Struth: Landschaften, in: Intermedia, hrsg. von B. Engelbach und M. Dobbe, Ausst.-Kat. Museum für Gegenwartskunst, Siegen 2005

1968	· geboren / *born* in Remscheid, lebt / *lives* in London
1990–1992	· Bournemouth and Poole College of Art & Design, Dorset
1998	· Gastprofessor an der / *Guest professor at the* Hochschule für Bildende Künste Hamburg, Hamburg

Einzelausstellungen (Auswahl) /
Solo Exhibitions (Selection)

1992	· PP5 Galerie, F. C. Gundlach, Hamburg
1993	· Maureen Paley Interim Art, London · Ars Futura Galerie, Zürich · L. A. Galerie, Frankfurt/Main
1994	· Galerie Daniel Buchholz, Köln · Andrea Rosen Gallery, New York · Galerie Thaddaeus Ropac, Paris
1995	· Maureen Paley Interim Art, London · Regen Projects, Los Angeles / Portikus, Frankfurt/Main · Stills, Kunsthalle Zürich, Zürich · Galerie neugerriemschneider, Berlin
1996	· Andrea Rosen Gallery, New York · Wer Liebe wagt lebt morgen, Kunstmuseum Wolfsburg, Wolfsburg · Galleri Nicolai Wallner, Kopenhagen · ars furtura Galerie, Zürich · Faltenwürfe, Galerie Daniel Buchholz, Köln / Kunstverein Elsterpark, Leipzig
1997	· I Didn't Inhale, Chisenhale Gallery, London · hale-Bopp, Art Köln / Galerie Daniel Buchholz, Köln
1998	· Andrea Rosen Gallery, New York · Fruiciones, Museo Nacional Reina Sofia, Espacio Uno, Madrid
1999	· Soldiers – The Nineties, Andrea Rosen Gallery, New York / Ars Futura Galerie, Zürich · Soldiers, Kunstverein Aachen, Aachen · Regen Projects, Los Angeles · Maureen Paley Interim Art, London · Wako Works of Art, Tokyo · Eins ist sicher: Es kommt immer ganz anders als man denkt, Städtische Galerie, Remscheid · Germany Saros, Galerie Daniel Buchholz, Köln · Galerie neugerriemschneider, Berlin
2002	· Vue d'en haut, Palais de Tokyo, Paris
2003	· View from above, Louisiana Museum of Contemporary Art, Humlebæk/Dänemark · If one thing matters, everything matters, Tate Britain, London · De Hallen, Haarlem · Galerie Daniel Buchholz, Köln · Andrea Rosen Gallery, New York

2004	· Freischwimmer, Galerie neugerriemschneider, Berlin · New Photographs – Part I, Wako Works of Art, Tokio · Freischwimmer, Tokyo Opera City Art Gallery, Tokio · Regen Projects, Los Angeles
2005	· Galeria Juana de Aizpuru, Madrid

Gruppenausstellungen (Auswahl) /
Group Exhibitions (Selection)

2000	· AutoWerke. European and American Photography, Deichtorhallen Hamburg, Hamburg · Galerie Meyer Kainer, Wien · Galerie Rüdiger Schöttle, München
2001	· AutoWerke, Hedengaagse Europese en Amerikaanse fotografie, Frans Hals Museum, Haarlem
2002	· Magnani, London · Shopping, Schirn Kunsthalle, Frankfurt/Main · Remix: Contemporary art & pop, Tate Liverpool, Liverpool
2003	· Photograph to photograph, Collection Lambert, Musée d'art contemporain, Avignon · It's unfair!, Museum De Paviljoens, Almere · M_ARS. Kunst und Krieg, Neue Galerie Graz am Landesmuseum Joanneum, Graz · Abstraction in photography, Von Lintel Gallery, New York · Attack! Kunst und Krieg in den Zeiten der Medien, Kunsthalle Wien, Wien · Photographs, Wako Works of Art, Tokio · Öffentlich Privat. Das Bild des Privaten in der deutschen Nachkriegsfotografie, Galerie für Zeitgenössische Kunst, Leipzig
2004	· Imágenes en movimiento / Moving Pictures, Guggenheim Bilbao, Bilbao · fast forward – Media Art. Sammlung Goetz, ZKM I Zentrum für Kunst und Medientechnologie, Karlsruhe · Outlook. International Art Exhibition Athens 2003, Arena – Society for the Advancement of Contemporary Art in Athens, Athen · A Clear Vision. Photographische Werke aus der Sammlung F.C. Gundlach, Deichtorhallen Hamburg, Hamburg · Von Körpern und anderen Dingen. Deutsche Fotografie im 20. Jahrhundert, Deutsches Historisches Museum, Berlin · Atmosphere, Museum of Contemporary Art, Chicago

- Likeness – Portraits of artists by other artists,
 Wattis Institute for Contemporary Art,
 San Francisco
- On the Body and Other Things /
 Von Körpern und anderen Dingen,
 Moscow House of Photography,
 Moskau
- Biennale, Museum of New Art, Pontiac
- Speaking With Hands: Photographs
 from the Buhl Collection, Solomon R.
 Guggenheim Museum, New York

2005
- Monument to now,
 Deste Foundation,
 Centre for Contemporary Art, Athen
- The Flower as Image –
 From Monet to Jeff Koons,
 Louisiana Museum of Contemporary
 Art, Humlebæk/Dänemark
- Encounters in the 21st Century:
 Polyphony – Emerging Resonances,
 21st Century Museum of Contemporary
 Art, Kanazawa/Japan
- Atlantic & Bukarest,
 Museum für Gegenwartskunst, Basel
- Covering the Real, Kunst und
 Pressebild von Warhol bis Tillmans,
 Kunstmuseum Basel, Basel

Bibliografie (Auswahl) / *Bibliography (Selection)*

Stills, Ausst.-Kat. Kunsthalle Zürich 1995

Wolfgang Tillmans, hrsg. von
Burkhard Riemschneider, Köln 1995

Wer Liebe wagt, lebt morgen, Ausst.-Kat.
Kunstmuseum Wolfsburg, Ostfildern 1996

Burg, Wolfgang Tillmans, Köln 1998

Totale Sonnenfinsternis / Total Solar Eclipse,
hrsg. von Daniel Buchholz, Köln 1999

AutoWerke, hrsg. von Christa Aboitiz u. a.,
Ostfildern 2000

Isa Genzken, Wolfgang Tillmans – Science Fiction,
Hier und Jetzt zufrieden sein, Ausst.-Kat.
Museum Ludwig, Köln 2001

Wolfgang Tillmans / Peter Halley / Jan Verwoert /
Midori Matsuri, London 2002

If one thing matters, everything matters –
Wolfgang Tillmans, Ausst.-Kat.
Tate Britain, London 2003

1965	geboren / *born* in Starnberg, lebt / *lives* in München / *Munich*, Berlin
1987–1991	Akademie der Bildenden Künste, München / *Munich*

Einzelausstellungen (Auswahl) /
Solo Exhibitions (Selection)

1994	· Perfect World, Galerie Wittenbrink, München · Galerie Michael Zink, Regensburg
1997	· Galerie Alberto Peola, Turin
1998	· Scene Shift, Galerie Wittenbrink, München
1999	· Galerie Rudolf Kicken, Köln · Galerie Wittenbrink, München
2000	· Galería Helga de Alvear, Madrid · Kunstverein Grafschaft Bentheim, Neuenhaus · Espai Lucas, Valencia
2003	· Galerie Storms, München · Galería Helga de Alvear, Madrid
2004	· Galerie Storms, München

Gruppenausstellungen (Auswahl) /
Group Exhibitions (Selection)

1993	· Urban Camera, Kunstverein Augsburg, Augsburg
1994	· Neuer Kunstverein Aschaffenburg, Aschaffenburg
1995	· Der Zweite Blick, Haus der Kunst, München · Standpunkt Stadt, Städtische Galerie Regensburg, Regensburg
1996	· Von hier, Galerie Wittenbrink, München
1997	· Bejing National Gallery, Peking / Shanghai Art Gallery, Shanghai
1998	· Die Sammlung IV, Städtische Galerie im Lenbachhaus, München · Nationales Kunstmuseum der Ukraine, Kiew
1999	· Dial M for, Kunstverein München, München · Das Gedächtnis öffnet seine Tore, Städtische Galerie im Lenbachhaus, München

2000	· Supermodel, Museum of Contemporary Art, North Adams · Close up, Kunstverein Freiburg, Freiburg/Breisgau / Kunsthaus Baselland, Muttenz · Juli, Kunstsammlung Tumulka, München · AutoWerke, European and American Photography, Deichtorhallen Hamburg, Hamburg
2001	· AutoWerke, Hedengaagse Europese en Amerikaanse fotografie, Frans Hals Museum, Haarlem
2002	· Urbane Sequenzen, Museum Schloss Hardenberg, Velbert-Neviges
2003	· Interrogare il luogo, Studio La Città, Verona · true fictions, Inszenierte Fotokunst der 90er-Jahre, Städtische Galerie Erlangen, Erlangen / Stadtgalerie Saarbrücken, Saarbrücken · Förderpreise 2003, lothringer dreizehn, München · The City, U.B.R. Galerie, Salzburg
2004	· Realidad y Representación. Coleccionar paisaje hoy, Fundación Foto Colectania, Barcelona · true lies. Lügen und andere Wahrheiten in der zeitgenössischen Fotografie, museum franz gertsch, Burgdorf / Kallmann-Museum, Ismaning
2005	· Gezähmte Natur, Brandenburgische Kunstsammlungen Cottbus, Cottbus · Park – Zuflucht und Wildwuchs in der Kunst, Staatliche Kunsthalle Baden-Baden, Baden-Baden

Bibliografie (Auswahl) / *Bibliography (Selection)*

Der Zweite Blick, Ausst.-Kat. Haus der Kunst, München 1995

Alexander Timtschenko, Ausst.-Kat. Galerie Alberto Peola, Turin 1997

Künstlerische Realitäten, in: tain 4/1998

S. Müller, Der Eiffelturm steht in der Wüste von Nevada, in: art 7/1999

S. D. Lehner, Alexander Timtschenko, in: Flash Art International, März/April 1999

Dial M for, Ausst.-Kat. Kunstverein München, München 1999

AutoWerke II, hrsg. von Jone Elissa Scherf, Ostfildern 2000

In Szene gesetzt, Architektur in der Fotografie, hrsg. von Götz Adriani, Ostfildern 2002

1963	geboren / *born* in Birmingham, lebt / *lives* in London	
1985–1987	Chelsea School of Art, London	
1987–1990	Goldsmiths College, London, B.A. Fine Arts	

Einzelausstellungen (Auswahl) /
Solo Exhibitions (Selection)

1994 · Maureen Paley Interim Art, London

1995 · Western Security,
Hayward Gallery, London

1996 · Wish You Were Here,
De Appel, Amsterdam
· City Projects – Prag, Part 11,
The British Council, Prag

1996 · Maureen Paley Interim Art, London

1997 · Galerie Drantmann, Brüssel
· Jay Gorney Modern Art, New York
· Wiener Secession, Wien
· 1 D – 16,
Chisenhale Gallery, London /
Kunsthaus Zürich, Zürich
· Emi Fontana, Mailand

1998 · Gallery Koyanagi, Tokio
· Centre d'Art Contemporain, Genf

1999 · Galerie Anne de Villepoix, Paris
· Drunk, De Vleeshal, Middelburg
· Maureen Paley Interim Art, London

2000 · Serpentine Gallery, London

2001 · Sous influence, Musée d'Art Moderne
de la Ville de Paris, Paris
· Broad Street,
Museu do Chiado, Museu Nacional de
Arte Contemporanea, Lissabon
· Unspoken,
Kunstverein München, München

2002 · Mirror Image,
UCLA Armand Hammer Museum,
Los Angeles

2003 · Mass Observation,
Museum of Contemporary Art, Chicago
· Maureen Paley Interim Art, London

2004 · Family Portraits: Trauma, Prelude,
De Hallen, Haarlem
· Regen Projects, Los Angeles
· Museum for Contemporary Art,
Kiasma Nykytaiteen museo, Helsinki
· Shhhh…,
Victoria and Albert Museum, London

Gruppenausstellungen (Auswahl) /
Group Exhibitions (Selection)

1993 · BT Young Contemporaries,
Cornerhouse, Manchester
· Stoke-on-Trent,
Centre for Contemporary Art, Glasgow

1995 · X/Y, Centre Georges Pompidou, Paris

1996 · Life Live, Musée d'Art Moderne de la
Ville de Paris, Paris
· Playpen & Corpus Delirium,
Kunsthalle Zürich, Zürich
· The Cauldron,
Henry Moore Institute, Leeds
· Pandemonium,
London Festival of Moving Images,
ICA, London

1997 · The Turner Prize 1997,
Tate Gallery, London
· Sensation, Saatchi Collection,
Royal Academy of Art, London /
Hamburger Bahnhof – Museum für
Gegenwart, Berlin
· LD., Nouveau Musée, Villeurbanne
· Bloom Galerie, Amsterdam

1998 · Real Life: New British Art, Japanese
Museum Tour, Tochigi Prefectural
Museum of Fine Arts, Tochigi /
Fukuoka City Art Museum, Fukuoka /
Hiroshima Museum of Contemporary
Art, Hiroshima / Tokio Museum of
Contemporary Art, Tokio

1999 · Common People,
Fondazione Sandretto Re
Rebaudengo per l'Arte, Turin
· Sweetie: Female Identity in British
Video, The British School, Rom

2000 · Intelligence: New British Art 2000,
Tate Britain, London
· Puerile '69,
The Living Art Museum, Reykjavik
· Tate Modern Collection,
Tate Modern, London
· docudrama, Bury St. Edmunds Gallery,
Bury St. Edmunds
· Let's Entertain,
Walker Art Center, Minneapolis
· Quotidiana, Castello di Rivoli, Turin
· Makeshitt,
ArtPace, San Antonio, Texas
· AutoWerke, European and American
Photography,
Deichtorhallen Hamburg, Hamburg

2001 · AutoWerke, Hedengaagse Europese
en Amerikaanse fotografie,
Frans Hals Museum, Haarlem
· No Harm in Looking,
Museum of Contemporary Art, Chicago
· Videoreihe 6 Künstler – 6 Positionen,
Sammlung Goetz, München

2002 · Remix: Contemporary art & pop,
Tate Liverpool, Liverpool
· I promise, it's political,
Museum Ludwig, Köln

2003 · Schrägspur,
Hamburger Kunsthalle, Hamburg
· Die Wohltat der Kunst,
Sammlung Götz, München
· Fast Forward,
ZKM | Museum für Neue Kunst,
Karlsruhe
· 2. Biennale Tirana,
National Gallery of Arts Tirana, Tirana
· micro/macro, British Art 1996–2002,
Kunsthalle Budapest, Budapest

2004 · Manifesta 5, San Sebastián Biennale
· Museum of New Art, Michigan
· Collection Agnès B, Les Abattoirs,
Frac Midi-Pyrénées, Toulouse
· Soziale Kreaturen. Wie Körper
Kunst wird,
Sprengel Museum Hannover, Hannover
· Happiness: A Survival Guide for Art
and Life, Mori Art Museum, Tokio
· A Century of Artists' Film in Britain,
Tate Britain, London

2005 · Irreducible,
Wattis Institut for Contemporary Art,
San Francisco
· Emotion Pictures,
Museum an Hedendaagse Kunst,
Antwerpen

Bibliografie (Auswahl) / *Bibliography (Selection)*

Jon Savage, Vital Signs, in: Artforum, März/1994

Robert Garnett, The British Art Show, in:
Art Monthly, Dezember/Januar 1995

Paul Bonaventura, Profile: Wearing Weil, in:
Art Monthly, März/1995

NowHere, hrsg. von Laura Cottingham, Ausst.-Kat.
Louisiana Museum of Modern Art, Humlebæk/
Dänemark 1996

Le Shuttle, Ausst.-Kat. Künstlerhaus Bethanien,
Berlin 1996

Signs that say what you want them to say and
not Signs that say what someone else wants you
to say, Ausst.-Kat. Maureen Paley Interim Art,
London 1997

Gilda Williams, Die Kunst Gillian Wearings, in:
Parkett 52/1998

Gillian Wearing, Monographie, London 1999

AutoWerke, hrsg. von Christa Aboitiz u. a.,
Ostfildern 2000

Mass Oberservation, hrsg. von D. Molon, Ausst.-
Kat. Museum of Contemporary Art, Chicago 2002

Soziale Kreaturen, Ausst.-Kat. Sprengel Museum
Hannover 2004